Michelangelo da Caravaggio

Authors:
Félix Witting and M.L. Patrizi

Layout:
Baseline Co. Ltd
61A-63A Vo Van Tan Street
4th Floor
District 3, Ho Chi Minh City
Vietnam

© 2012, Confidential Concepts, Worldwide, USA
© 2012, Parkstone Press International, New York
Image-Bar www.image-bar.com

ISBN: 978-1-906981-83-9

Printed in Italy

Félix Witting and M.L. Patrizi

Michelangelo da Caravaggio

PARKSTONE
INTERNATIONAL

Michel:º da Caravaggio

Contents

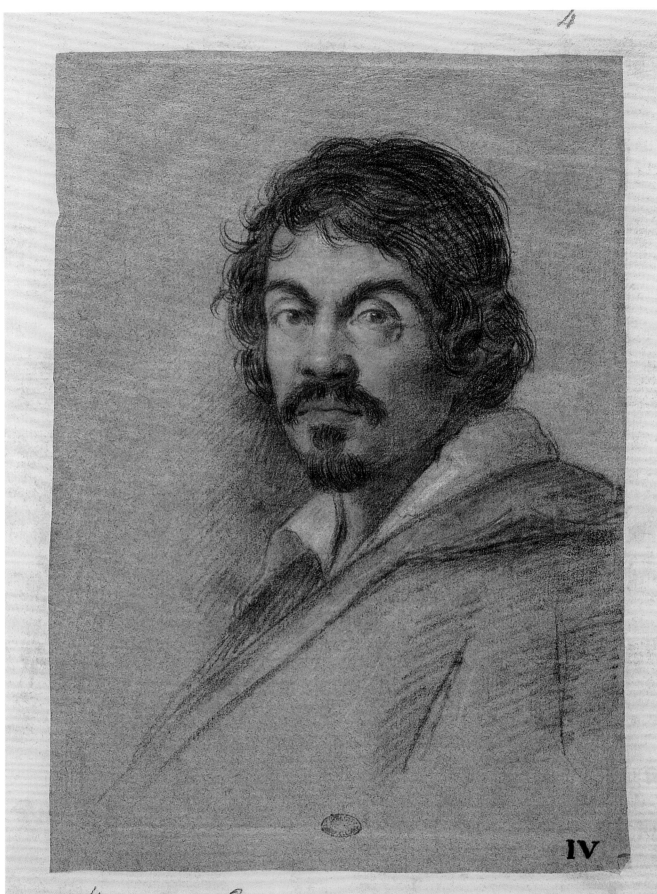

Michel: da Caravaggio

Introduction

Although Caravaggio and his art may were forgotten for almost three hundred years, it can safely be said that since the beginning of the 20th century this oversight has largely been compensated for. Despite his dismissal by critics (was it not Poussin who stated that he came in order to destroy painting?) and his fall into oblivion, his name seems to have reappeared in collective memory during certain periods of history. Even in his own time, a contemporary of Caravaggio, Giovanni Baglione recognised the artist's importance as a discoverer of a distinctly modern style[1]. Despite stating that Caravaggio had a great desire for the "approval of the public, who do not judge with their eyes, but look with their ears", and that he had urged many younger artists to pay attention to the colouring alone instead of the composition of figures, Baglione described Caravaggio's works as "made with the greatest diligence, in the most exquisite way". Caravaggio's patron, Marchese Vincenzio Giustiniani di Bassano (1564-1637), never doubted Caravaggio's genius during the artist's lifetime. In a letter to the advocate Teodoro Amideni he quotes the painter, reiterating a point of view that he found conclusive[2]: "as Caravaggio himself said, a painting of flowers requires as much care as one of people" – "of the highest class of painters – we have Caravaggio". Caravaggio painted his "Cupido a sedere" (*Amor Victorious,* p. 89) for him, and when the altarpiece of Saint Matthew for the Capella Contarelli in the Church of San Luigi dei Francesi was rejected by the congregation, it was the Marchese who acquired it[3]. The art historian Giulio Cesare Gigli indulged in extravagant praise for Caravaggio in the *pittura trionfante* about his art: "This is the great Michelangelo Caravaggio, an awe-inspiring painter, the marvel of art, the miracle of nature"[4]. In the 18th century, the director of the Spanish Academy in Rome, Francisco Preziado, described the artist, in a letter to Giambattista Ponfredi dated 20 October 1765, as the founder of a school to which Ribera and Zurbarán also belonged[5]. During the age of Classicism, sporadic attention was paid to the artist and his tumultuous life, but it was during the Romantic era that particular interest in this pioneer of the Baroque was aroused. The great philosopher Schopenhauer (1788-1860) acknowledged the importance of his work[6], but from an expert point of view it was Waagen (1794-1868), professor of Art History, who sought to describe Caravaggio's characteristics[7]. As an art historian, Manasse Unger (1802-1868) then carried out studies in a more academic vein on the artistic effects of the painter in his *Kritische Forschungen* (*Critical Research*)[8], and wrote Caravaggio's biography[9], which was as complete as it could be at that time, according to J. Meyer's historical judgement. It was the art historian Eisenmann who later tried to make sense of the fluctuating criticism concerning the importance of this artist[10]. A literary portrait of

Ottavio Leoni, *Portrait of Caravaggio.*
Pastel on paper, 23.5 x 16 cm.
Biblioteca Marucelliana, Florence.

Caravaggio was published by the historians Woltmann (1841-1880) and Woermann (1844-1933), putting the artist within the historical development of painting[11]. Strangely reserved, but thus causing all the more excitement, were the few but grave words of art historian J. Burckhardt (1818-1897), which appeared in a dedication to the artist in the first edition of *Cicerone*, and which was barely altered in later adaptations of this work[12]. Meanwhile, modern painters such as Théodule Ribot (1823-1891) had already sided with the master of the Baroque with their theories on art, deliberately searching for a way to preserve the intentions of their French Caravaggio, the master Valentin de Boulogne[13]. Only an objective historical look at the artist and his works and the recognition of a psychological dimension to his œuvre were missing in order to penetrate beyond literary enthusiasm to Caravaggio's immortal merits.

The life of Caravaggio has given rise to numerous biographical interpretations, all focused on the violent and extravagant personality of the painter. One of these, written in the form of a poem, is the famous *Notizia* by Mancini (the translation of which appears towards the end of this book), which relates the major events in the life of Caravaggio. According to this poem and other various historical sources, Michelangelo Merisi was born in September 1571, probably the 29th, the feast of Saint Michael the Archangel, in Milan where his father worked for Francesco I Sforza, Marchese of Caravaggio. The predisposition for painting which Caravaggio demonstrated at an early age could have been inherited from his father who was, as Mancini states, "foreman and architect to the Marchese of Caravaggio". This contradicts the writings of Bellori (of which there is also a translation towards the end of this book) according to whom Caravaggio, whose father was a mason, like his contemporary Polidoro, would have, from a young age, carried the buckets of lime and plaster used in the making of frescos. It seems rather probable that Caravaggio inherited a fine talent from his ancestors although certain biographers have minimised its significance.

His parents were honourable citizens. As an employee of the Marchese, his father enjoyed a certain protection, from which Caravaggio would benefit throughout his life. In 1576, the plague that swept the Duchy of Milan forced Michelangelo Merisi's family to flee the city. They moved to the small town of Caravaggio where Michelangelo spent his childhood. Several months after their departure from Milan, Michelangelo Merisi, then aged six, lost his father.

Seven years later, on 6 April 1584, Caravaggio began his apprenticeship in the studio of the painter Simone Peterzano in Milan, where he studied with diligence for four or five years. He already showed some signs of extravagance, caused, it is said, by his excessive and hot-tempered personality.

Sick Bacchus or *Satyr with Grapes*,
c. 1593.
Oil on canvas, 67 x 53 cm.
Museo e Galleria Borghese, Rome.

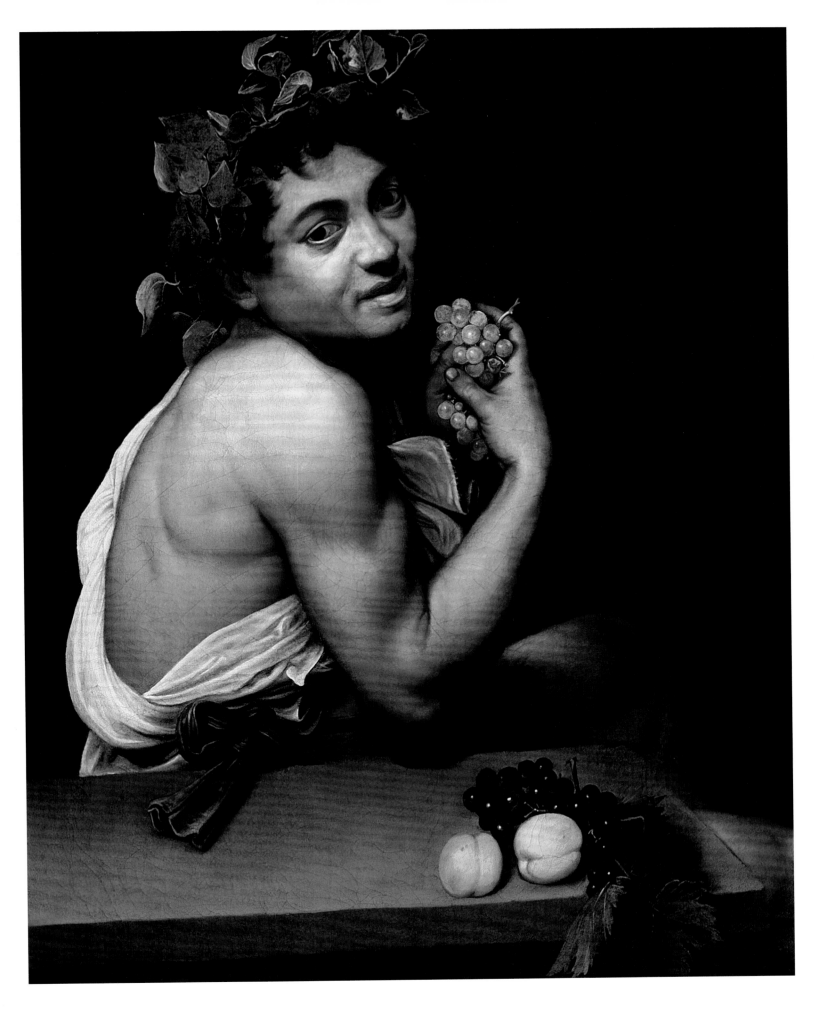

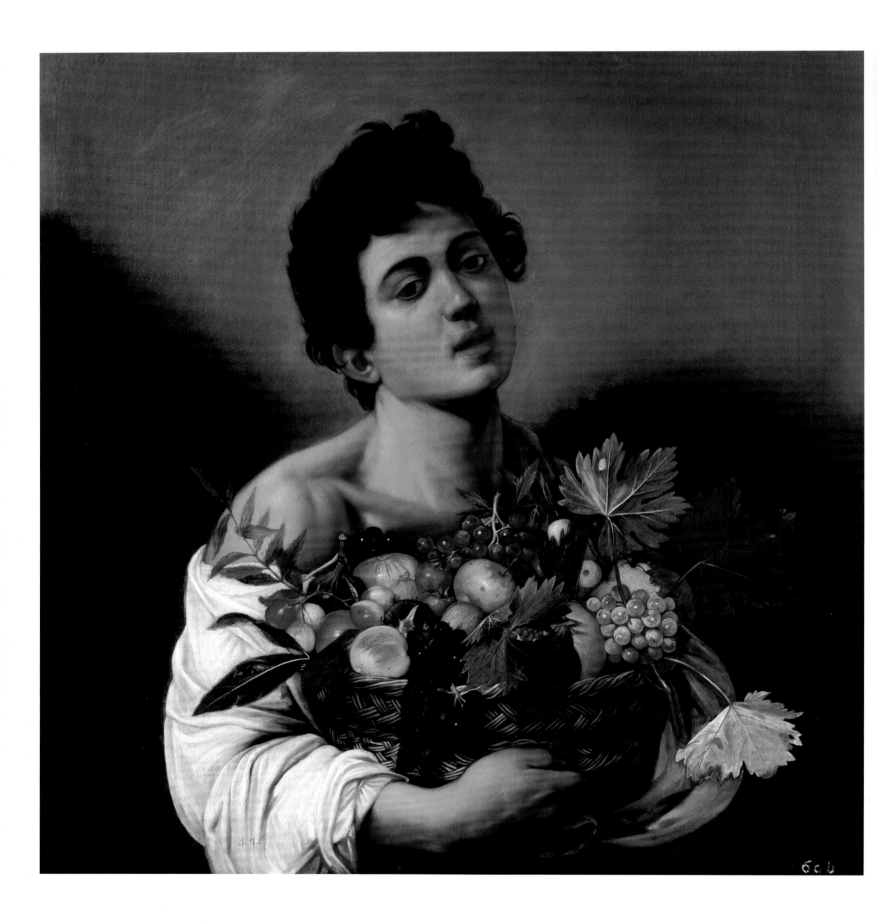

HIS FATE

The Early Years and Departure for Rome

Milan

Some early works preserved in Milan from the time when Caravaggio lived in the city, and presumed to be his, have been somewhat neglected by research. Despite the fact that today their attribution to Caravaggio is contested, these works are nevertheless important to our investigation, as they demonstrate certain characteristics typical of his work. Caravaggio developed his tendency towards the monumental genre from the observation of work by the Bergamasque painter Giovanni Cariani (active between 1511 and 1541); in his group of merry companions on a terrace from the year 1519 and in his *Lute Player* he touched on similar motifs to Caravaggio. Later Caravaggio would dedicate himself in a significant way to this imposing genre, though even at the beginning of his career he tended towards the grandiose. In certain of these Milanese works, the hand of Michelangelo Merisi's master can easily be perceived. This master was Bernardino Lanini[14], in whose work the influence of Gaudenzio Ferrari is clearly recognisable. At this time, Caravaggio seems to have concentrated solely on the physical form of the human figure, depicted simply against a neutral background. Setting aside the classical heritage, the figure takes over the painting. This would become gradually more and more apparent in his work, and eventually one of Caravaggio's distinguishing features. Caravaggio was also noticeably inspired by the work of Butinone, in particular the evocative motif of Saint Anne surrounded by her family. A certain tautness in a number of his paintings evokes the works of the former Milanese School, and highlights the fact that the young Caravaggio had only a limited number of resources at his disposal, which forced him to fight his way towards the freedom to which he aspired from a young age.

It can be observed that the young artist turned towards portraiture, attracted – as his early works demonstrate – by the realistic representation of genre motifs. The

Boy with a Basket of Fruit, c. 1593.
Oil on canvas, 70 x 67 cm.
Museo e Galleria Borghese, Rome.

grandeur of his style already marked him out from his contemporaries. On examination of the works of his masters, it can be supposed that it was the exhortations of Gaudenzio Ferrari and his Milanese successor Bernardino Lanini that encouraged him to imitate them[15]. The bright colours used by these two artists can also be found in Merisi's early works, an aesthetic impression used to great and unusual effect in Caravaggio's later works. However, Caravaggio demonstrated considerable skill in the modelling of the human form much earlier than the artists mentioned, and he revealed powers of observation only previously seen in another Lombard artist, Guido Mazzoni, who had displayed similar skill with his clay sculptures, notably those in the Church of Santa Anna dei Lombardi[16]. The head of Nicodemus in *The Entombment* (p. 90) in the Vatican Gallery indicates that he studied the sculptor's work, which was striking in its naturalism. Likewise, it was probably Lanini who spoke to Caravaggio of Venice, where, after five or six years in Milan, the artist spent some time.

Venice

After such preparation, it was logical that Caravaggio would be fascinated by the Venetian artists. The glory of Giorgione and Titian, who had only recently died, was still radiant; Veronese's modelling and the vibrant colours of Paris Bordone certainly attracted Caravaggio, but it was above all Tintoretto, with his striking artistic talent, who fascinated the young artist. Unger described the great Venetian artist, with respect to Caravaggio, in the following way: "Tintoretto, faced with the nature of man and his natural tendency to violence, depicts this characteristic somewhat simplistically without giving the opportunity to analyse the origin of these violent impulses"[17].

Eerie, threatening nights, where lightning streaks the sky and the smoky flames of blazing bonfires leap up to the sky, create a strong contrast to whole parts of his paintings which are in the dark, whereas others are spookily illuminated by greenish, glaring lights[18].

The intense colouring, which had attracted Caravaggio so much to the work of Gaudenzio Ferrari and his successors, dazzled him in Tintoretto's œuvre. He applied what he found there in a decided manner to the cycle of paintings of Saint Matthew for the Church of San Luigi dei Francesi, producing an even more striking effect. But it was Tintoretto's ability to synthesise multiple expressions within a single painting, thus bringing out the innermost feelings of the characters, which was very

Boy Bitten by a Lizard, 1593.
Oil on canvas, 65.8 x 52.3 cm.
Longhi Collection, Florence.

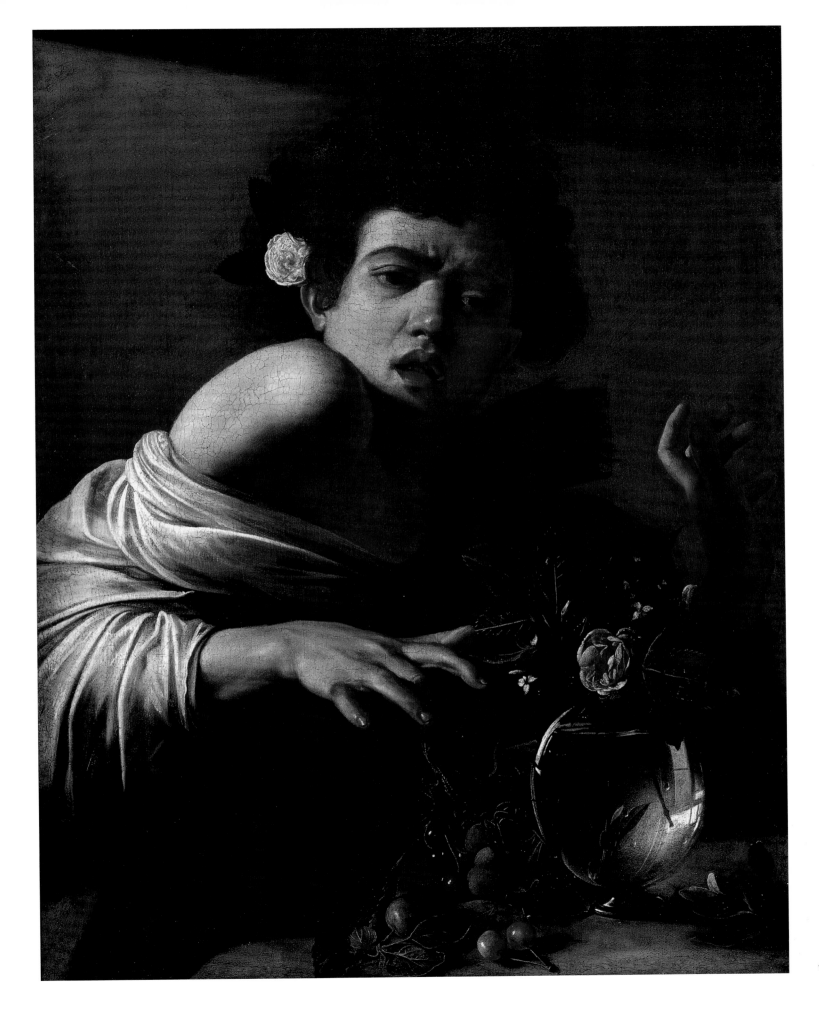

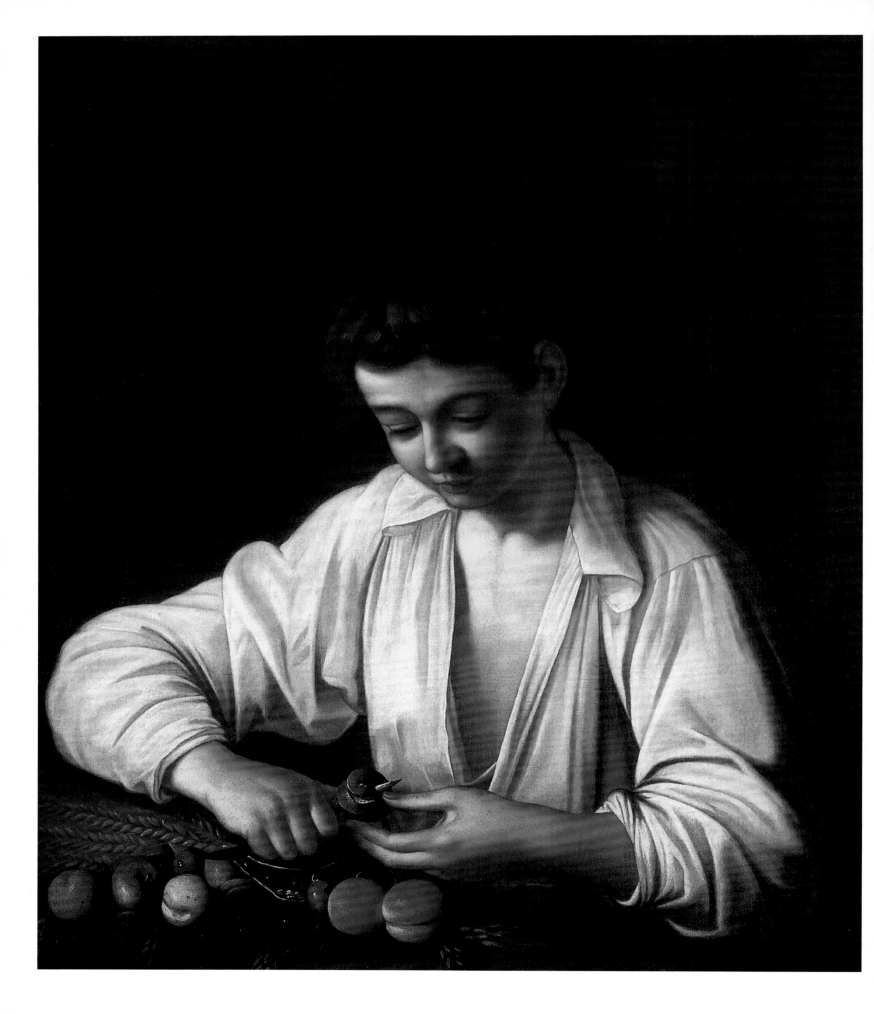

much the unifying element in his work that Caravaggio admiringly sought to adopt. The Milanese artist's talent for three-dimensional modelling never tempted him, however, into the exciting narrative elements that the Venetian artist had so remarkably mastered.

We may assume that, after leaving the Lombard capital, Caravaggio was in Venice around 1585. Although we cannot know for certain when he arrived in the city, there is no doubt that the death of his mother around that time would have strengthened his resolve to leave Milan. The artistic influence that Milan had on him was later assessed as central to his subsequent artistic development[19]. According to Baglione, Federigo Zucchero made a comment about Caravaggio's work to which we owe the certain indication that, in reality, it was Giorgio Barbarelli, known as Giorgione, under whose spell the young artist fell. "I cannot look at them without seeing the influence of Giorgione", commented the well-known mannerist of the Roman School about Caravaggio's paintings in San Luigi dei Francesi[20], a judgement that did not really fit the works criticised, as they had already overcome the Venetian influence and displayed Caravaggio's own characteristic style. In Roman artists' circles at that time it was believed that Caravaggio had close links to Venice. From this period, the young and susceptible artist indulged in the magic of Venetian painting, which was then at its peak. The painters of the time most admired by Caravaggio were attempting to characterise their subjects better by creating works of large dimensions on a restrained background. One thinks particularly of Giorgione's portraits of men in Berlin and Brunswick[21], and of the portrait of a young man by Torbido at the Pinakothek in Munich[22]. Caravaggio's own canvases reached almost gigantic proportions, beyond the works of Torbido and Giorgione. The idea of pure contemplation of the subject, which the Venetian artists preferred, was in this way surpassed by Caravaggio.

According to Eisenmann, there is a painting of the biblical Judith from Caravaggio's Venetian period, formerly in the La Motta Collection in the Treviso region, which is now said to be in English private possession. Waagen, who otherwise conveys a precise knowledge of these collections, does not mention the painting. There is one work depicting Judith and Holofernes, painted around 1598-1599, that can be found today in the Palazzo Barberini in Rome (pp. 34-35). According to Baglione, Caravaggio may have painted another of the same subject for the Signori Costi in Rome. It is difficult to judge whether he is referring to the same work, but there is nevertheless another depiction of Judith, painted several years later in 1607, that is currently in Naples. It seems likely that Baglione was referring to a copy.

Boy Peeling Fruit (copy), c. 1592-1593.
Oil on canvas, 75.5 x 64.4 cm.
Private collection, Rome.

Departure for Rome

Some years later, aged twenty-one, Caravaggio went to Rome where, undoubtedly helped by his uncle who already lived in the city, he lodged with a landlord who lived a modest life, Fr Pandolfo Pucci di Recanati, an acquaintance of Monsignor Pucci, beneficiary of St Peter's Basilica in Rome. A document left by the historian W. Kallab indicates that the artist lived in comfortable conditions, but complained about certain aspects of domestic life, in particular about the meals which were composed entirely of salad and chicory. This is partly why after some months he left the home of Pandolfo Pucci, to whom he gave the nickname "Monsignor Insalata". This same document indicates that the host commissioned from the young painter several works with religious subjects which were intended for his home town. It was at this time that Caravaggio fell ill and, having no money, he was admitted to the hospital of Santa Maria della Consolazione, where, during his convalescence, he painted numerous canvases for the Prior.

Caravaggio's experiences in Venice were still strongly influencing him whilst in Rome, and he continued to concentrate on acquiring his own majestic style. That was the aim behind, and the result of, his apprenticeship in the studio of the Cavalier d'Arpino. In 1593, Caravaggio entered the studio of the successful painter Giuseppe Cesari d'Arpino, also known as the Cavalier d'Arpino. Baglione tells us that "he stayed with the Cavalier Giuseppe Cesari d'Arpino for several months"[23]. Caravaggio turned to him in order to find connections to artistic circles in the Eternal City. Guiseppe Cesari has left frescos in the Trinità de' Monti, in the chapel of the Palazzo di Monte Cavallo, and – his best work – in the Capella Olgiati in San Prassede. In the Capella Contarelli in San Luigi de' Francesi, where he started the frescos, Caravaggio was to become his successor[24].

D'Arpino worked mostly as a fresco painter and tried to pass on to his pupil the somewhat grandiose side of Romanesque art, from which base he could expand the means and resources at his disposal. Caravaggio's works show that he neither ignored the advice of his artistic masters, nor the works of other artists, often even those of a heterogeneous style. He studied Antique art with diligence and emulated Michelangelo Buonarotti. He even undertook the painting of the sign of his brother Frangiabigio Angelo's perfumery, in this way further developing genre painting[25], as we can see in *The Fortune Teller* (pp. 22, 23).

However, save his tendency for grandeur, the Cavalier d'Arpino, with his more generalistic style, had very little to pass on to the painter from northern Italy. Even so,

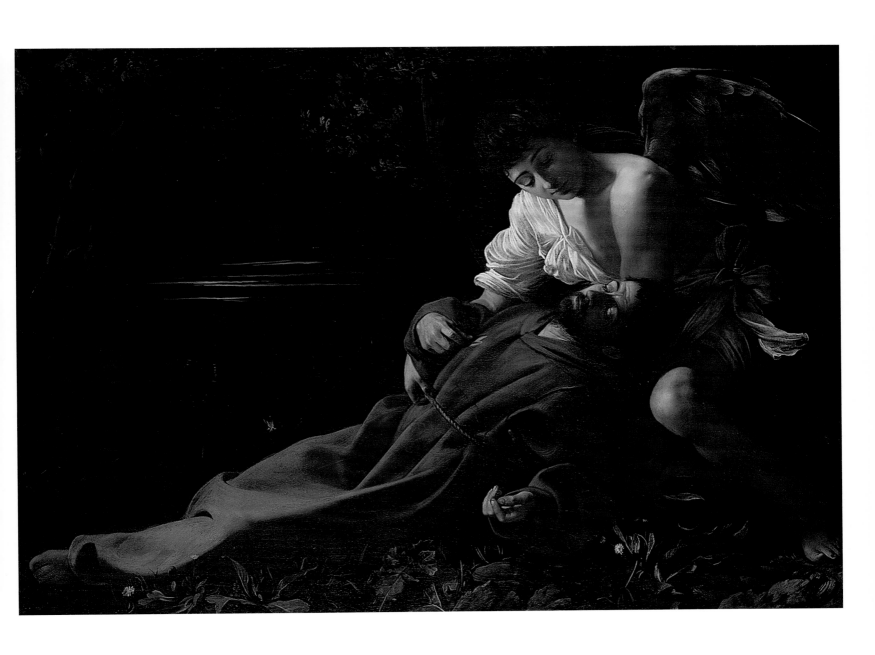

The Ecstasy of Saint Francis, 1594.
Oil on canvas, 92.5 x 128 cm.
Wadsworth Atheneum Museum of
Art, Hartford (Connecticut).

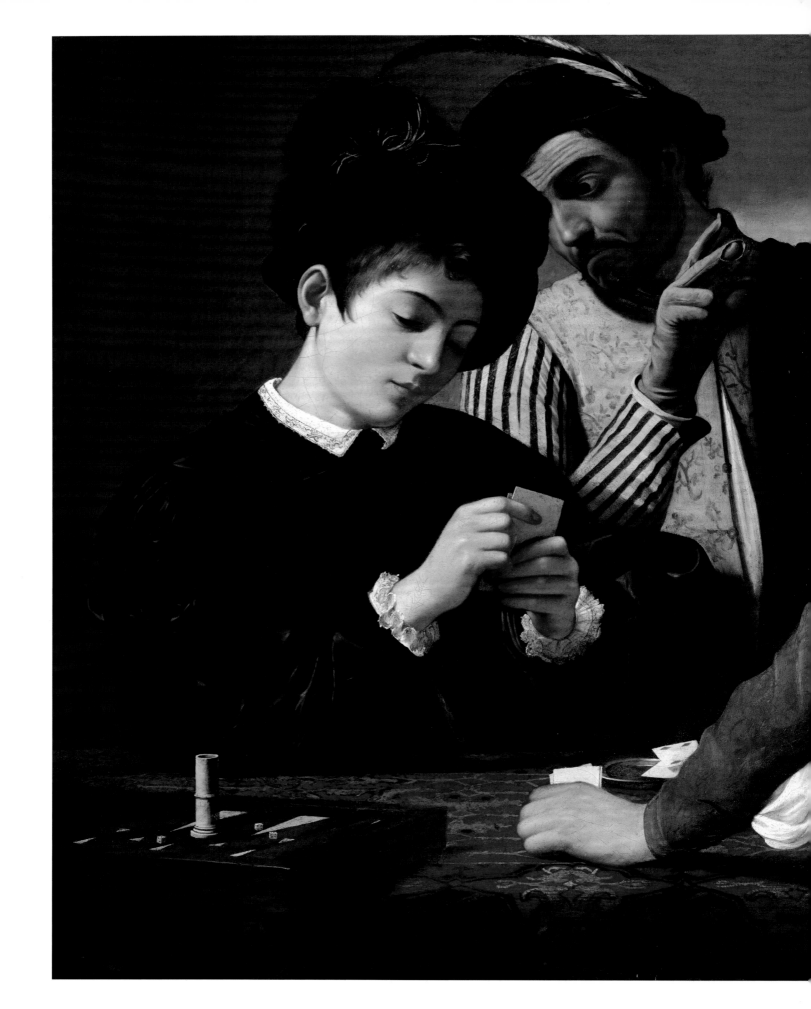

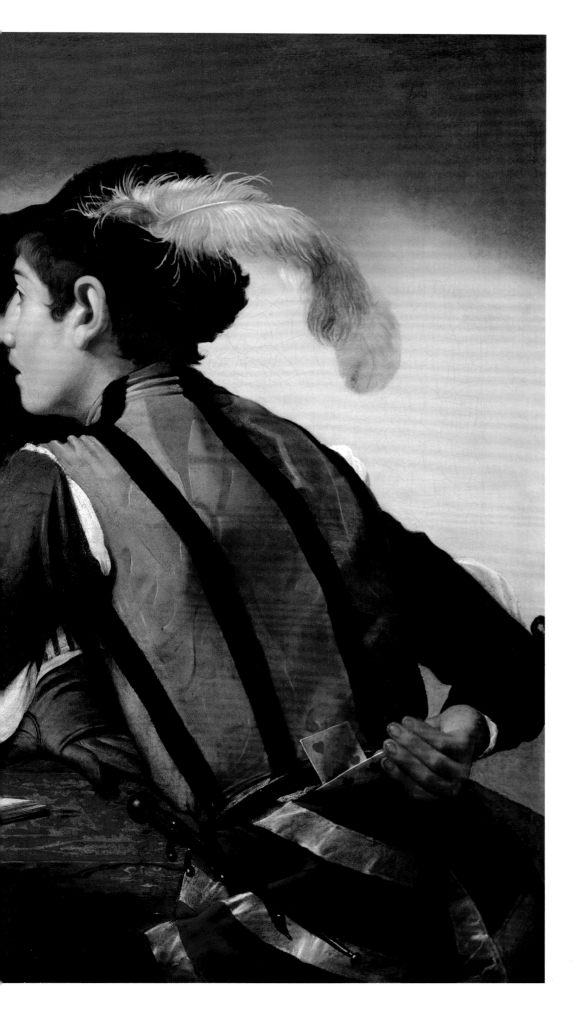

The Cardsharps, c. 1595.
Oil on canvas, 94.2 x 130.9 cm.
Kimbell Art Museum, Fort Worth.

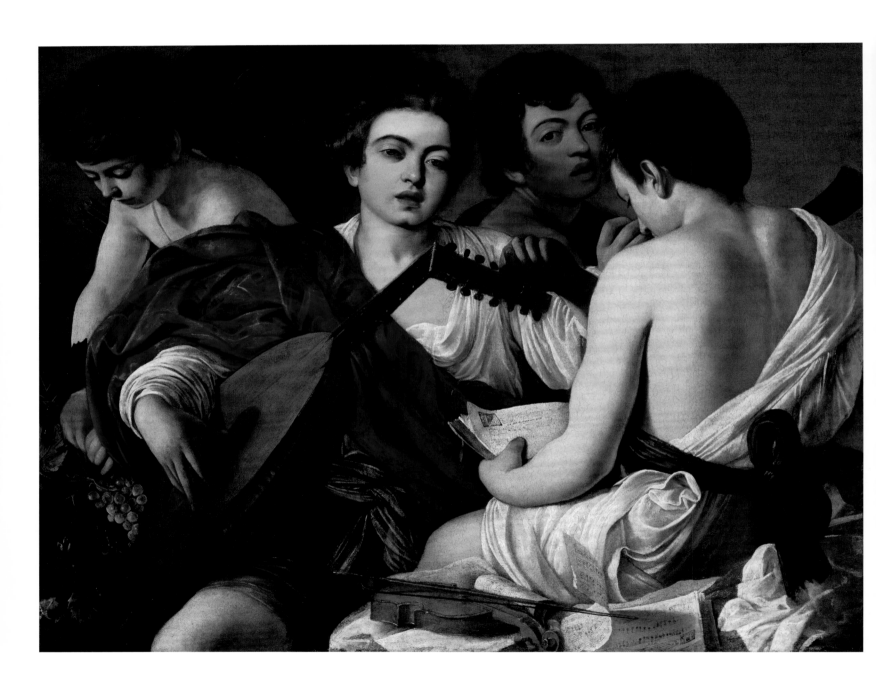

The Musicians, c. 1595.
Oil on canvas, 92 x 118.5 cm.
The Metropolitan Museum of Art,
New York.

at that time, Giuseppe Cesari was considered one of the most influential artists in Rome. One imagines that an unknown protector recommended Caravaggio to Cesari, opening the door to his prestigious studio. Whilst the Cavalier d'Arpino concentrated on frescos, Caravaggio, as Baglione clearly states, devoted himself first and foremost to oil painting[26]. He was employed "to paint flowers and fruit". The still life genre, which was very fashionable in Lombardy, began to evolve towards a very realistic representation where each detail was highlighted as if it had been magnified by an optical lens. The representation of natural elements predominated in the first works of Caravaggio: *Boy with a Basket of Fruit* (p. 10), *Boy Peeling a Fruit* (copy, p. 14), and *Basket of Fruit* (p. 26). The sensuality of the two boys in these works is evident, though the declaration by certain critics that these paintings are odes to homosexuality seems somewhat exaggerated and simplistic. It is true, however, that slightly parted lips charge a painting with eroticism, and Caravaggio did occasionally hide messages within his works. Thus the fruit that the boy is peeling could be a bergamot, a bitter orange, the symbol of Universal Love. During the Middle Ages, it was not unusual for a husband to put on vermillion robes, which Goethe declared in his treatise "represent the colour of extreme ardour as well as the gentlest reflection of the setting sun"[27]. Therefore this painting could symbolise the transition from child to adult, with the bitter taste of the fruit representing the end of innocence.

Nevertheless, Nature was not, for Caravaggio, the great protector and dominator of mankind that so many other artists took it to be. Nature provided him with no feelings of exaltation nor of lyrical depression, it did not flood his soul with joy or fear, it inspired neither adoration nor meditation within him. It offered him simply a framework, a theatrical scene within which to place his characters or a series of objects, which he could reproduce faithfully on the canvas, conforming to the fundamental principles of naturalists. He was aiming, according to his own words, "to imitate the things of nature", while at the same time conforming to the standards set by his Lombardian masters. As previously noted, Caravaggio himself said on this subject that "a painting of flowers requires as much care as one of people". Although Merisi pronounced this himself, he did later admit, conforming to the general opinion of the time, that the human form could never be compared to simple fruit and vegetables. Beyond the prevalence of vegetables, Caravaggio's contemporaries must have been impressed by the realism of his paintings. The sensuality which emanates from Caravaggio's early works deeply moves the spectator from the first viewing. However, his first masterpiece, the soft and luminous landscape of the *Rest on the Flight to Egypt* (pp. 28-29) – which clearly reminds us of the style of Giorgione – evokes more than the simple sensory impressions of the outside world. The serene sky reflected in the calm water, the caress of light on the oak tree, the cherry laurel and

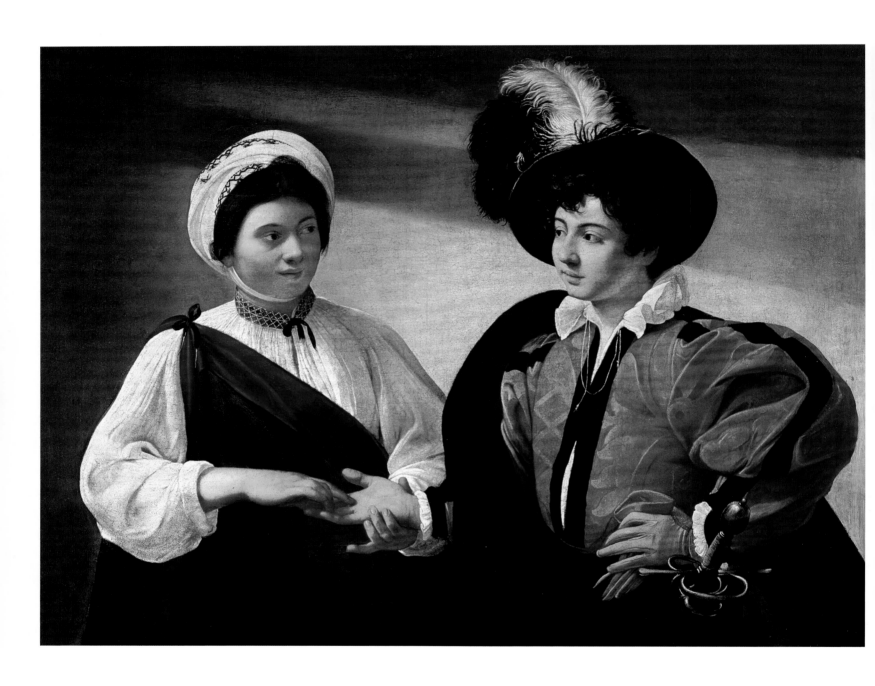

The Fortune Teller (second version),
c. 1595-1598.
Oil on canvas, 99 x 131 cm.
Musée du Louvre, Paris.

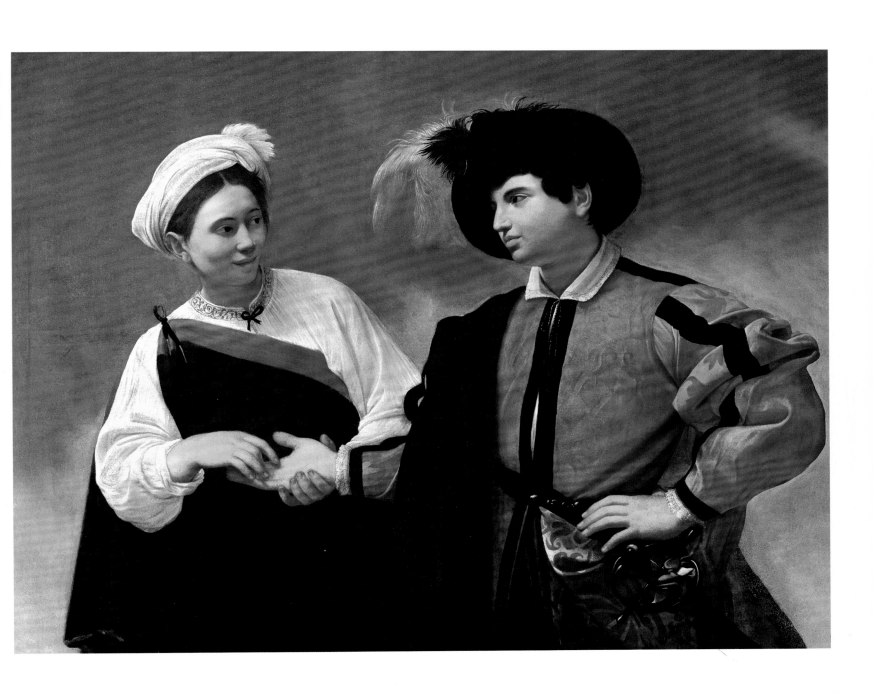

The Fortune Teller (first version),
c. 1595.
Oil on canvas, 115 x 150 cm.
Musei Capitolini, Rome.

the white poplars; the tender flair of the marshland reeds with their frayed leaves surrounding the three-leaved brambles have been brought together in order to create a harmony, a source of beauty to which the young artist was sensitive. In addition, Caravaggio paid particular attention to the expression of the face, as one can see in the apparent pain of the child in *Boy Bitten by a Lizard* (p. 13). The instantaneousness of the boy's reaction and the mask of pain on his face are so unmistakeably realistic and accurate that they cannot help but evoke feeling in the viewer. The working of the facial expression is remarkable and the intensity of feeling within the work is extraordinary. Throughout his career, Caravaggio worked ceaselessly at the expressions and feelings of his subjects.

After several months, according to Baglione, Caravaggio, independent of a master, occupied himself with painting some self-portraits in the mirror. There are several works today which could be examples of these, but their attributions are still debatable[28]. Amongst the impressions collected in Venice, for example, there was a painted self-portrait made up of warm tones, essentially brown in colouring, with which the thick white paint of the collar and clothes contrasted strikingly, and a soft, gentle face despite the sword "which sat so loosely in its sheath". The somewhat heroic golden tone sets the painting within his early Roman period. Another self-portrait, at one time in the collection of the Duke of Orleans, is currently missing[29]. It showed the artist in a beggar-like outfit, seen almost entirely from behind in a lost profile pose, holding a mirror in front of him, in which his weathered but not unattractive face is reflected; next to him is a skull. He next painted Baglione as Bacchus with grapes "with much diligence, but little sentiment"[30]. This painting, which was at one time lost, was seized by tax officials from the Cavalier d'Arpin in 1607. It can now be found in the Galerie Borghese, where it has been for several years. Caravaggio may have represented himself here as the sick Bacchus, excited to be recreating reality. The youth's pale and wan complexion gives away his poor health (p. 9). Is this the malaria, as many critics like to think, that debilitated Caravaggio? Whether or not this is so, the dubious whiteness of the cloth indicates the painter's convalescence. The fruit in the foreground is also noticeable as a silent witness to the still lifes of Caravaggio's early work. Likewise, the fact that he placed this fruit in the foreground, rather than the god Bacchus, betrays the artist's typical will to go against all the supposed "rules" of the time. Sensuality reigns in this painting, and the exposed shoulder of the figure only serves to reinforce this impression. Gorging himself on grapes, the youth turns towards the viewer as if in invitation. The realism in this painting is striking, and one can see the extent of Caravaggio's mastery of the art of feeling and suggestion. The figure's *contrapposto* pose highlights the influence of the statuary art of the artist's namesake, Michelangelo Buonarotti.

Bacchus, c. 1596.
Oil on canvas, 95 x 85 cm.
Galleria degli Uffizi, Florence.

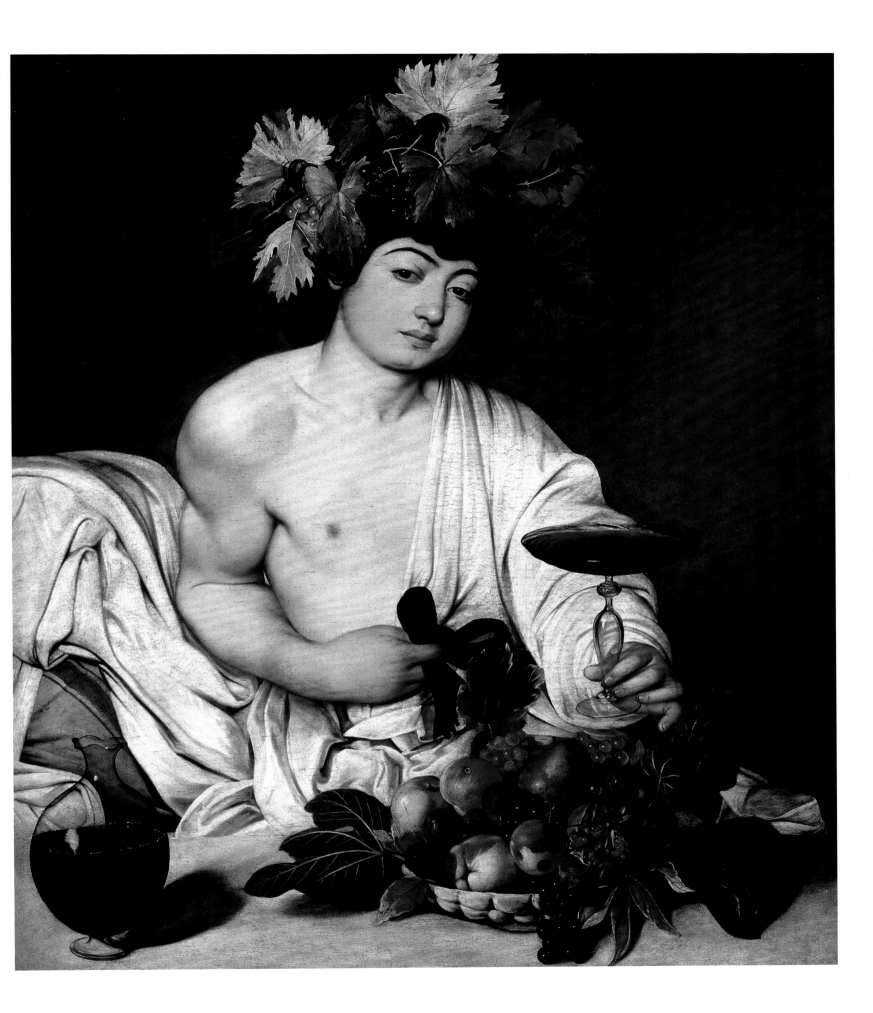

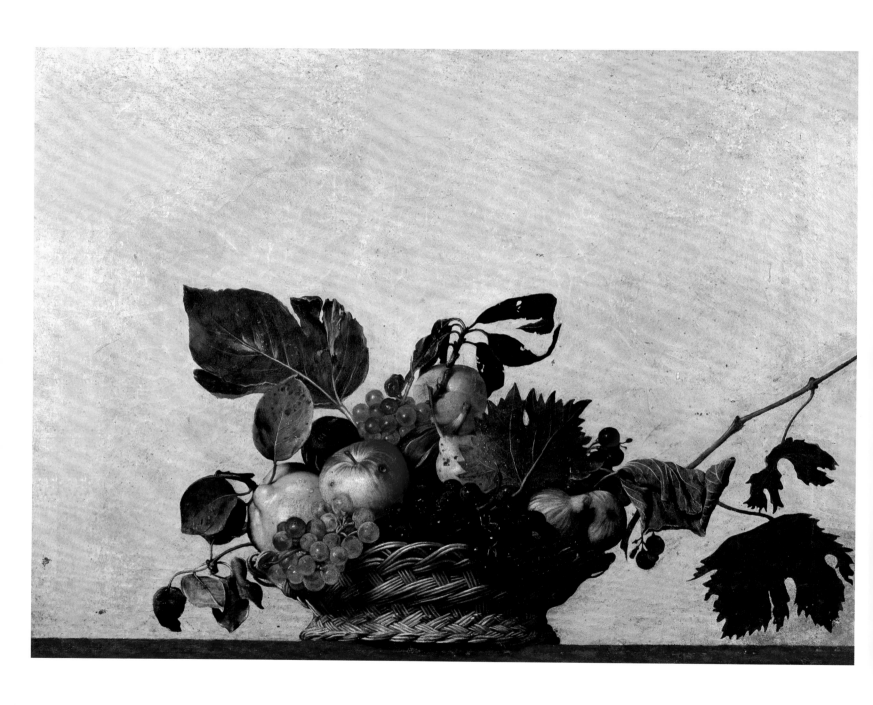

Basket of Fruit, c. 1597.
Oil on canvas, 47 x 62 cm.
Biblioteca Ambrosiana, Milan.

Caravaggio next worked with Monsignor Fantin Petrignani, who allowed him the use of a room in which to paint. Later, around 1595-1597, thanks to the art dealer Maestro Valentino, his work caught the attention of Cardinal del Monte, and from then on the artist was under his protection[31]. He was welcomed with magnanimity into the Cardinal's home, where he benefited from this new environment. His entry to the palace, where he rubbed shoulders with scientists, in particular Galileo, musicians and artists in pursuit of innovation, allowed him to develop new forms of expression. He painted a "group of young musicians, portraits painted from life, very well made" for the Cardinal, which launched a new form of genre painting with music as the subject, which was common right into the 18th century. Of course there were occasional isolated forerunners on this subject, notably a concert (from the 15th century) with a mandolin player and a man and a woman singing, pictured from the waist upwards, attributed to Ercole dei Roberti[32]. In the same way, on the theme of "The Prodigal Son", there are several similar subjects in the Nordic art of the early 16th century, for example in the works of Hemessen and Lucas van Leyden[33]. As for members of the Venetian School, they had depicted similar subjects in a nobler way, such as Giorgione's depiction of a concert in the Palazzo Pitti and another concert by one of Titian's successors in the National Gallery in London.

However, Caravaggio used his own means to lift this genre to the height of an almost tendentious monumentality. A number of such *Musiche* – the attribution of which are not completely certain – are thought to be in English private collections, such as a concert with an old man with a lute, a younger man with a flute, and a singing boy in the collection of Lord Ashburton[34]. In Chatsworth House there is a concert of guitar and flute players with a singer, who is holding a full glass in his hand, which was previously attributed to Caravaggio but is now thought to be the work of one of his disciples, the great Valentin de Boulogne[35]. In Kassel there are two similar depictions of concerts[36]. Baglione mentions another painting, depicting a young man with a flute, which Caravaggio may also have made for the Cardinal, but whose attribution is still contested. In this painting he intensified his skill in imitation in competition with the Nordic artists, as in all the paintings of this genre. Remarkable also in the work is the vase of flowers, in whose water is reflected the window and other objects in the room. Baglione states that these works were created "with an exquisite application", recognising the great art of his adversary in the courts. *The Musicians* (p. 20) highlights the elegant setting that would evolve within Caravaggio's work from then on. Vegetables, fruit and other still-life objects were exchanged for lutes and violins. However, this genre is in no way naive. Cupid, who is clearly identified by his wings and arrows, only serves to accentuate

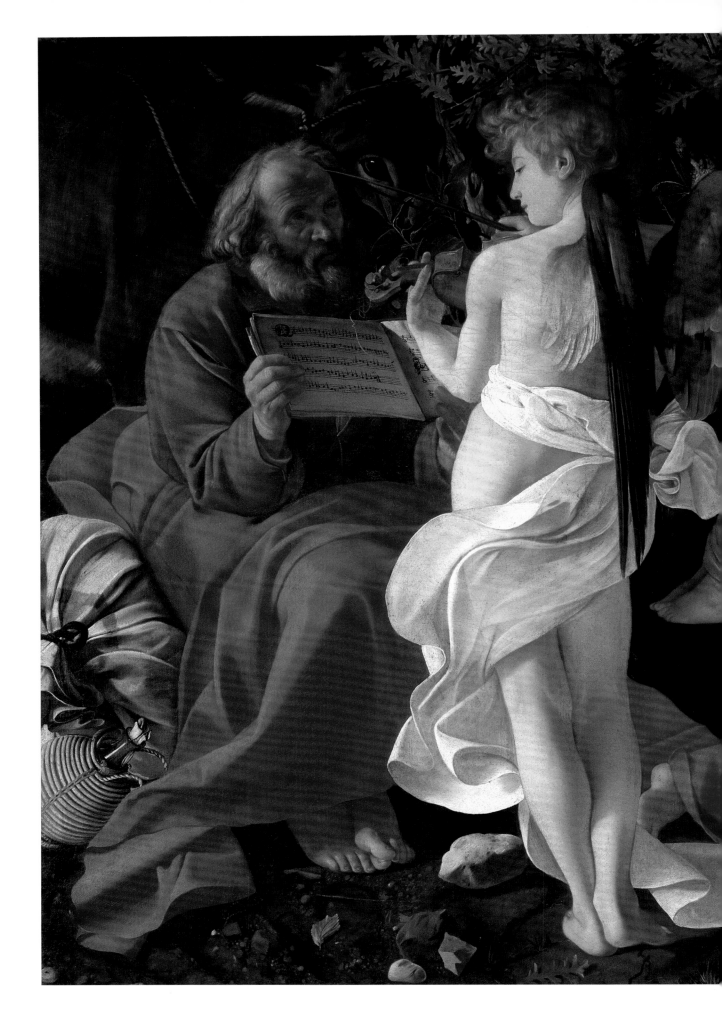

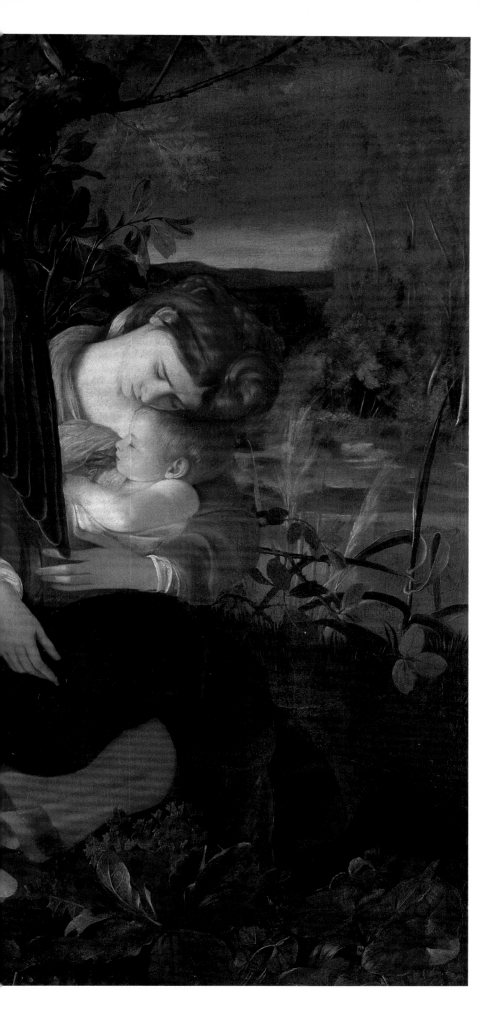

Rest on the Flight into Egypt,
1596-1597.
Oil on canvas, 133.5 x 166.5 cm.
Galleria Doria Pamphilj, Rome.

the sensuality that emanates from the figures. The fabrics draped over the musicians hide the essential parts, but the disordered cloth is equivocal in its nature, as is the lascivious gaze of the watching figure in the background.

Over the years, the representation of nature in which Caravaggio excelled was replaced by other themes, as outbursts of violence and aggressiveness were taking more hold of his life and work. The painter essentially endeavoured to reproduce the emotions and passions of mankind, such as vice, crime, or human suffering, beyond any mere aesthetic effect.

The recurrent themes of his work echoed his mood and, as a musical chord can be deconstructed, one could also deconstruct the themes of his paintings into notes: those of darkness, blood, scoundrels and gamblers, cheats and Bohemian thieves. These notes are accompanied by a background rhythm of subjects and musical episodes, while unrestrained bursts of comedy bring a discordant note into solemnly tragic or sacred events.

Despite the naive character that had been attributed to him, we must underline the fact that Caravaggio's personality traits attracted him towards an obscure style of painting (or "Tenebrism"), his works enlivened by a breath of Realism. The obscure depth of his work is filled with the intimate feelings of their creator. One cannot exclude the idea that his taste for strong contrast of shade and light may correspond to the use of a long-matured technique. This technique seeks to evoke in the spectator an emotion in harmony with the dramatic tonality of the representation, by imprinting upon the forms an energetic relief favourable to a realistic expression of his art. But the consistency of his style and the profusion of shade, despite some technical loopholes, suggest with reason the artist's predilection for contrasting colours, reflecting his "brilliant and tormented" temperament, as Bellori recorded.

During these formative years for his art, he produced numerous canvases. The work he carried out for the Contarelli chapel established his reputation and the prelates of Rome decided to entrust him with the creation of large religious paintings. It was not unusual for his commissioners, as princes and prelates engaged in a game of "cultural rivalry", to order several versions of the same subject from the artist to enrich their collections with the same masterpieces; scenes of the *Nativity*, the *Supper at Emmaus*, *Saint Jerome*, *David and Goliath*, *The Fortune Teller*, *The Cardsharps*, and *Mary Magdalene* were all such subjects. He would borrow certain characters from one painting and place them in another composition, such as the old woman with her head in her hands in a gesture of terror, a figure that appears in both *Burial of Saint Lucy* (p. 146) and

Penitent Magdalene, 1596-1597.
Oil on canvas, 122.5 x 98.5 cm.
Galleria Doria Pamphilj, Rome.

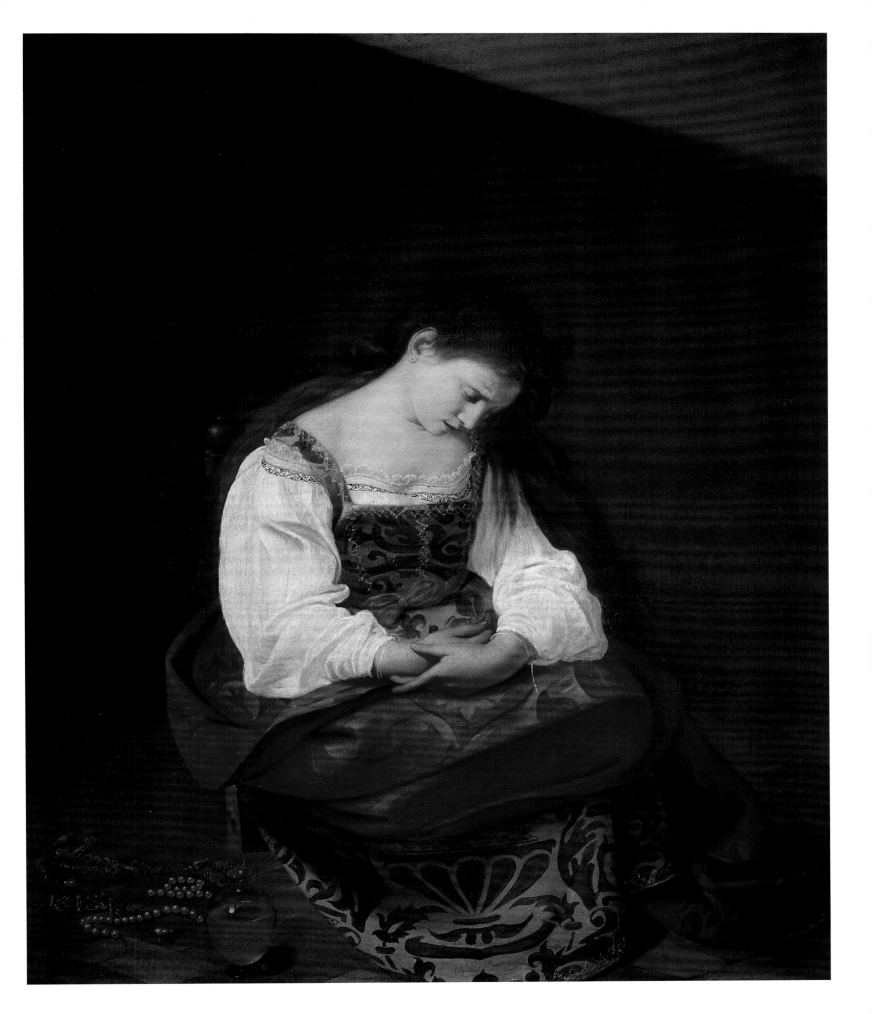

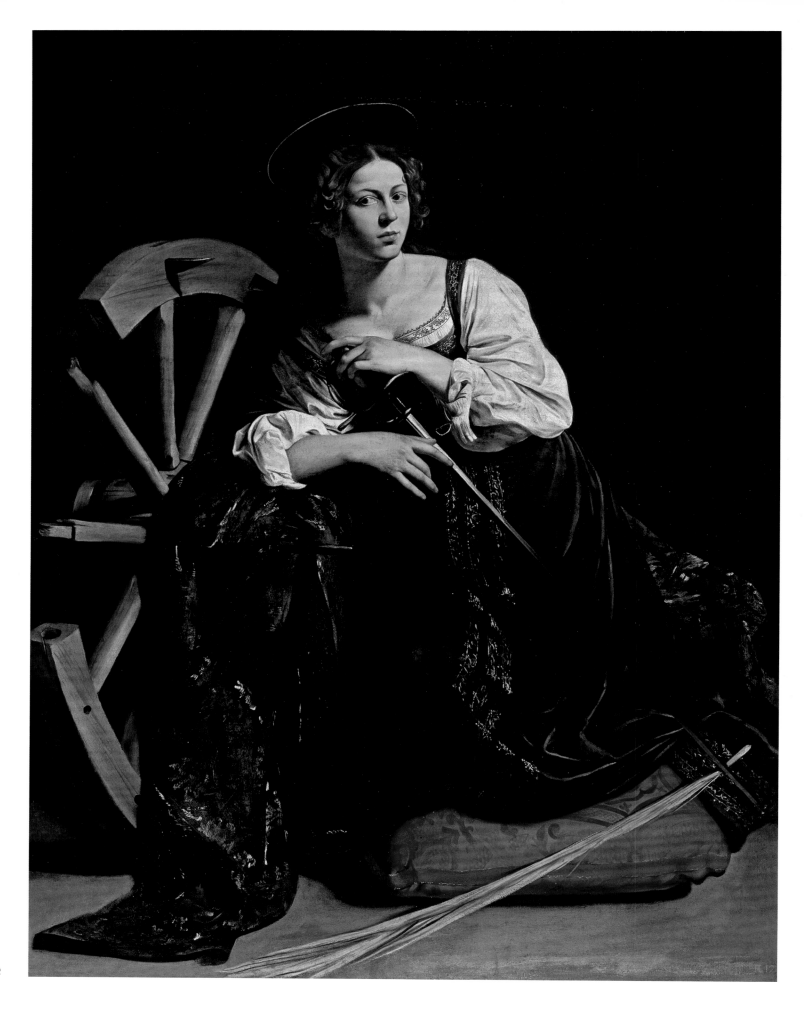

The Beheading of Saint John the Baptist (p. 155). Another old woman seen in profile, reminding us of *La Vecchia* by his great influence Giorgione, is present both in *The Tooth Puller* (p. 180) and in *Judith Beheading Holofernes* (pp. 34-35).

The painter could unknowingly also repeat the same pictorial gesture or, by simple predilection, favour a line, a form, a type of lighting, or a contrast he judged interesting. This led him to re-employ certain expressive details such as the very sensual incline of the neck of certain male and female figures, seen in such works as *The Musicians* (p. 20) and *Rest on the Flight into Egypt* (pp. 28-29), or the details of a flexed hand visible in the painting of *Narcissus* (p. 45) and *The Beheading of Saint John the Baptist*. Although these details have contributed to the definition of his style and allowed art historians to identify certain paintings as his work, the attribution of certain works, such as *Ecce Homo* (p. 104) and *The Tooth Puller*, still remains uncertain. Indeed, his very personal techniques, notably the incisions made in the thickness of the undercoats, the brown border which he left around his figures, the dark backgrounds that grew more and more refined, and the light delivered by a vertical or lateral source, creating highly-contrasting zones of light and shade, were not applied systematically by Caravaggio, while his successors sometimes used the same methods.

Favouring realism over the idealisation of biblical characters, he went as far as placing Saint Matthew sitting astride a stool, turning his roughly-painted feet towards the spectator (p. 83). He painted the swollen, obscene body of a drowned woman in his representation of *The Death of the Virgin* (p. 80) and he symbolised, it seems, Architecture as a figure with the appearance of a woman from Trastevere holding a compass, or even Mary Magdalene with the features of common woman wearing dishevelled clothes and with her plaits undone (p. 31). All these attitudes can be interpreted as systematic executions of a naturalistic vision which was the goal of his art. He also painted *The Conversion of Saint Paul* (p. 79), in which a horse occupies almost all the canvas, along with a representation of *Saint John the Baptist* (p. 188) as a child in the desert playing with a sheep, in which he refrains from giving even the least spiritual dimension to the work. In *The Supper at Emmaus* (pp. 84-85), the innkeeper wearing a hat is probably an eminent associate of the painter, possibly Cardinal Barberini, the Cavalier Marino, or even Alof de Wignacourt, though we cannot be sure. He even painted a *Trinity* – now lost – representing two men sitting on a seat under which a pigeon seeks refuge, men who he probably rubbed shoulders with in the inn. By liberating himself from the conventions of religious iconography, his work was a decisive turning point in the representation of the stories of the saints and biblical figures, characters to whom he gave realism and humanity.

Saint Catherine of Alexandria, c. 1598.
Oil on canvas, 173 x 133 cm.
Museo Thyssen-Bornemisza, Madrid.

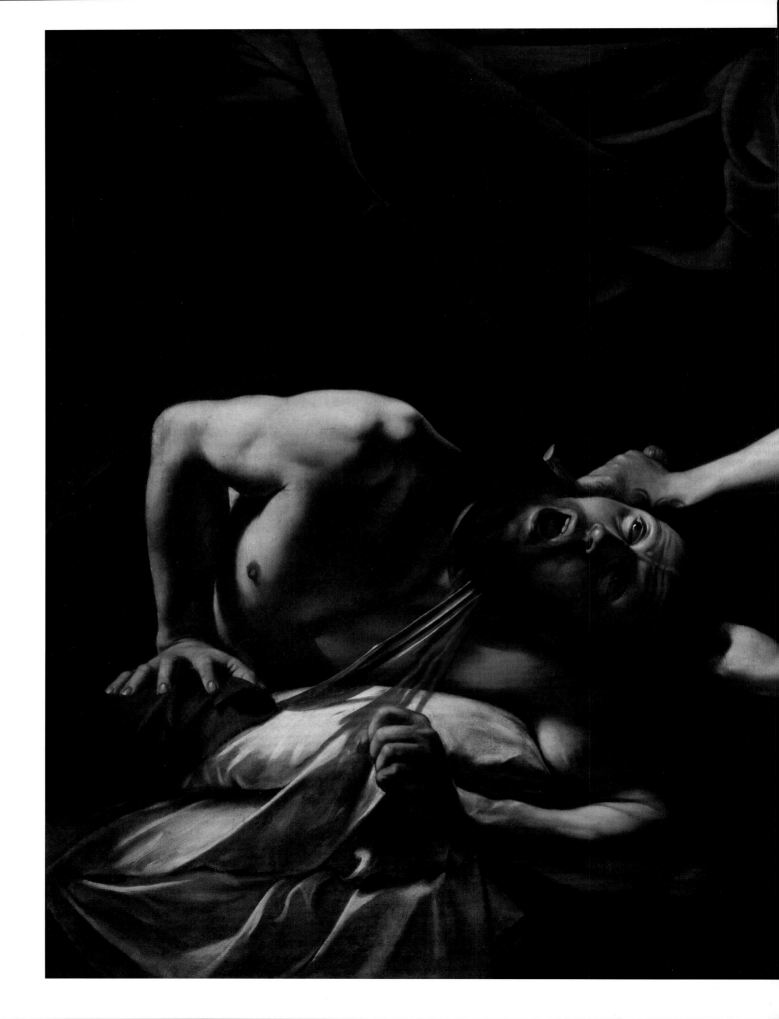

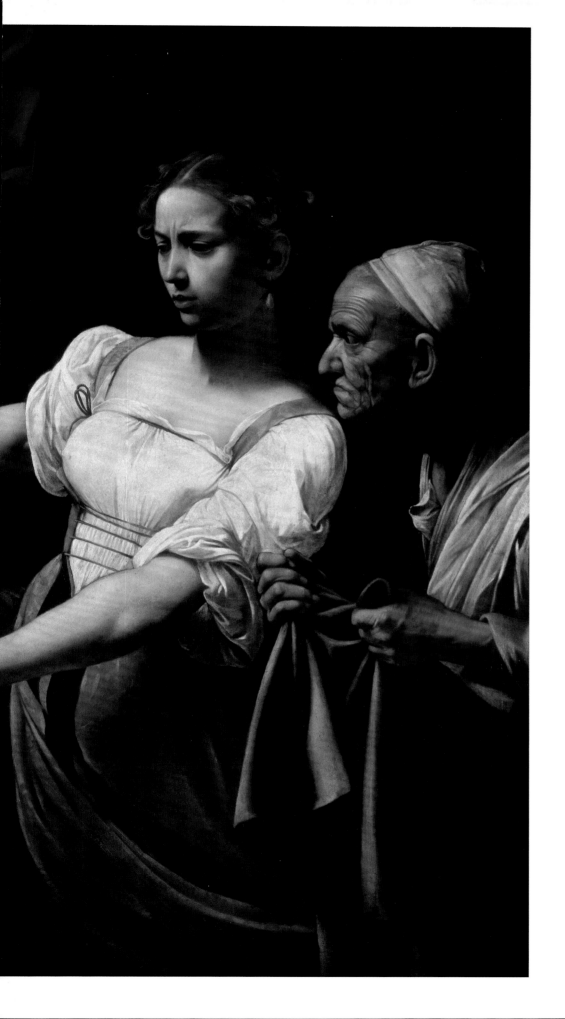

Judith Beheading Holofernes,
c. 1598-1599.
Oil on canvas, 145 x 195 cm.
Galleria Nazionale d'Arte Antica di
Palazzo Barberini, Rome.

The First Roman Works and the Church of San Luigi dei Francesi

The First Roman Works

Caravaggio's response to the imposing ambitions of the Roman Baroque was becoming more and more purposeful. Thus, soon after he arrived in Rome he proved capable of tasks of a greater style. Many remarkable paintings date from this time, notably *The Fortune Teller* (p. 23), *Rest on the Flight into Egypt* (pp. 28-29), *Penitent Magdalene* (p. 31) and *Martha and Mary Magdalene* (pp. 40-41). Caravaggio worked on the lighting in these paintings, of which *The Fortune Teller*, according to Baglione, was painted for the Cardinal del Monte, the best copy of which is in the Capitolinian collection (there is a replica in the Louvre)[37], and *Saint John the Baptist* (p. 70), sometimes known as *Youth with a Ram*, found in the Galleria Doria Pamphilj in Rome (with a replica likely in Pommersfelden Castle near Bamberg, Germany)[38]. The subject of the first of these paintings, which was created for his patron, was taken up by Manfredi and Strozzi in slightly lighter colours.

Saint John the Baptist shows the model of a young boy from the Ciociaria region of Italy, near the Campagna Romana, which he later liked to use to represent an Arcadian atmosphere. Half sitting, his right arm draped around the neck of the ram, the bucolic young shepherd turns his head towards the observer. The seat on which he is lounging is covered with a fur, and red and white cloths. The background is dark, with just a few tufts of grass in the foreground to mark the scene. The painting is of dull red and yellow tones and is strongly reminiscent of the frescos of the Cavalier d'Arpino, even if the strength of the scene deviates from the conventional tendencies of his Roman teacher.

Closely relating to this piece is the *Cupido a sedere* (*Amor Victorious*, p. 89), which is in the Gemäldegalerie in Berlin. According to Baglione, it was commissioned by the Marchese Giustiniani. The copy that went from the

Judith Beheading Holofernes (detail), 1598-1599.
Oil on canvas, 145 x 195 cm.
Galleria Nazionale d'Arte Antica di Palazzo Barberini, Rome.

Giustiniani Collection to the gallery in Berlin is the best of the known versions, one of which is kept in the museum in Dijon[39]. Cupid, who is depicted as a young boy with the customary arrows in his right hand, is accompanied by a still life arranged in brilliant disorder, made up of musical instruments, armour, and a musical score. His legs are akimbo, the left resting on a stool covered by a white cloth. It is the same boy model as that of the shepherd in the Galleria Doria Pamphilj, only more elegantly posed and even more strikingly three-dimensional. The colouring shows the last vestiges of the warm Venetian tones, though the image is already lit from above and slightly to the side, reflecting the lateral lighting which was becoming more and more common in Roman Baroque architecture. There is a companion to this piece, which is mentioned by Baglione. It depicts Cupid appearing in the guise of a mortal, and is the counterpart to *Cupido a sedere*[40]. As with the Archangel Michael, "divine love" has captured the high-spirited Eros, lured by the god of the underworld, and who is now lying helplessly on the ground. Not treated in such an interesting fashion as its counterpart, this painting shows the same characteristics of style with an even cooler overall attitude. These paintings of sacred and profane love do not appear to have been intended as counterparts as such, demonstrated by the fact that they were destined for different owners. While the former was painted for the Marchese Vincenzo Giustiniani, Baglione claims that the latter was amongst the pieces that Caravaggio painted for Cardinal del Monte. He also produced the head of a Medusa (p. 42) for the Cardinal, which the latter gave as a present to the Grand Duke Ferdinand of Tuscany. The painting has remained in Florence until this day[41]. In hindsight, J. Burckhardt's assessment of this painting now seems too harsh[42], writing: "Always eager to capture the instantaneous expression, he therefore neglects the deeper expression, painting a female head on the verge of decapitation exactly as he would paint her when a tooth is being extracted." In view of the principles of style inherent in Renaissance art, Caravaggio had to make the expression so pronounced as to maintain the balance as a whole; the three-dimensionality, created with the help of exquisite means of reproduction, moves from the pictorial habits of his previous works towards the incredible. No painting from the Roman School of that time gives such a magnificent effect. Thus, the great deeds of his Roman period seem understandable.

The fact that Caravaggio was equally interested in *bambocciate*, though in a more dignified form than the traditional small depictions of everyday life, obviously induced him to try to make use of drawing techniques, although he did not choose engraving with a dry needle, but etching. As an authority on techniques in the field of painting, he may have been attracted to it because of its artistic effect. We have

Saint John the Baptist, c. 1597-1598.
Oil on canvas, 169 x 112 cm.
Museo Tesoro Catedralicio, Toledo.

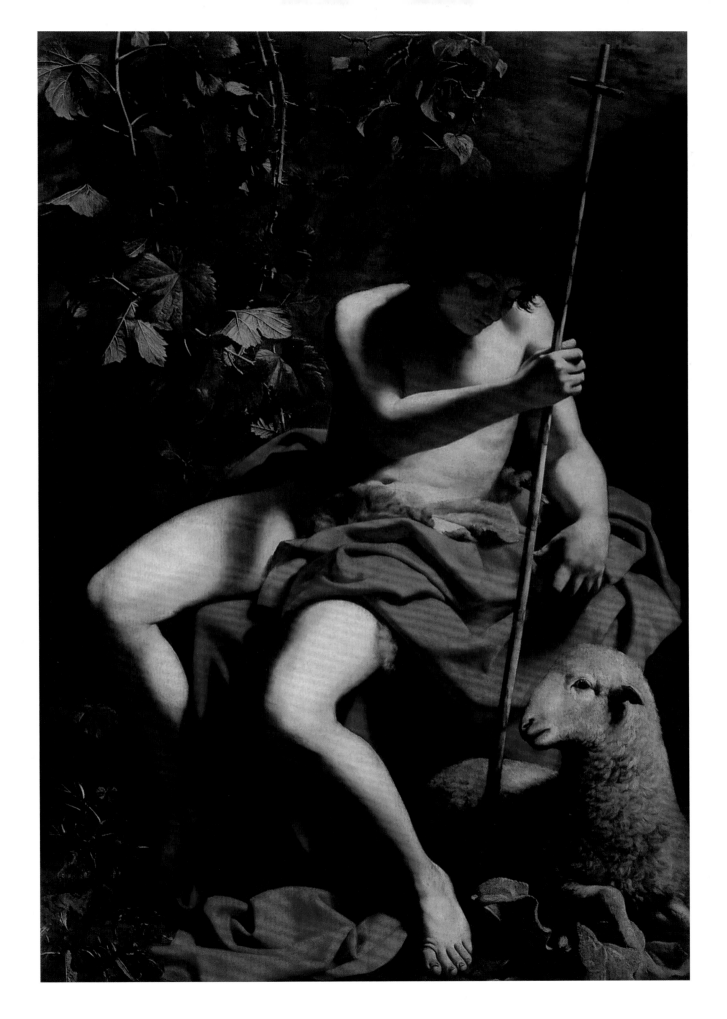

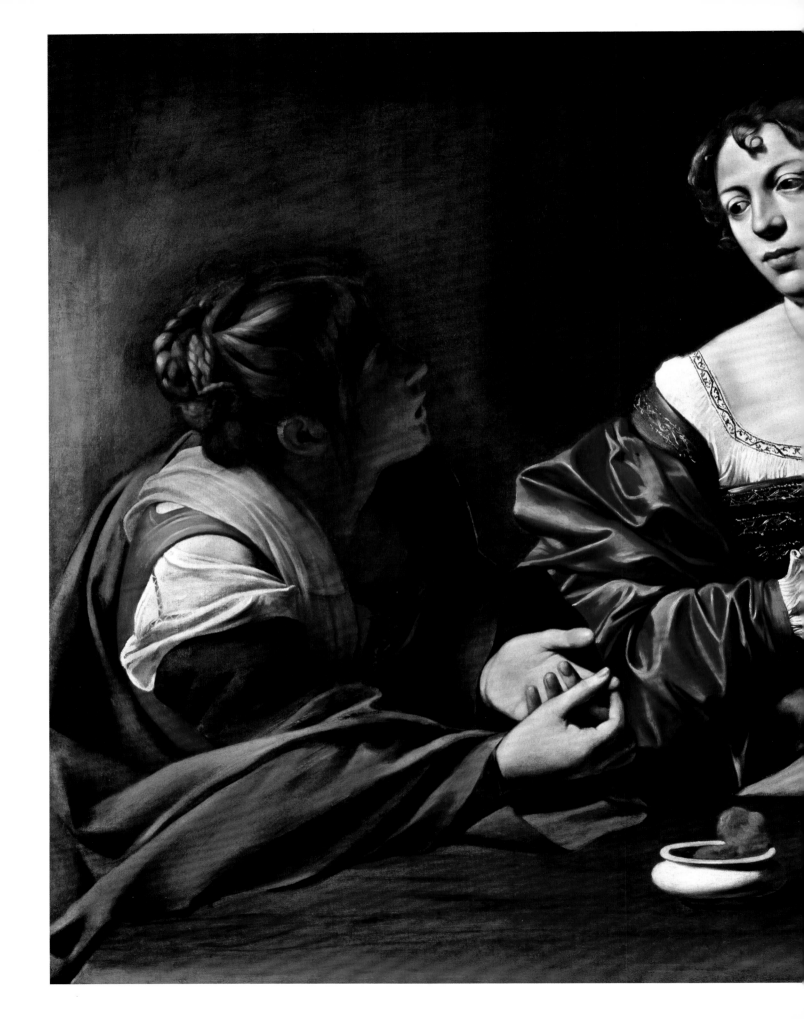

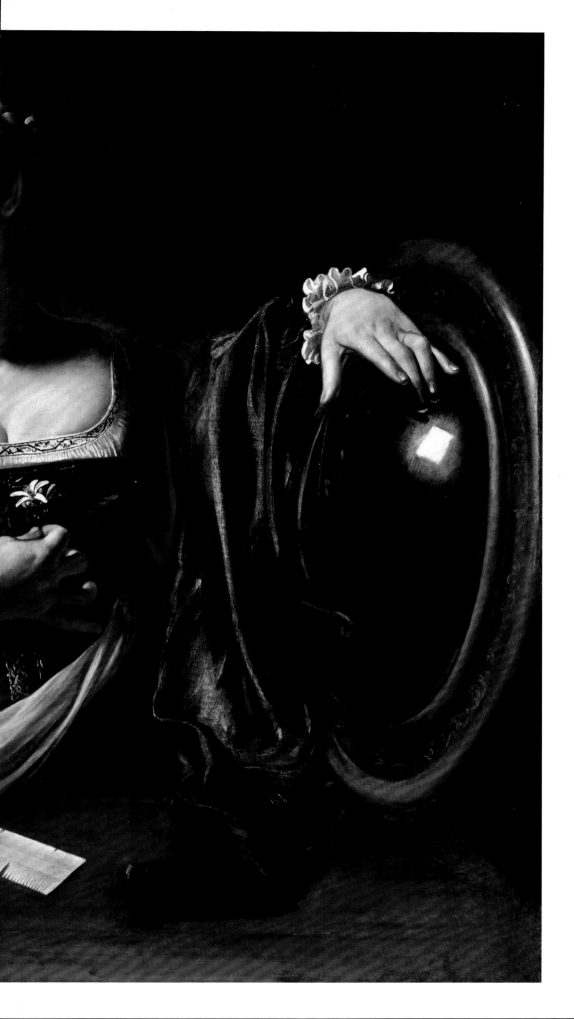

Martha and Mary Magdalene, c. 1598.
Oil and tempera on canvas,
100 x 134.5 cm.
The Detroit Institute of Arts, Detroit.

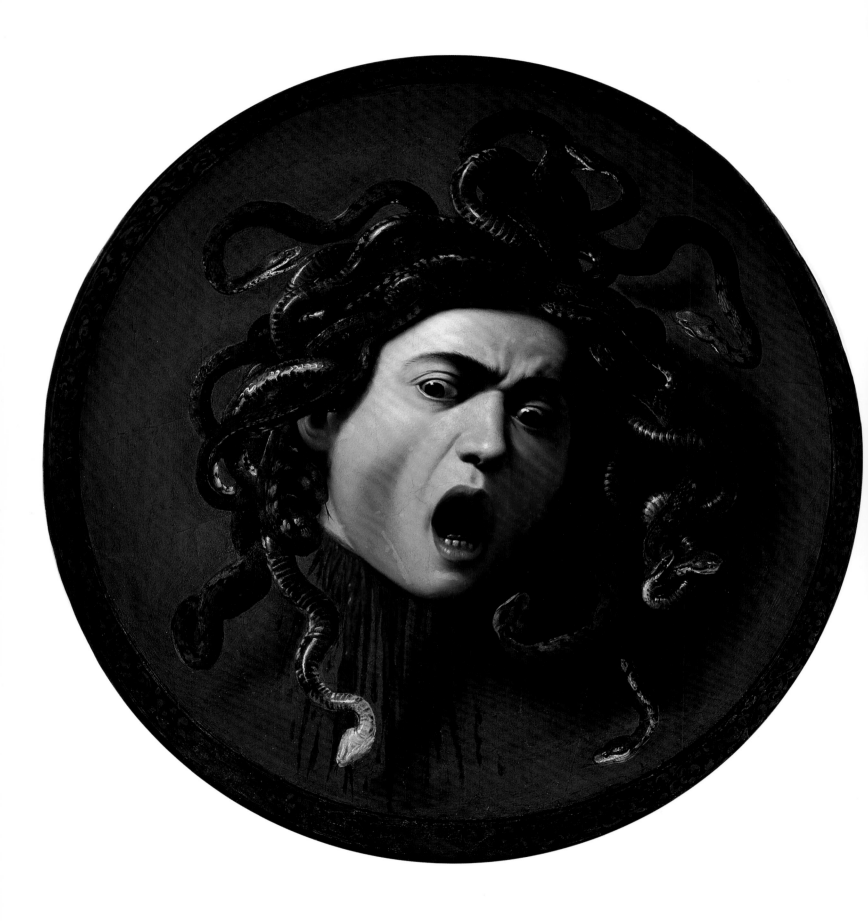

one of his etchings from the days when he was the pupil of the Cavalier d'Arpino, the subject of which indicates that it was made during his period of genre painting. In this etching, which is dedicated to his teacher and signed MA. I. F., we see again the motif of the Bohemian woman that he used in the painting in the Musei Capitolini, but here more elaborate. It is possible that the monochromatic work gave him the idea. It depicts a gypsy telling a young man his fortune, while between them an old man appears as an independent witness and to the left is a boy, who is pulling a purse out of the youth's suit, with which the young man must pay the woman whose advice he requests. In the top left-hand corner are words filled with resignation: *Fur. Demon. Mundus senex fraude.* (A thief. The devil. The world at the hand of an old man's ruse).

The best-known of Caravaggio's *bambocciate*, though not mentioned by his biographers, is that of *The Cardsharps* (pp. 18-19) in the Kimbell Art Museum in Texas[43]. The demonic terror within the subject, so obviously highlighted in this work, matters less than the strength of expression of the figures, which Caravaggio seems to have almost sculpted, foregoing the depiction of any surroundings. The painting, on a coarse canvas and of a relatively small size, shows half-length figures. It demonstrates a vital change in the evolution of the artist's work, which took place following progress in Baroque art in Rome, forcing him to move beyond his Venetian experiences. Despite the fact that his earlier techniques can be seen in the fine colouring and the sweetness of the young faces, the neutral background of dark green and black, as well as the attempt to highlight the forms with light, indicate strongly the new direction that Caravaggio's work would take.

The Paintings of the Church of San Luigi dei Francesi

From 1599 onwards, Caravaggio received his first commissions from the congregation of the Church of San Luigi dei Francesi, for whom he painted *The Calling of Saint Matthew* (p. 53), *The Martyrdom of Saint Matthew* (p. 57), and the famous *Saint Matthew and the Angel* (p. 83). "Regarding the works created for the Cardinal del Monte in the Cantarelli chapel of the Church of San Luigi dei Francesi, *Saint Matthew and the Angel* could be found beneath the altar; on the right-hand side, the apostle is being called by the Redeemer and on the left he is being stabbed by his persecutor, with a crowd of onlookers."[44] These works, which can still be found in part in that very chapel, are closely linked to the renown of the artist from Lombardy. Caravaggio's teacher, Giuseppe Cesari, who

Medusa, 1591-1592.
Oil on canvas mounted on a poplar wood shield, 60 x 55 cm.
Galleria degli Uffizi, Florence.

had already decorated the ceiling of this chapel with frescos, is likely to have helped him to obtain this commission[45]. Caravaggio, who, it seems, never painted frescos, integrated his work into the completed decoration with monumental paintings set into the chapel. These canvases painted in oils did not really contribute to the budding Baroque style of the salons of the time, but the subtle technique and sombre colouring of their execution blended harmoniously with the light stucco of the space. The position of the chapel as the last on the left just before Rainaldi's choir cupola, encouraged the painter to delve deeper into his imagination and resources. As the chapel was deliberately kept in darkness, the painter immediately set himself the task of introducing a scheme throughout the portrayals whereby the masses of light and shade and the coloured and neutral forms would be distributed between the works. In this way, only when all the works were seen together could their true effect be appreciated. A consideration for the architectonic conditions of the church building are clearly noticeable in the quieter composition of the left wall (*The Martyrdom of Saint Matthew*) and the scene of the right wall, which is built in a rising diagonal (*The Calling of Saint Matthew*), lending the chapel decorations as a whole an extremely organic integration into the building. The colouring is reduced to the strict minimum and the events are calculated in an almost authoritative manner, as is the setting of these events. On the whole, the light and colour are carefully shed on the elements that the painter chooses to stress. This realisation encouraged the artist to highlight the attributes of the figures as he had never done before, so that they almost became an artistic phenomenon.

Jakob Burckhardt explains that Caravaggio enjoyed proving to the observer that, despite all the holy events of former times, everything had happened in as ordinary a way as in the streets of end of the 16th century. He adds that Caravaggio loved nothing more than passion, whose volcanic eruption he could represent so well, even if he expressed it in numerous powerful, hideous characters[46]. This observation of the Romanesque element of the paintings positively highlight the way in which Caravaggio, and Baroque art as a whole, must have found essential. This counts as much for the representation of a being capable of arbitrary movement and its surroundings as for the use of purely sensual means, or even through the use of characteristic traits in the case of a portrait for example. It is on this that Caravaggio concentrates in his cycle of Saint Matthew in the Contarelli Chapel, much more so than in his *bambocciate*[47].

With this understanding of the intentions of the Roman Baroque artists, Caravaggio decided to use light to an even greater extent in his paintings, in order to highlight

Narcissus, 1598-1599.
Oil on canvas, 110 x 92 cm.
Galleria Nazionale d'Arte Antica di Palazzo Barberini, Rome.

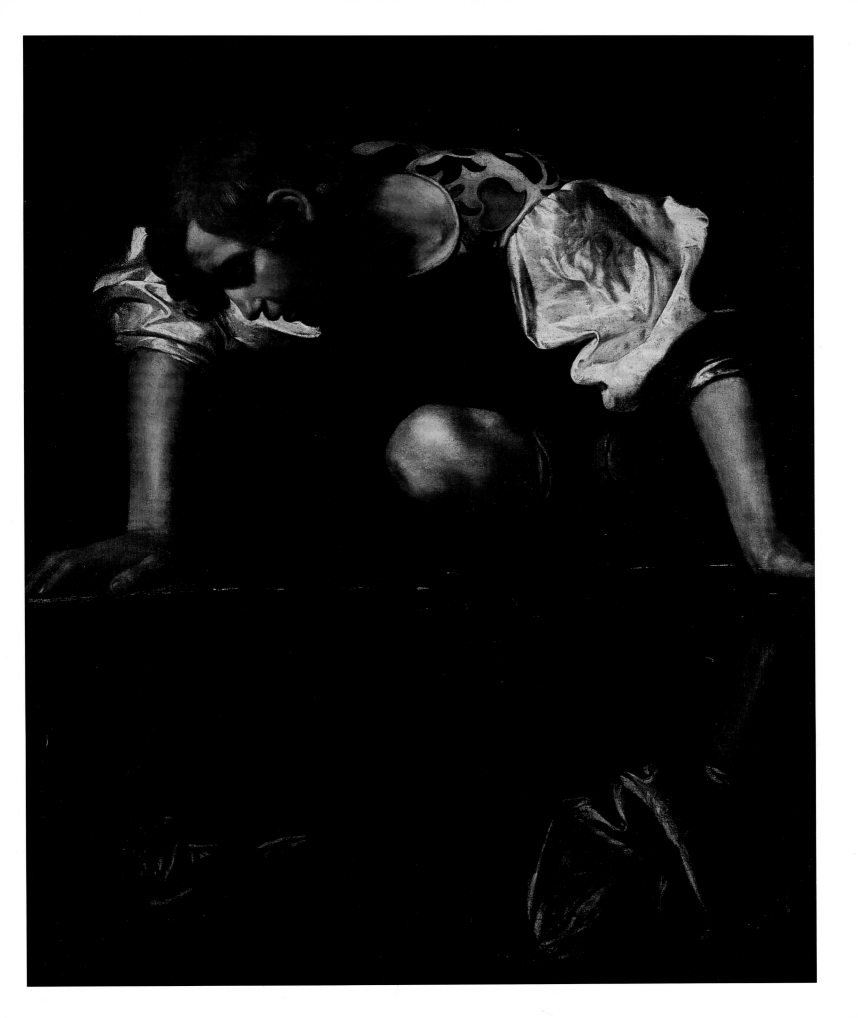

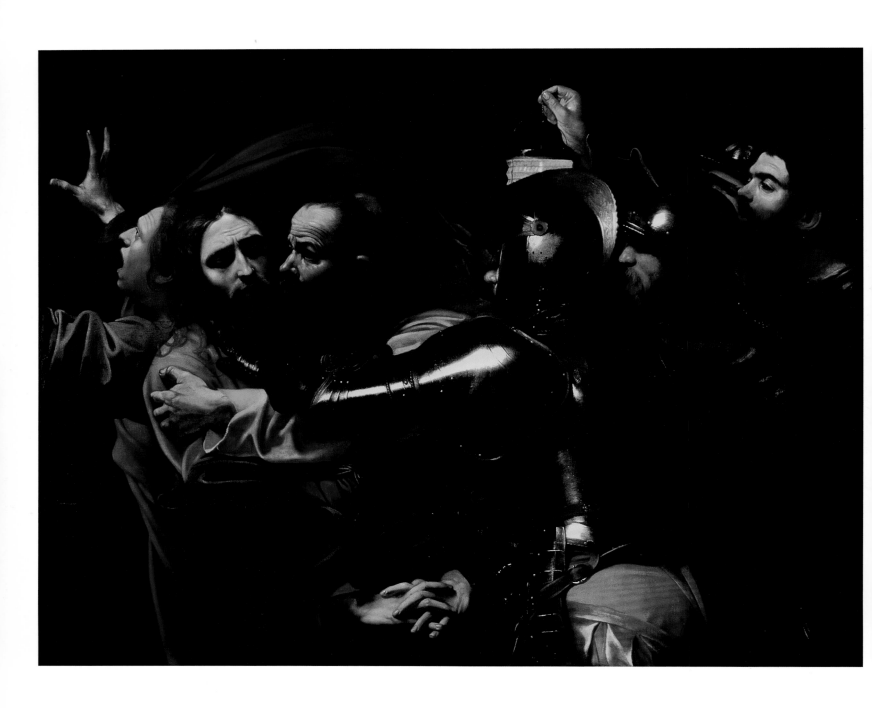

The Taking of Christ, 1602.
Oil on canvas, 133.5 x 169.5 cm.
National Gallery of Ireland, Dublin.

their demonic effect; this was the "light from above"[48], which in reality resulted from the increasing use of lateral lighting in Baroque rooms, whether in churches, chapels or halls in the *palazzi*. With these natural architectural conditions, Caravaggio achieved a brilliant illumination in his paintings which, when positioned correctly, produced a wondrously harmonious effect.

The choice and application of the pigments went hand in hand with Caravaggio's sense of artistic style. A distinct sulphur-yellow for the background and a luminous colour for the intermediary plane created the bearings from which he was able to form the space with his subject, and gave, from the first glance, a primary hierarchy to the scene. According to Baglione, however, this disorientated young artists, even the most talented amongst them. With these essential tools, Caravaggio created the foundations of a Baroque style which prevailed throughout the 17th century, and which was entirely different to the style of his pre-Roman works. Therefore, when Federigo Zucchero declared in front of Caravaggio's paintings in San Luigi dei Francesi that he saw nothing in them but Giorgione's thoughts[49], then his judgement meant little more than an exhortation that Caravaggio should work towards an even more personalised manner of painting. At heart, the heroic character of the works had nothing in common with the balanced style of the Venetian master of the High Renaissance.

The chapel achieved its full effect through Caravaggio's work of art, which at that time was on the altar. It depicts *Saint Matthew and the Angel* and is now in the art gallery of the Berliner Museum, in trust[50]. "The work pleased no one," reported Baglione, so that it required the artistic sense of the Marchese Vincenzo Giustiniani to save the rejected picture. "The latter took them, because they were the works of Caravaggio," adds the biographer. If we look past the extremely realistic figure of the Evangelist, which at first does not stand out, and focus on the activity of the scene, the eye is drawn into a whirl of highs and lows, of heights and depths, of light and shade, and of coloured and monochrome areas, whose harmonious application and distribution suggest an eminently personal artistic sense. Palestrina's style of mass setting would have to be called upon in order to characterise this peculiar overlapping of *arioso* and *recitativo secco*, and to describe the attraction of this most daring of Caravaggio's compositions. The angel, who holds the hand of the bending Evangelist in a slightly affected manner, is very close in style to the shepherd boy from the Capitolinian Collection, and the Cupid of the two allegories of love. However, here, he appears even more natural and sovereign-like – a real model for Saraceni, who tried to capture this element of Caravaggio's art, without, as the angel in his *Rest on the Flight into*

Egypt (pp. 28-29) in the Galleria Doria Pamphilj in Rome shows, achieving the rigorous strength of his teacher[51]. Caravaggio's attempt to depict the messenger from heaven in a more adult, and at the same time more human, way than art had done so far cannot go unnoticed. In the same way that Cupid, traditionally represented as a *putto*, becomes an adolescent boy full of self-confidence and coquetry, Caravaggio's depiction of the celestial companions of the holy figures is also radical.

His first successes, however, had a shadow cast over them by the refusal of several major works by some of his commissioners, as was the case in the cycle of Saint Matthew in the Church of San Luigi dei Francesi. This was also the case in *The Conversion of Saint Paul* (p. 79) and *The Crucifixion of Saint Peter* (p. 65) destined for the Cerasi Chapel. Next, Caravaggio painted a *Saint Anna Metterza*, the *Madonna dei Palafrenieri* (p. 112), which makes reference to the commissioners. Today, this painting can be found in the Borghese Gallery, and it is of the same style as that of the *Madonna di Loreto*, but further developed. The three figures, Saint Anne, the Virgin Mary, and the child Jesus, are depicted standing, almost like sculptures, an aspect which is all the more emphasised by the neutral background. The figure of the young Christ, who is portrayed as a boy of around ten years of age, symbolically crushes the head of a snake, and shows a close resemblance to the adolescent models of the altar-piece of San Luigi dei Francesi and the *Madonna di Loreto*. Mary appears more mature and detailed in comparison with the picture in San Agostino, while Saint Anna, as *donna abbrunata*, evokes the wailing old woman in *The Entombment* (p. 90) in the Vatican. The pale greenish tone that permeates the painting clearly highlights Caravaggio's light from above, and removes all familiar warmth from the colours and complexion. This was probably the excuse for the church authorities of San Pietro in Vaticano to have the painting removed from the altar. It was probably the reason why the Roman Curia of Saint Peter's in the Vatican removed the work from the altar. Baglione reports that following this decision, the work was offered to Cardinal Scipione Borghese as a present, and it went from the Cardinal's possession to the Borghese Gallery.

In his great altarpiece for the Church of Santa Maria della Scala in Rome, Caravaggio used a more favourable light. From the possession of the Duke of Mantua, who acquired the piece, and in whose gallery it was kept until the beginning of the 19th century, this work came into the collection in the Louvre[52]. It depicts a subject rarely seen in Italian paintings: *The Death of the Virgin* (p. 80). Whilst a recurrent theme in Nordic art, prior to Caravaggio's work it was only seen

Portrait of Maffeo Barberini, Future Pope Urban VIII, 1599. Oil on canvas, 124 x 99 cm. Private collection, Florence.

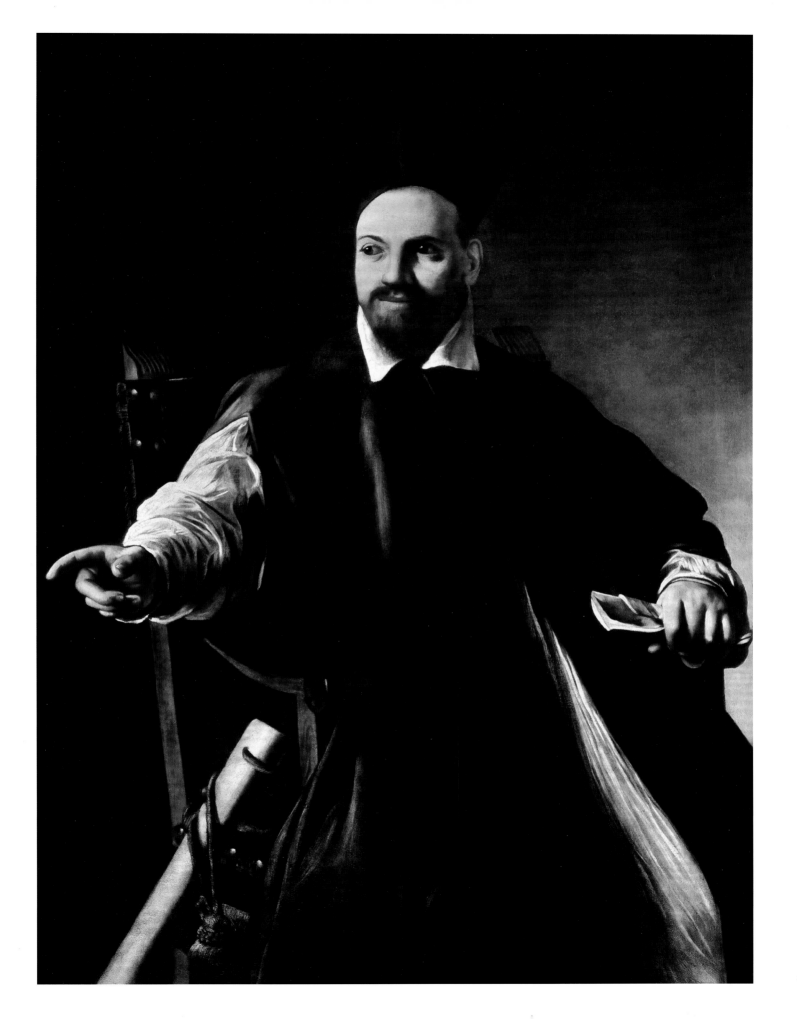

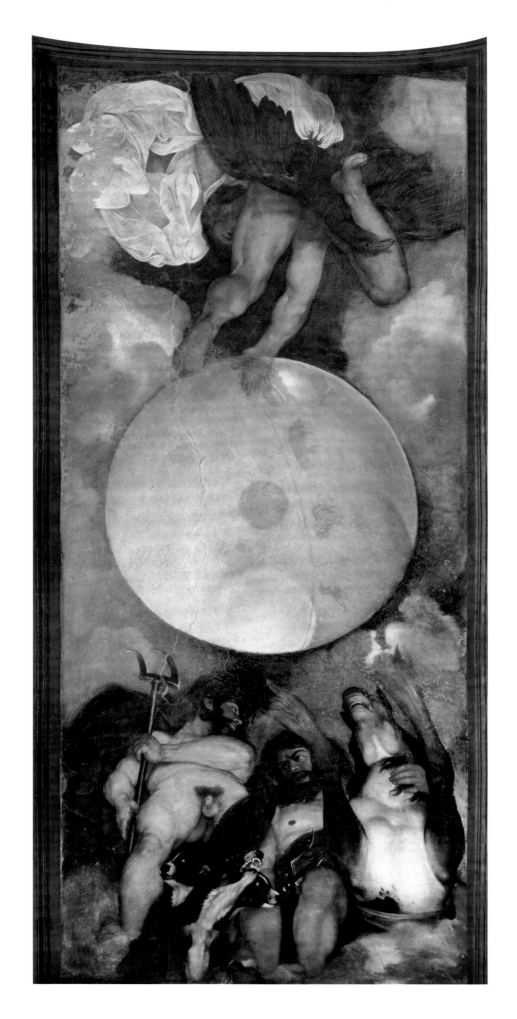

in Italian art in a painting by Carpaccio, now in the Ferrara Gallery, and in another by Salvo d'Antonio as part of an altarpiece for the Cathedral in Messina. Caravaggio endowed his work with a great magnificence, without for one moment suppressing his talent for expressing grief and pain in the most energetic way. These apostles, who are mourning the Virgin, are rough, rustic fellows, and the holy woman, who is sitting on a wooden chair at the foot of the bed, is a maid of humble origin. They express their feelings in the natural manner of simple beings; without measure and without beauty. Their profound grief is completely honest in its representation. Caravaggio achieved this narrative art through the careful modelling of the figures, which, surpassing the expression of all his previous works, indicate the future evolution of his painting. Despite the apparent irrationality in the composition, his work demonstrates a spatial depth was achieved that, for the first time in his artwork, seems to be a conscious choice. The body of the Virgin, which has been laid diagonally from left to right, drawing the eye to the furthest planes of the painting, helps to create this sense of depth. This impact is reinforced by the young girl seated in the foreground, who, acting as a foil for this complex composition, highlights Caravaggio's new insights into the determining factors in the composition of an image, despite their tentativeness at this stage. An enormous curtain, almost like a *velarium*, which stretches across the shaded upper part of the image, also gives a certain depth to the painting. Far from decorative in intention, as the Bolognese School used such a motif, the drapery lends the work an aura of great gravity. Its deep red, with variations of lighter and darker shades, makes the colour range of the lower parts, which are placed in bright light or *chiaroscuro*, livelier and more charming partially through the thick application of the pigments. The brethren of Santa Maria della Scala also refused *The Death of the Virgin* because, to represent the Virgin, the painter used the portrait of a courtesan. In addition, the "bloated" corpse of the Virgin was deemed "too human", and the copper bowl full of vinegar for washing the body did not convince them. However, no less a painter than Peter Paul Rubens recognised the significance of the painting; he is said to have persuaded the Duke of Mantua to buy it[53].

Yet at no time did Caravaggio abandon the manner of painting which he had developed, and he pursued with perseverance his search for original aesthetic concepts. Although he was obliged to rework all his canvases because of the religious reservations of his patrons, his artistic faith remained unaltered and his submission was only superficial.

At the beginning of the year 1600, when Giordano Bruno was tortured in Rome, Caravaggio's manner was still being developed, and the first signs of his

Jupiter, Neptune and Pluto,
1597-1600.
Ceiling painted in oil, 300 x 180 cm.
Casino Boncompagni Ludovisi, Rome.

subversive attitude towards the religious institutions which then dominated the eternal city were already perceptible. During the Counter-Reformation, Pope Clement VIII, taken by a violent desire for order and repression, decided to "clean" the streets of Rome and undertook a series of measures against street gatherings, gaming, the carrying of weapons and prostitution. It was precisely during this period that Caravaggio painted the "profane" works which brought him renown and which he populated with people he had met in the streets. In this climate of religious repression, it is difficult to have a precise idea of the painter's convictions, even more so as the pope had recently removed from a church an altarpiece on which a representation of *Saint Catherine of Alexandria* (p. 32) had offended him.

Nevertheless, the painter did not abandon his mission to renew the style of painting at the risk of going against the jurisdiction of the religious authorities. The work of this rationalist Naturalist expressed the mysteries and miracles of Christianity in the way that many artists have represented the gods of pagan classicism. The more important the transcendental content of the events and stories experienced by biblical characters, the less the painter had recourse to traditional religious symbols. The *Penitent Magdalene* (p. 31) painted in 1596-1597, one of his first religious works, illustrates Caravaggio's pictorial choices. Far from the traditional representations which set Mary Magdalene in the desert, he places the young woman, not undressed but richly clothed, in a dark interior traversed by a ray of light, and places on the ground a small perfume bottle and next to it, as a symbol of the material wealth from which she will progressively turn away, some scattered jewellery. Contrary to the sculpture in wood by Donatello that one can see in the Bargello Museum in Florence, Caravaggio's Magdalene is embodied by a young woman from a good family, who is living an interior experience, progressively possessed by divine grace. The painter, through his aesthetic choices, breaks decisively with earlier representations of the saint's life. His later religious works are also imaginative and innovative, giving the saints a new face, representing unusual episodes in their lives and introducing unorthodox details into the scene.

Following a commission from Ciriaco Mattei, Caravaggio also painted the scene "when Our Lord walked to Emmaus". From this quotation by Caravaggio's biographer, one might think that the artist had depicted Christ's encounter with the two disciples on the road to Emmaus, but such a version has not been found amongst his surviving works. We do, however, have three versions depicting the moment when Christ makes himself known to the disciples in Emmaus. One

The Calling of Saint Matthew,
1599-1600.
Oil on canvas, 322 x 340 cm.
San Luigi dei Francesi, Rome.

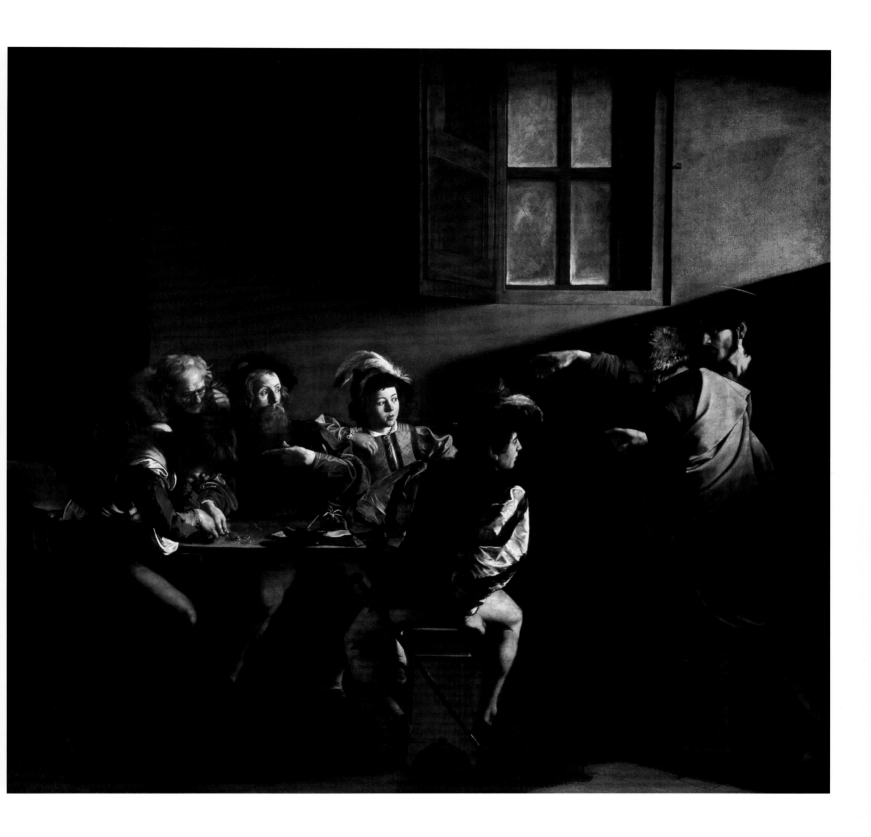

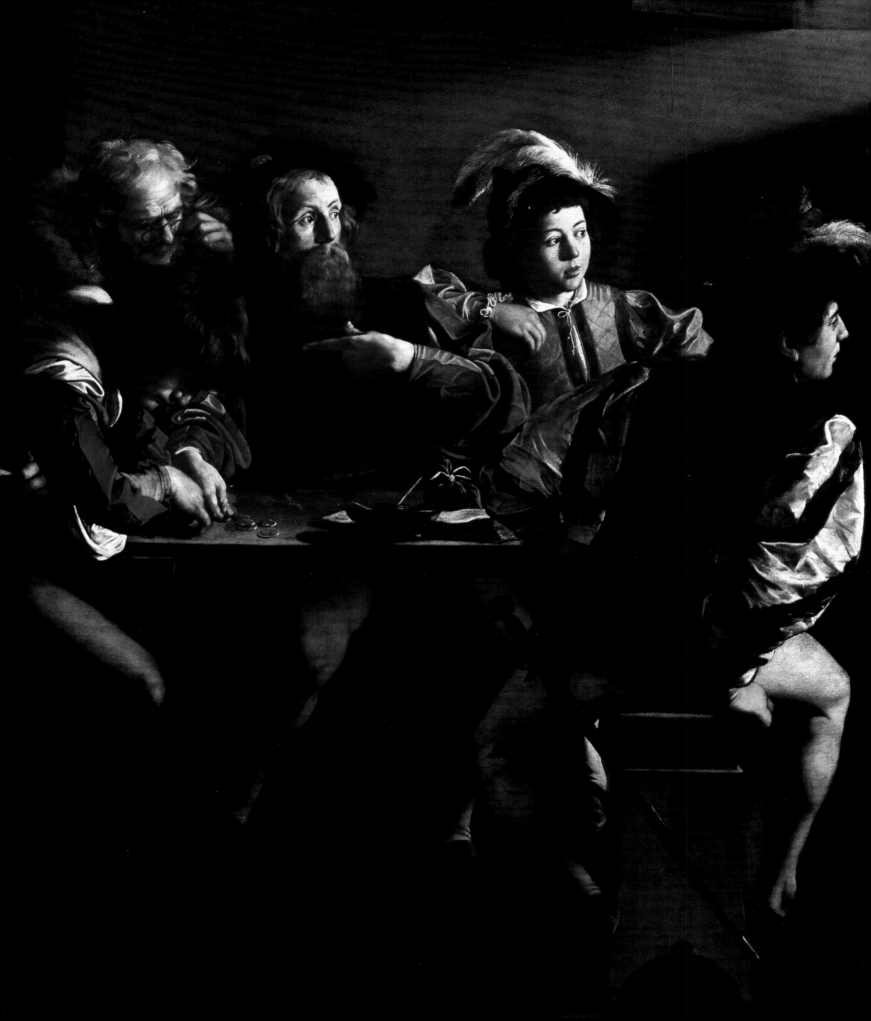

painting which portrays this scene, found in the National Gallery in London was, according to information from the catalogue, created for Cardinal Scipione Borghese, and may in all likelihood be regarded as the original[54]. There is a copy which is probably in Milan, and another replica is in the church of Notre-Dame in Bruges[55]; the former is very similar to that from Caravaggio's studio, the latter is assumed to be the hand of a Flemish successor. The London painting demonstrates a delightful sweetness regarding the presence of the figures. The phrase "passion leads to art" also belonged to the gospel of the Carracci[56], but for them it was more a fancy for modelling the muscular physique than for the power of psychological expression. Here, the tone of the scene is reminiscent of the style of Caravaggio's *bambocciate*, as the artist knew them. The painting depicts a group in a tavern, where the wine has clearly been flowing. Yet in other parts of the painting there is such nobility, a transcendence that shines through despite its material slant, and due solely to these shimmering, profane and supernatural creatures, the piece has a special charm. The tavern's landlord, who himself appears in the scene, gives a sense of reality to this image of the miraculous. At the same time, the colouring is so intense that for this reason alone it should be recognised as one of the most balanced and enticing works produced by Caravaggio, who otherwise favoured dark tones. The picture trade, based on fast production, which he had run together with Prosperino delle Grottesche shortly before, seems to have been of such importance to him that he had guaranteed a certain freshness of invention[57].

The *Supper at Emmaus* (pp. 174-175) is significant for the distance the painter allows himself to go: in the representation of Jesus appearing to the two disciples, Caravaggio chooses to humorously represent an innkeeper wearing his hat accompanied by a waitress, both of whom are dressed in 17th-century attire. This technique, which gives the scene a certain shift in time, had already been used by the painter in his first painting of Mary Magdalene. For the painting that can be seen in the Cesari chapel (*The Conversion of Saint Paul*), Caravaggio, ignoring the celestial vision, prefers to anchor the scene in the material reality of a horse-riding accident which symbolises the shock experienced by the apostle. Caravaggio, who in the paintings of Saint Matthew in the chapel in San Luigi dei Francesi had already tried to revolutionise and renew the fundamental laws of painting, outdid this monument to his recently-discovered style in an even more magnificent way in the paintings he carried out for the Cerasi for their chapel in Santa Maria del Popolo in Rome. On the right-hand wall of the chapel to the left of the nave, directly next to the choir[58], is *The Conversion of Saint Paul*, and on the left-hand wall *The Crucifixion of Saint Peter*. J. Burckhardt's judgement of the

The Calling of Saint Matthew (detail),
1599-1600.
Oil on canvas, 322 x 340 cm.
San Luigi dei Francesi, Rome.

works, in which his dislike of Caravaggio is clearly expressed, remains exaggerated and restricts access to the understanding of an important moment in the Baroque[59]. His reproach concerning the horse, from which the apostle has slid following his vision, which almost completely fills the picture on its own, seems unjustified given the mastery of the application of the paint in the forms and colours. On the contrary, it is the contrast between the struck-down animal and the divine messenger who is standing in the background which renders the impact even more significant. From a purely artistic point of view, this pushing of enormous corporeal masses into the foreground marks the point at which painting left its previous tendencies behind.

According to Baglione, Caravaggio also painted *The Incredulity of Saint Thomas* (pp. 76-77) for Ciriaco Mattei, depicting the apostle as he touches the side of the Risen Christ with his finger[60]. Although J. Meyer mentions the disappearance of this work, which was once exhibited in the Palazzo Giustiniani, it has since been found and is now in the Schloss Sanssouci in Potsdam[61].

Contrary to decadent figurative compositions, in his work, Caravaggio never represented a god surrounded by clouds, nor a divine eye with almighty vision in the classic radiant triangle. The gazes of Caravaggio's Madonnas, Saints, or Christs never turn towards heaven. Contrary to the ecstatic faces and eyes of the characters painted by Guido Reni or Carracci, the divinities of this realist painter never stray far from the terrestrial horizon in either thought or gaze. Certain paintings offer up a prayer to the Virgin (*Madonna di Loreto*; *Madonna of the Rosary*, p. 115), but it is more an anxious supplication that worldly pain might cease than a conjuration against a mysterious and perpetual punishment, or an aspiration to the beatitudes of a hypothetical paradise. Only that which in the Christian religion symbolises the sanctification of human suffering seemed to have awakened a sincere sentimental impulse in Caravaggio. His authentic compassion for the weeping apostles surrounding the bed of the Virgin is convincing, as is his profound respect for the majestic sadness of Christ (*Ecce Homo*, p. 104). Equally as convincing is his piety in depicting the suffering Christ tied to the column and whipped (*The Flagellation of Christ at the Column*, pp. 184-185), as is his admiration for the heroic torment of the mother, who envelops her son's corpse with her love (*The Entombment* p. 90). The artist, attracted more by terrestrial life than by theological issues, seems not to have been compelled to constant religious practice. On the contrary, Michelangelo Merisi may have given credit to far-fetched beliefs and superstitious practices. He who was so distant from sacred mysteries may have believed in the protection of a benevolent demon

The Martyrdom of Saint Matthew,
1599-1600.
Oil on canvas, 323 x 343 cm.
Contarelli Chapel, San Luigi dei Francesi, Rome.

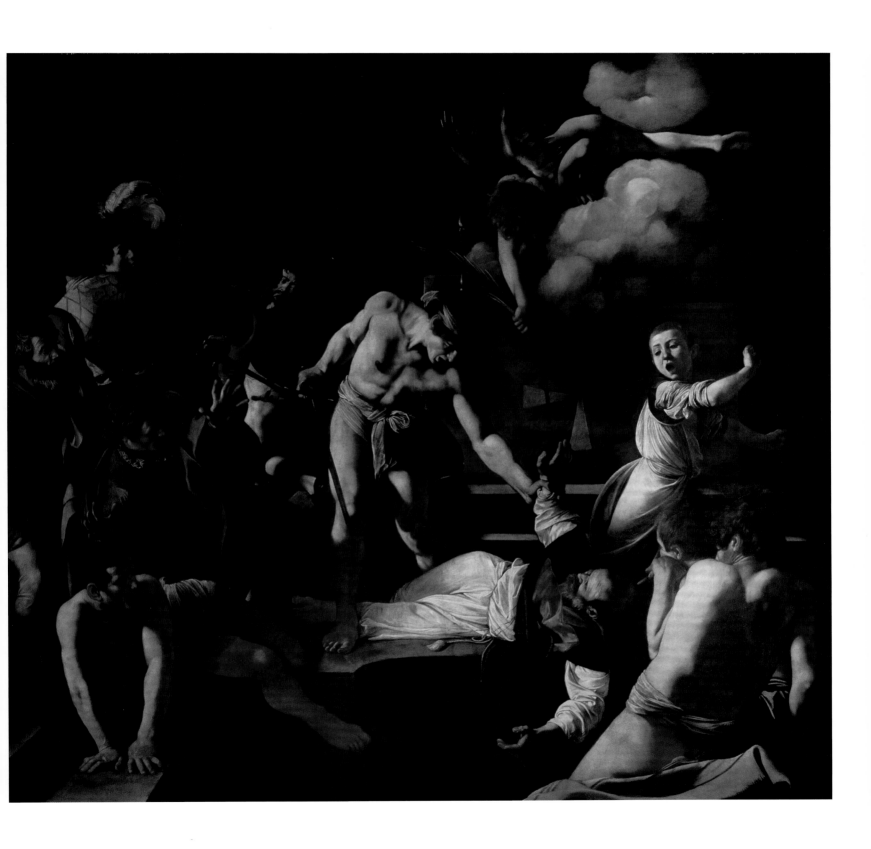

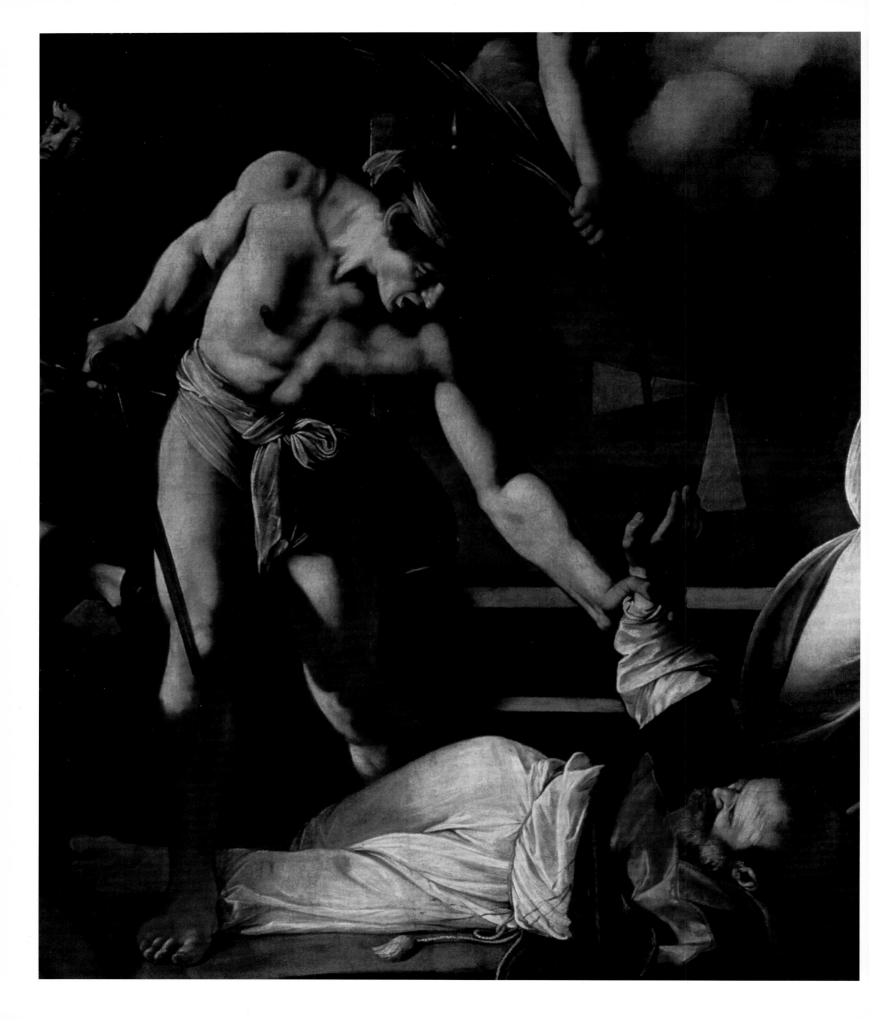

during the long periods he spent playing cards. When he painted Bohemian fortune tellers, was it an allusion to a personal experience, in that he did not mind giving them his own hand to have his fortune told, or was he addressing a theme of which he was questioning the meaning?

The period of his life that Caravaggio spent in Rome – little more than ten years between the end of the 16th century and the beginning of the 17th – was marked by frequent brawls, scandals surrounding his principal paintings, and disagreements with the authorities. He rubbed shoulders with disreputable people and his reputation as a violent and quarrelsome man began to spread. Incapable of controlling his language and his behaviour, he once composed a defamatory satire against the painter Giovanni Baglione. Another time, in an inn, he petulantly threw a plate of artichokes in the face of the waiter; one night he attacked a certain Spampa de Montepulciano with a stick and a sword cane; on other nights he shouted insults at the police or hit a sergeant guard at the prison of Castello Sant'Angelo, or even threw bricks at the shutters of a certain Bruna Prudenzia. He appeared before the courts several times for not honouring his debts, for going out armed with a sword at night without authorisation, and for having perpetrated criminal acts in the shop of Diome de Ferrucci, the student of Cresti Dominico nicknamed the *Passignano*. He attacked the assistant to a notary over a woman, and in a fit of jealousy he could not prevent himself from seriously threatening the painter Guido Reni. The latter, frightened by such a formidable adversary, got some formidable-looking men to intimidate Caravaggio, getting him to back down. Another time, Caravaggio sent a hired Sicilian killer to injure the face of the painter Niccolò Pomarancio who had succeeded in obtaining the commission of a large fresco in the dome of the Basilica Santa Maria in Loreto.

His life in Rome was therefore rather tumultuous, and a number of documents recall these criminal and other moral affairs for which he was imprisoned. In 1606, at the end of an inevitable criminal descent, he injured with his sword the thigh of the young Ranuccio Tomassoni who died from the wound. The reason for this action seems to have been a quarrel over a game of court tennis or a difference in opinion over the merits of the ambassador of the Grand Duke. Caravaggio was condemned to death for this murder. Documents found long after the fact imply that, in reality, it would have been Tomassoni who would be the first to challenge Caravaggio and not the latter who would have attacked him.

The artist then had to run away from Rome and try to obtain a pardon from the Pope, but without showing any remorse or any desire to change his ways.

The Martyrdom of Saint Matthew (detail), 1599-1600.
Oil on canvas, 323 x 343 cm.
Contarelli Chapel, San Luigi dei Francesi, Rome.

Immediately after his stay in Rome, Caravaggio attended to his wounds, probably contracted during the fray, and worked for a short time in Zagarolo near Palestrina, where the artist had sought protection with Duke Marzio Colonna[62]. According to Baglione's report, he painted the Magdalene here[63]. The painting, of which there seems to be a copy in a private collection in Rome, shows the artistic style of the final works that Caravaggio had created in Rome[64]. According to Bellori he is also said to have painted a portrayal of *The Supper at Emmaus* for the Duke of Colonna[65]. As mentioned above, Baglione reported that Caravaggio had painted a picture of the same subject for Ciriaco Mattei in Rome, which, in all probability, is the version in the National Gallery in London[66]. In this case, as with that of the paintings in the Capella Cerasi in Santa Maria del Popolo in Rome, we can hardly suppose that Caravaggio occupied himself with copies of the same representation. In order to evaluate this correctly, Bellori's information of an original composition of the Emmaus scene for Colonna must therefore be doubted; in reality these are copies produced by a school, which, in the case of the copy in the Ferdinandeum in Innsbruck suggest a Flemish successor.

It is tempting to compare a different work of art our painter created to the Roman paintings mentioned. This is *The Crowning with Thorns* (pp. 92-93) which can now be found in the Kunsthistoriches Museum in Vienna. Certain commentators have mentioned the existence of other versions of the subject[67], but nothing has been proved. The painting, which measures 127 cm high and 166 cm wide, shows the Saviour from the waist up with tied hands between two half-length figures of armoured and turbaned soldiers. In comparison with the description in the Gospel, Caravaggio accentuated the brutality of the scene in his depiction. Matthew (27:30) tells us only that the soldiers hit Christ on the head with a cane. But in his own, unfinished *The Flagellation of Christ*, now in the Alte Pinakothek in Munich, Titian already has the crown of thorns pressed onto Christ's head in the Nordic manner, with the soldiers holding clubs, a motif that Caravaggio used even more brutally as a result of his soldiers' realism. The modelling of the figures in the painting, which is yellowish in tone, reflects the artist's complete mastery of his tools. The dexterity of the armour's reproduction, reminiscent of *The Conversion of Saint Paul* (p. 79) in the church of Santa Maria del Popolo, points to an increased artistic method of portrayal, whose exemplary effect is still recognisable in the works of Caravaggio's Roman pupils, the Venetian Carlo Saraceni and the French painter Valentin, who show national and personal differences in their manner of painting. Back on his feet after his convalescence, and having sketched several paintings, Caravaggio then went to Naples.

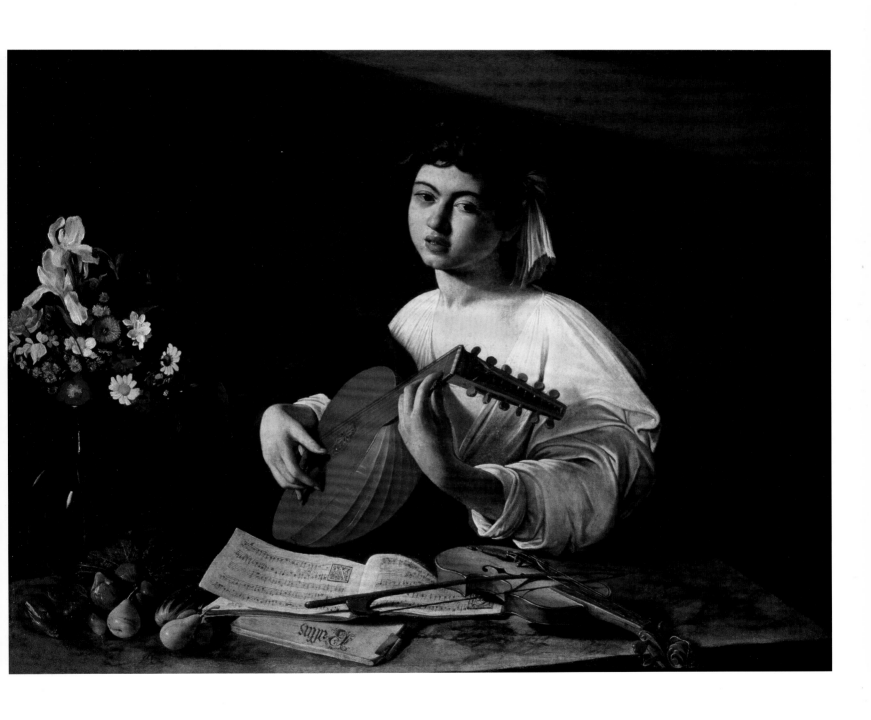

The Lute Player, c. 1595.
Oil on canvas, 94 x 119 cm.
The State Hermitage Museum,
St Petersburg.

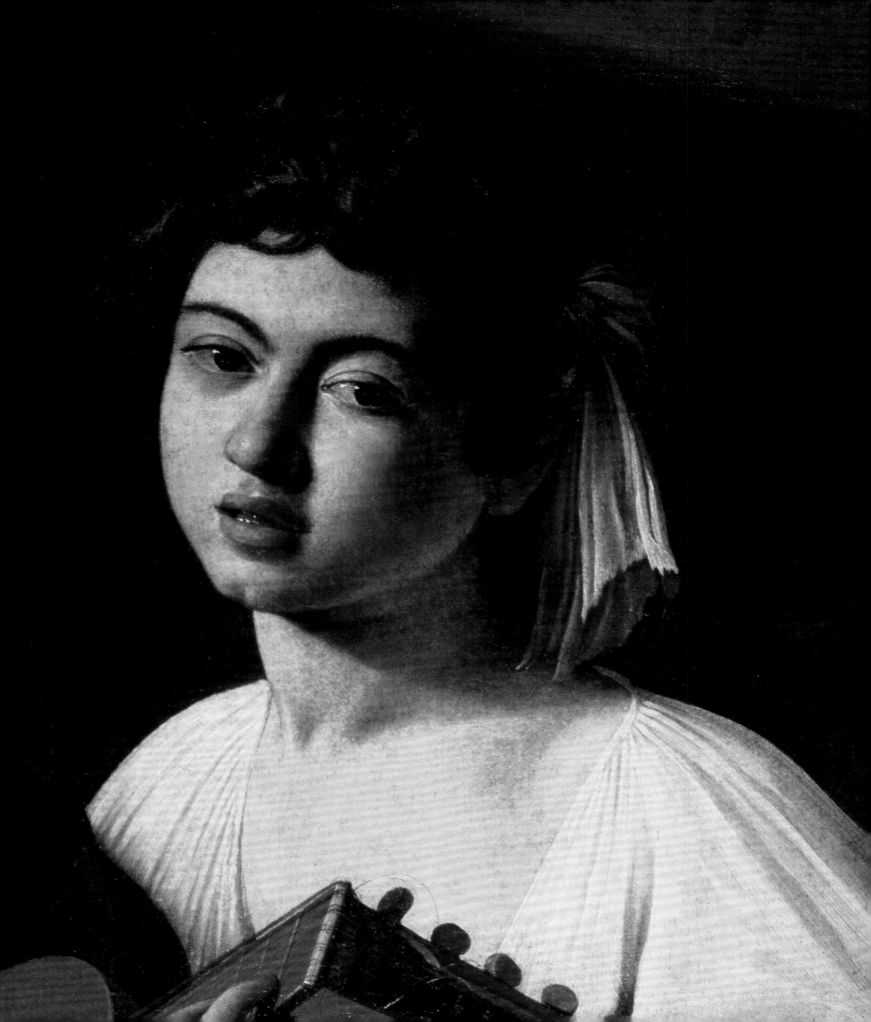

Condemned to Exile

Naples

The impact of Angicourt's Gothic Naples was to be of far-reaching importance for Caravaggio's art[68]. The varying styles of northern France that were manifest in this sunny city made an unusual impression on the artist, reflected in the works he created there after his departure from Rome. The abundance of luminous tones in the Gothic cathedrals, set against the light, calm shade of the background, is expressed in his paintings through a colouring more ornate than he ever strove for in Rome. This is evident in his altarpieces, such as *The Flagellation of Christ* (p. 144) created for the Church of San Domenico Maggiore. In certain paintings he attempted to work against the impression of bright colour, which could have reduced the effect of grandeur, by applying the pigments that would determine the picture's overall colouring before applying the opaque prime coat. Thus Caravaggio obscures the brilliant colours with neutral half-tones, which, for him, was a new means of achieving the important comprehensive impression in his works. Through this, he became the influential founder of a certain movement of Spanish *seicento* painting, to which he became connected through Guiseppe Ribera during his time in Naples.

His work *The Seven Works of Mercy* (p. 136) dates from this time. It was commissioned by a very powerful religious institution, Pio Monte della Misericordia, to decorate its new church, and is at first glance incredible in the number of figures depicted in the scene. It attempts to symbolise all the charitable works that a Christian should do, found in the Gospel according to Saint Matthew (25:35-36): "For I was hungry and you gave me something to eat, I was thirsty and you gave me something to drink, I was a stranger and you invited me in, I needed clothes and you clothed me, I was sick and you looked after me, I was in prison and you came to visit me." To this is added the right, and even the obligation, that every Christian be given a tomb. For this work, Caravaggio received his highest payment (around 400 ducats), so for him it was an extremely important commission. The figures appear to be grouped in a dark corner of a street, which renders the scene even stranger. This is without doubt one of the first times in the history of painting that all the works of mercy have been represented

The Lute Player (detail), c. 1595.
Oil on canvas, 94 x 119 cm.
The State Hermitage Museum,
St Petersburg.

together in the same painting. Also, some of the characters perform two duties, such as the man who is tearing his coat in two in order to clothe the sick man, to whom he is also paying a visit. Caravaggio was certainly alluding here to Saint Martin, who dismounted from his horse to share his tunic with a beggar. The parallels are cleverly integrated into the canvas, whilst the cloak and the angels' wings give movement to the composition. The light falls diagonally from the left of the painting, highlighting precisely the important details. In reinforcing the drama of the spectacle, Caravaggio creates unity with his unusual treatment of the light, despite the number of acts appearing to take place. Far from deifying the scene, he restores the simple humanity of the protagonists, including that of the Virgin and Child, thanks to his work on the shadows.

In their work on lighting effects according to Caravaggio's style, the Spanish School of the *seicento* went even further in terms of the thickness of the application of the pigments, in order to create a sense of vibrating energy in the painting as a whole, which in all likelihood related to the shimmering light of southern Spain. Spagnoletto's *Drunken Silenus* from the year 1626 in the Museo di Capodimonte in Naples reveals that he was still greatly influenced by Caravaggio's work[69]. The latter dedicated himself, as he had done in Rome, to paintings intended for churches as well as to the portrayal of mythological and related conceptions. He mastered the treatment of light with his characteristic talent, making his paintings exceptional in their execution. *The Holy Family* (p. 143), probably painted in 1607, dates from this Neapolitan period. There are at least three versions of this work in existence, the attributions of which are in dispute. The colouring is here at its most harmonised, and the colour red resonates particularly strongly.

Caravaggio's deep-rooted respect for the reality of appearance also guided him in relation to colour. Contrary to Lodovico Carracci's ideal choice of colouring, where his light blue and pink compositions were created for a totally different sort of observation, Caravaggio remained closer to the material substance of the pigment as, for him, it already meant something artistic in itself, in representation and in effect. The chemical character of the pigment fascinated him, and gave his paintings their first impact. The carmine feather in the hat of *The Chess Players* (p. 179, this painting has since been attributed to his successors, but the influence of his pictorial characteristics are very strong) and the soft colour of Salome's velvet robes have the same overall effect as the tone of a musical instrument has on a piece of music. It is irreplaceable, an essential ingredient in the whole piece, on which the impression and understanding of the work of art

The Crucifixion of Saint Peter, 1600.
Oil on canvas, 230 x 175 cm.
Cerasi Chapel, Santa Maria del Popolo, Rome.

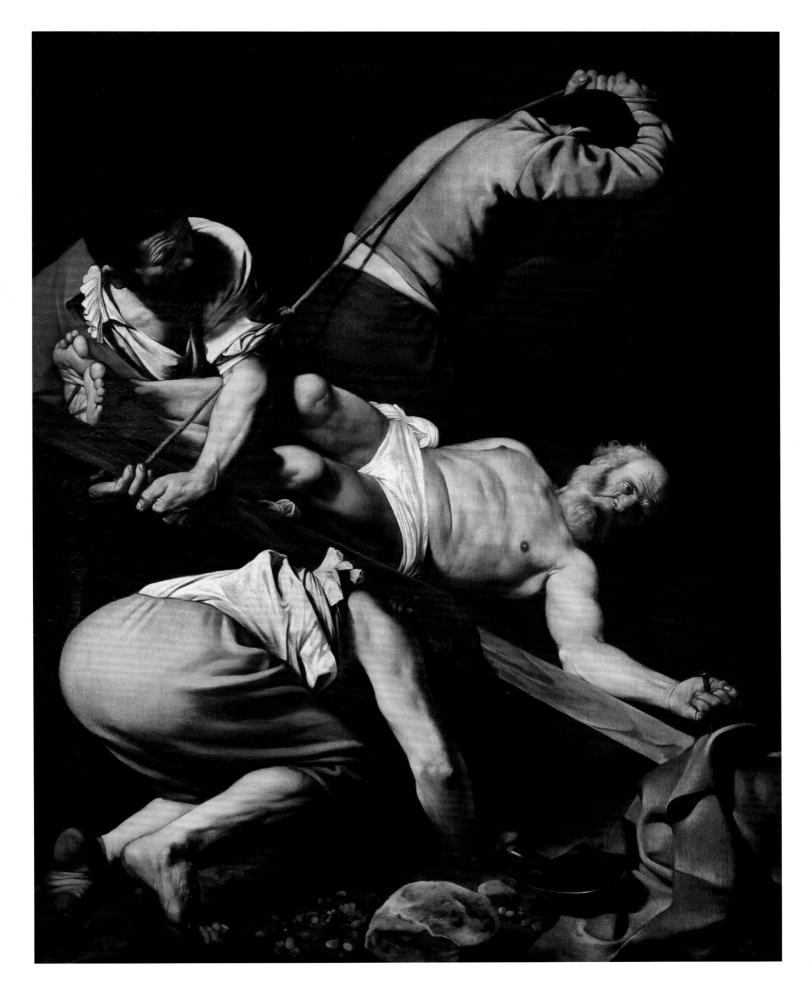

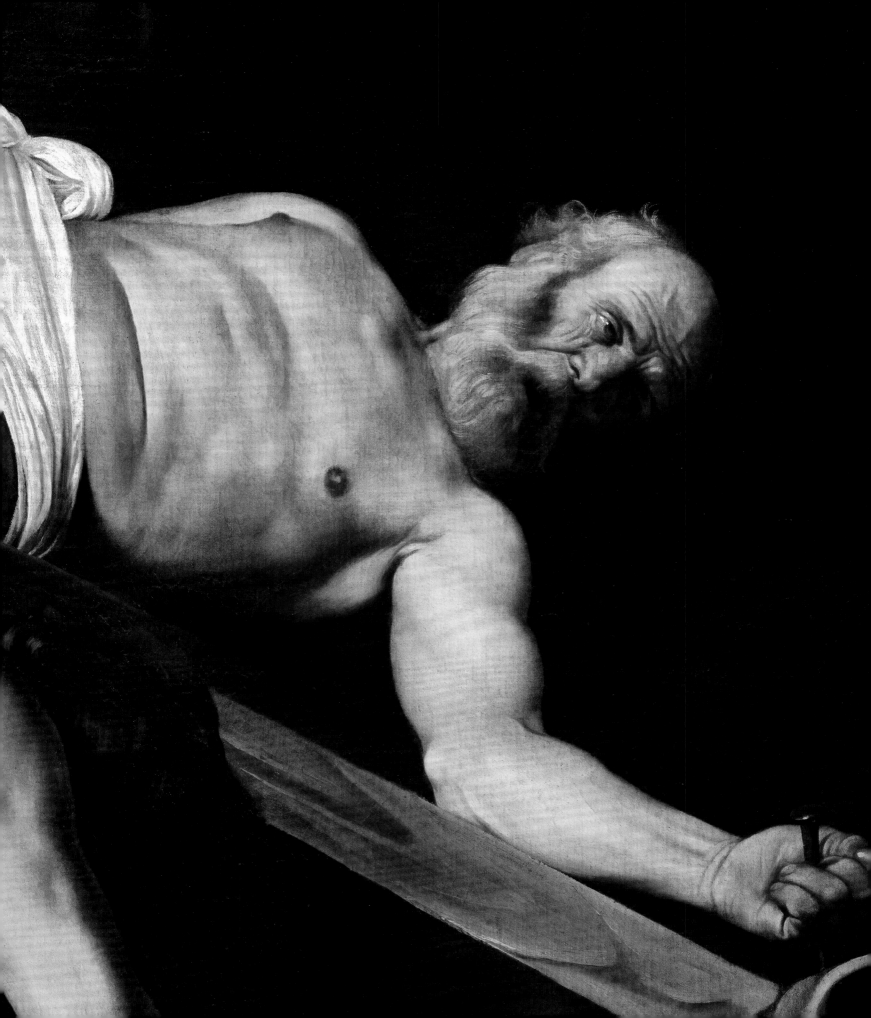

are dependent. Caravaggio's relationship with colour pigment allowed him to leave the original raw colour. Through the spatial organisation of the composition on a background of opaque tones, he managed to enhance the predominant base colour of the work. Caravaggio's works, particularly those executed in Naples, show an almost systematic treatment of colour in this way. However, he always insisted on the use of natural colouring in his paintings. Federigo Barocci's colour scale, composed arbitrarily, was alien to him[70], as were the works of Cigoli, which seem strangely animated by the glazing and the glistening colours. But Caravaggio was most interested in countering the naturalistic effect of his three-dimensional compositions, without erasing it, with the range of colour in his works, and the creation of a meaningful aesthetic whole for the lasting gaze.

There is also mention of an *Orpheus*, an example of profane art amongst his works that is now inaccessible. It would certainly allow closer study of Caravaggio's connections to the Spanish School of painting, which can be followed from this point to Velázquez' *The Feast of Bacchus* and *Mars Resting*. One of Caravaggio's missing works deserves to be mentioned in this context: a depiction of four Cyclopes forging arms for Aeneas, which was at one time in the Cabinet of the Reynst brothers.

The impact of the artist's stay in Naples for much of 1607 can be seen in the great artistic maturity displayed in his works at the time. The style he had developed in the paintings of Saint Matthew in San Luigi dei Francesi took on an authoritative quality, and Caravaggio's powerful example lent itself from then on to similar conceptions. It was probably in Naples that Ribera, as well as Salvator Rosa slightly later, gained decisive inspiration from Caravaggio. They created their naturalistic etchings in the style of genre paintings, with which they gained their independence from the Bolognese School, though more from a technical point of view than thematic.

Caravaggio's work in Naples allowed him to introduce the Roman Baroque style into painting. The architecture of the time also bore the marks of this style, such as the installation of the long nave up to the extraordinary dome in the Church of San Filippo Neri (Gerolomini) by Dionigio di Bartolomeo and Lazzari, realised between 1592 and 1619, and the Palazzo Reale as indicated by Domenico Fontana. In the same way, the impressive paintings of the Lombard artist, who had by then become truly Roman, triggered the development of the new style in art. Besides the above-mentioned Guiseppe Ribera and Salvatore

The Crucifixion of Saint Peter (detail), 1600.
Oil on canvas, 230 x 175 cm.
Cerasi Chapel, Santa Maria del Popolo, Rome.

Rosa, other linked artists are Mattià Preti, known as Il Calabrese, Luca Giordano, Lanfranco, and Monrealese.

Malta

The artistic domination of southern Italy could not have undermined Caravaggio's impact there; it was as though they had been preparing for his arrival. It was at Valletta in Malta that the residence of the Grand Master of the Order of the Knights of Malta appeared to offer him sufficient protection[71]. It can be said with certainty that Caravaggio worked in Malta around 1608, and several pieces bear witness to his stay on the island. Some of his paintings have survived there, works which had an undeniable effect on the final development of his art. The first example is a depiction of *The Beheading of Saint John the Baptist* (p. 155) in the Church of San Giovanni in Valletta[72]. It is a wide picture of significant dimensions, and this genre-like style of painting marked a revolution in the painting of altarpieces. In this case, Caravaggio has completely abandoned the symbolic element of transubstantiation in the background, and has created a scene that is purely genre in content – a final consequence of the tendencies he expressed so blatantly in the paintings for San Luigi dei Francesi. This work is equally important in terms of its majestic style, a style which would become, as we shall see, a distinguishing feature of his final works. The figures in this painting have been placed on the left-hand side, crowded together to leave a large open space on the right. The overall psychological potency of the work provokes an effect which had never before been accepted in Baroque painting. This daring inclusion of empty space into the whole concept compensates for the cruelty of the unmotivated action taking place on the other side in an almost architectonic sense. Caravaggio seems to have employed means that originated from a completely different plane of observation to those he had used previously, which makes the audacity of the work significant. These are the consequences of a Baroque feeling for space, which was continued only by the Spanish School during the 17th century.

This work, *The Beheading of Saint John the Baptist*, is undeniably an astonishing masterpiece. It was executed very quickly, such that the canvas can be seen through the thin undercoats in certain places, and features, as we have seen, a rigorous and admirable composition. The painter succeeded in conferring a realistic aspect on the scene without reducing the dramatic tension of the torture scene (expressed by the old woman who holds her head in her hands). The number

The Conversion of Saint Paul, 1600.
Oil on cypress wood, 237 x 189 cm.
Odescalchi Balbi Collection, Rome.

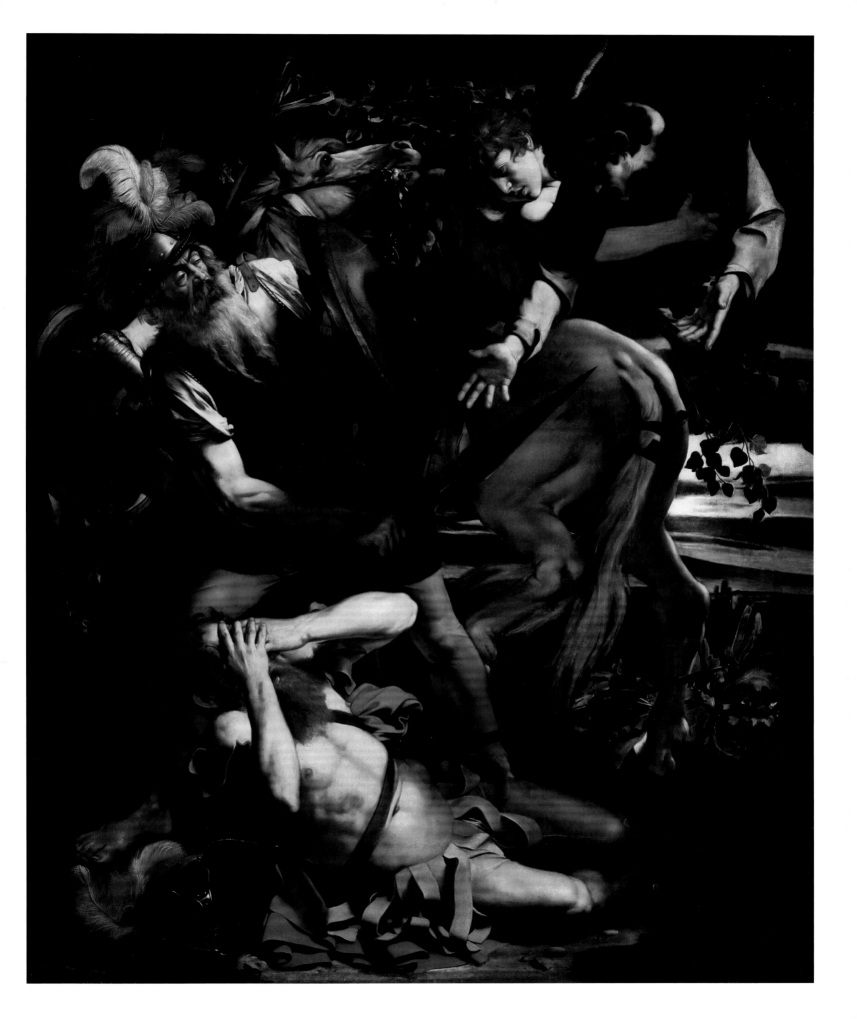

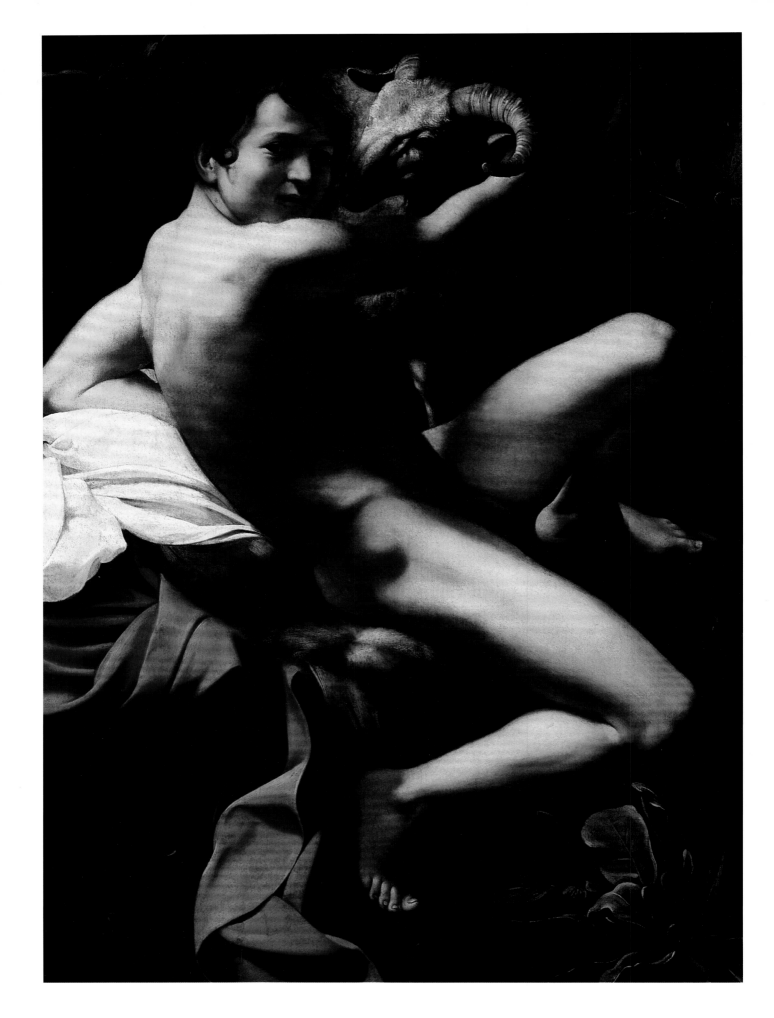

of figures within the painting is limited: five principal protagonists and two prisoners at a slight distance, observing the martyr, though powerless to help. The lines of vision converge on the victim and the torturer in the centre of the composition. We are stupefied by the violence and the unwavering power of the soldier, lit by a ray of light from the left; not content with having severed the saint's neck with his sword, he unsheathes his dagger to complete his horrible task, and doesn't seem able to stop. Contrary to his previous representations, Caravaggio chose to paint the saint with his head forced to the ground and his hands tied behind his back, lying on the ground as he is murdered.

Saint John the Baptist, who baptised Christ, was the patron saint of the Order of the Knights of Malta, so as well as the sacrament of baptism the painting symbolises the sacrifice of the knights who died whilst fighting in the numerous clashes with the Turks. This painting, an impressive work 361 centimetres high and 520 centimetres wide, was placed in the Oratory of the Knights of Malta in St John's Co-Cathedral in Valletta.

In the same church housing Caravaggio's *The Beheading of Saint John the Baptist* there are two more of his paintings, which, although obviously completed by his pupils, clearly demonstrate his style. Above the entrance to the passage that leads to the chapels around the third chapel on the left-hand side of the nave, *Saint Jerome Writing* (pp. 148-149) can be seen on one side, and *The Magdalene*[73] on the other, though the latter may have been lost. *Saint Jerome Writing* can still be found in the cathedral.

The most celebrated testimony to Caravaggio's time in Malta is, of course, his portrait of the Grand Master of the Order of the Knights of Malta, Alof de Wignacourt, which is one of the artist's most famous masterpieces, and one that highlights his mastery of the art of portraiture. The motif of a representative portrait of a full-length figure seems here to be the expression of an important spontaneous solution, whose effect can be seen right up until Le Brun's state portraits. Caravaggio's work here reached its climax. The painting, now in the great gallery in the Louvre, should perhaps be hung somewhere else; only as an enhancing centrepiece within representational surroundings can the work be correctly seen. Only in that way can the imposing dignity of the subject and the spatial development into the deep half-light truly be felt. Whereas Titian's portrait figures appear as if sunk into an unconscious dream world, this portrait by Caravaggio expresses his desire to concentrate on the grandness of the main figure. Where otherwise an impish allegorical *putto* would play games with the

Saint John the Baptist, 1602.
Oil on canvas, 132 x 97 cm.
Museo Capitolini, Rome.

attributes of the person portrayed, in Caravaggio's painting is a true symbol of what the Grand Master would have wished; a young page can seen, carrying his master's helmet in true Caravaggian fashion. It is this page who lends an interesting note to the piece as far as colouring is concerned. The powerful brick-red of his doublet effectively relieves the reserved half-tones of the rest of the scene. The Spanish School knew how to learn from such occasional subtleties from the master. Coello above all liked to use this nuance in a range of red hues and made them the main colouring in paintings such as *Saint Catherine of Alexandria* (p. 32). Caravaggio, an outstanding portrait painter himself, demonstrated explicitly the typically honest character of his art in the *Portrait of Alof de Wignacourt* (p. 151). All his portraits were based on detailed and carefully thought out studies from life, and though they demonstrate tendencies that are the polar opposites of those of Carracci, Caravaggio succeeded in this portrait of the Grand Master in symbolising one of the most fundamental principles of his art: seeing the true appearance of the life model. In an artistic sense this is inherently unbearable, but is compensated for by the magic of his colours and the distinct attraction of his lighting, which, as in all his paintings, also distinguishes this work of art. It is the austerity with which he distributes those decided conditions, which guarantees this symbolisation a particular aesthetic aspect, and the hidden charm gradually reveals itself. In the clear meaning of every line and of each modelled form, Caravaggio's stylistic secret is revealed in an almost perfect way, and in such a form that the artist's talent and touch come together in remarkable harmony.

Contrary to his other paintings, in *The Beheading of Saint John the Baptist*, a work with a rigorous and original composition, the painter signs this work "Fra Michelangelo" with the Saint's blood. This is the only work signed by the artist's hand. It seems that with the term "Fra", the painter wanted to indicate that he had been granted a Knighthood of the Order of Malta, which was what he had always wished for. At this period in Caravaggio's life, exiled and condemned for the crime he had committed in Rome against Tomassoni, but having found protection and refuge in the Order of Malta, he waited patiently to return to Rome when pardoned by the Pope. This signature, written with the blood of the saint, seems to reflect the repentance and the aspiration of the painter to his salvation. It can also be interpreted as the affirmation of his notoriety as a painter because the paintings undertaken in Malta were very favourably received. Despite the protection and gratitude he was benefiting from, he was imprisoned once again apparently for having "seduced" the son of a high dignitary. He escaped, however, thanks to help from influential friends.

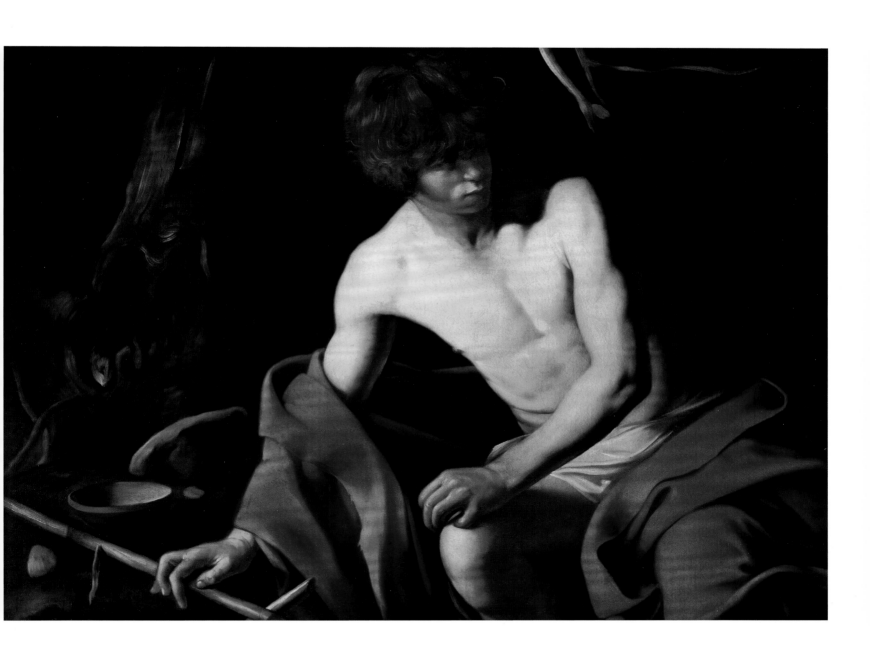

Saint John the Baptist, 1606.
Oil on canvas, 16.5 x 23 cm.
Museo e Galleria Borghese, Rome.

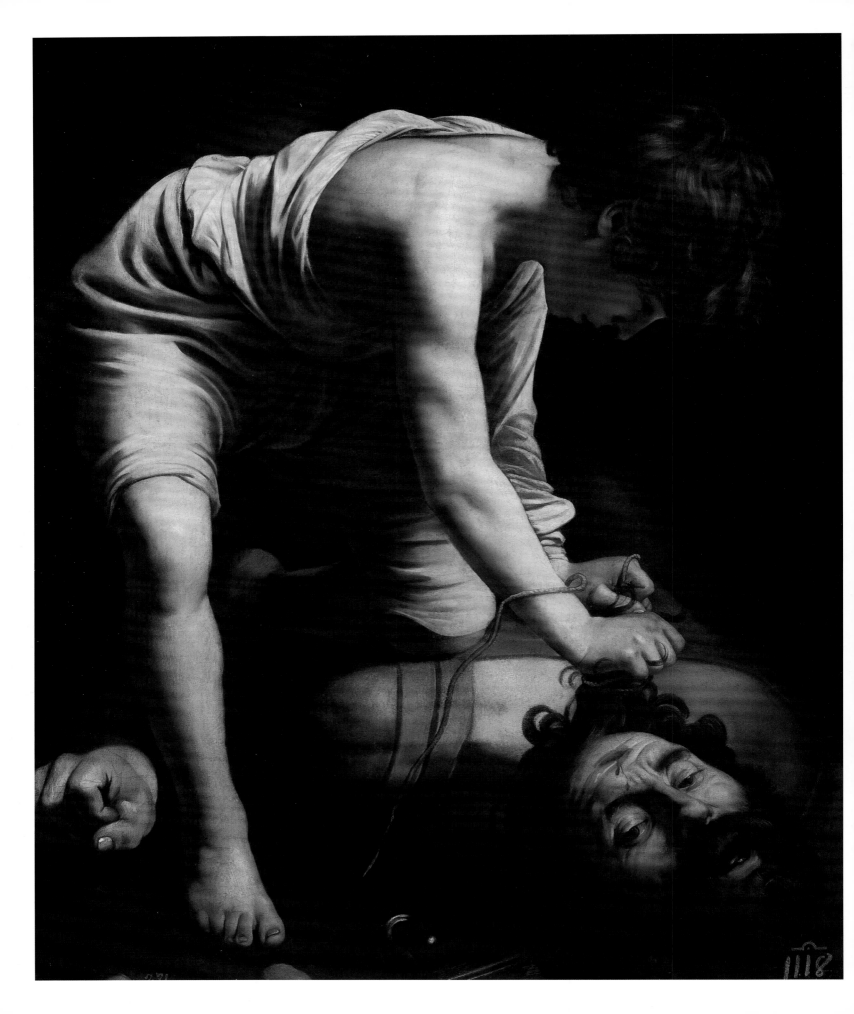

The Face as the Reflection of the Soul

The narrative portrait of Caravaggio outlined by his contemporaries, and documented by early biographers such as Bellori, Mancini, and Baglione, is stained with the pejorative impression left by his strange or criminal acts.

The pen-portraits outlined by the biographers of the time were based upon Caravaggio's sulphurous reputation and upon a primitive science which originated from the time of Catilina or Tigrin della Sassetta, whose principle was that a bad soul was reflected in the face ("*faccia ed anima cattiva*"). This so-called science claimed that it was possible to find indications as to the character of a person by observing their face and to discover, in the facial appearance of villains, the mark of the wrongdoings they had perpetrated.

The historian Philippe Baldinucci affirmed that Michelangelo de Caravaggio, "since he was a person of chaotic spirit, was therefore a man with a rough and ugly appearance". Giovanni Pietro Bellori, who wrote around fifty years after the death of the painter (the first edition of *Vite di Pittori, Scultori e Architecti moderni* dates from 1672), attributed to Caravaggio "a dull complexion, dark eyes, black eyebrows and hair," and added naively that "he nevertheless succeeded thanks to his natural gift for painting". The author mentions a medallion representing a "natural" portrait on which Caravaggio is portrayed with a thick and bushy, furrowed brow, and an almost ferocious look in his eyes. His nose is long, three-lobed, and flattened, his eyelids and lips are thick, and his cheeks bony. His right hand holds with vigour a common weapon rather than the refined one of a Knight of Malta. This description perhaps followed the same prejudices that inspired the comments of the portrait placed officially in the Academy of San Luca and considered an authentic self-portrait of Caravaggio. The artist appears as a suspect person with a lean face and a pale complexion almost entirely in shade, with disturbing crossed eyes, a hand resting on the hilt of his sword, the other plunging in his pocket in a rather vulgar way.

Amongst the numerous other portraits influenced by these types of prejudices, one must cite the caricature attributed to Carracci, the *Sinister Villain*, where Caravaggio

David and Goliath, c. 1599.
Oil on canvas, 110.4 x 91.3 cm.
Museo Nacional del Prado, Madrid.

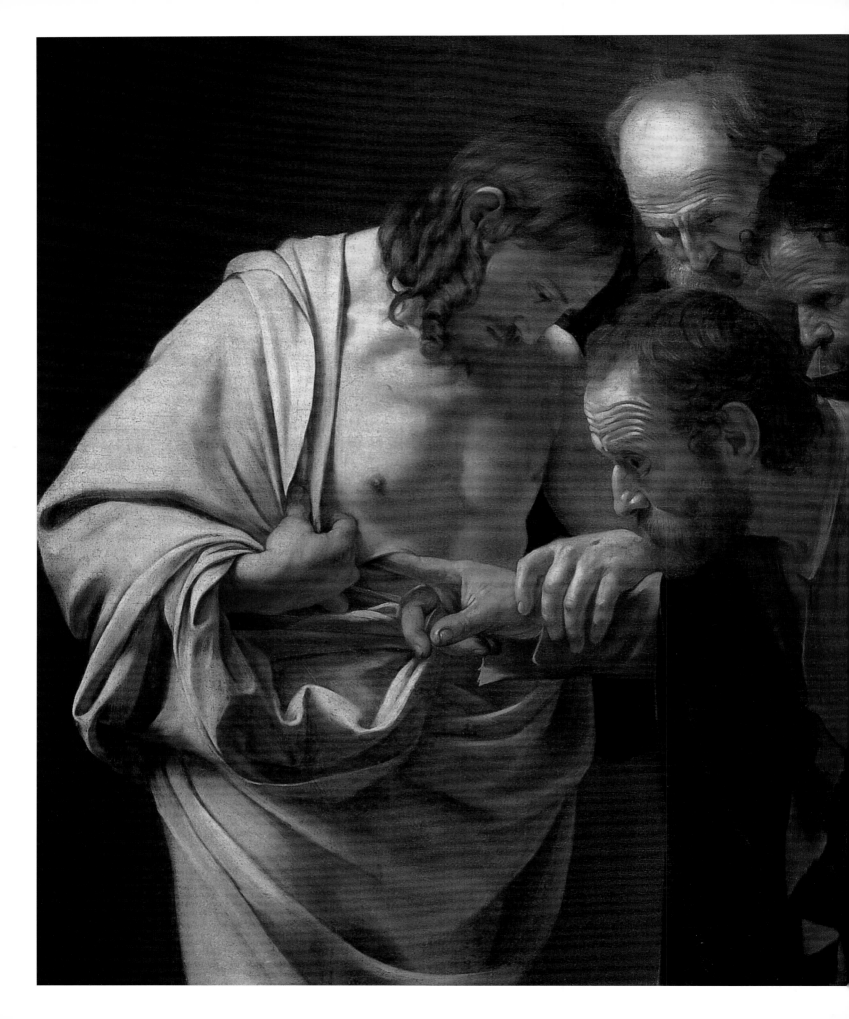

The Incredulity of Saint Thomas,
1601-1602.
Oil on canvas, 107 x 146 cm.
Die Bildergalerie im Park Sanssouci,
Potsdam.

is represented devouring vegetables inside a tavern lit by a tiny opening. If we concentrate solely on the few writings left by the artist, he seems to have amused himself by incorporating several self-portraits into some of his paintings, as was common practice at the time. There seem to be three authentic portraits of Caravaggio: the first shows him in his youth and is signed with the following note: "From Caravaggio, his poor painter who gave Sansovino his portrait as you see him for a couple of chickens".

The second portrait is a detail of *David with the Head of Goliath* (p. 170) where the artist has represented himself as the giant in the centre of the painting. His presence in the background of *The Martyrdom of Saint Matthew* (p. 57), which is believed to have been painted during the most sombre period of the artist's brief life, constitutes the third portrait of the painter.

In all three portraits the forehead is large and straight, the nose wide and regular, the eye sockets of normal size and inclination, the hair, like the eyebrows and the irises, a dark chestnut brown, the outline of the lips well marked. His teeth are normal without the double diastema (the space between the incisors) that one can see in the half-open mouth of Goliath. No sign of asymmetry is perceptible, and the skull and the forehead are harmoniously proportioned. In conclusion, his physiognomy is more that of an intellectual than that of a criminal.

The facial appearance of the artist may also be seen in other works. Indeed, he may be one of the players in *The Morra Players* (the furthest on the left) in the Galleria del Accademia in Venice. His regular profile appears as the character of the young traveller in *The Seven Works of Mercy* (p. 136) in Naples. Moreover, no one could contest the close resemblance of the guitar player in the paintings *The Musicians* (p. 20) or *The Concert*, where his well-modelled and distinguished hands are plucking the strings of the instrument. Only the very intense red of the face contrasts with Caravaggio's brown complexion.

In the famous painting *Sick Bacchus* (p. 9), considered a self-portrait by most art historians, one can see the signs of the disease from which Caravaggio was suffering. The "sinister" appearance of the artist, interpreted as the reflection of his perverse soul, was perhaps only the earthy complexion of a person whose blood was infected, that of a victim of malaria and its relapses.

Certain critics believe that the illnesses from which he suffered in his youth may have had a significant influence on his destiny. Handicapped after falling from a horse, he

The Conversion of Saint Paul, 1600. Oil on canvas, 230 x 175 cm. Cerasi Chapel, Santa Maria del Popolo, Rome.

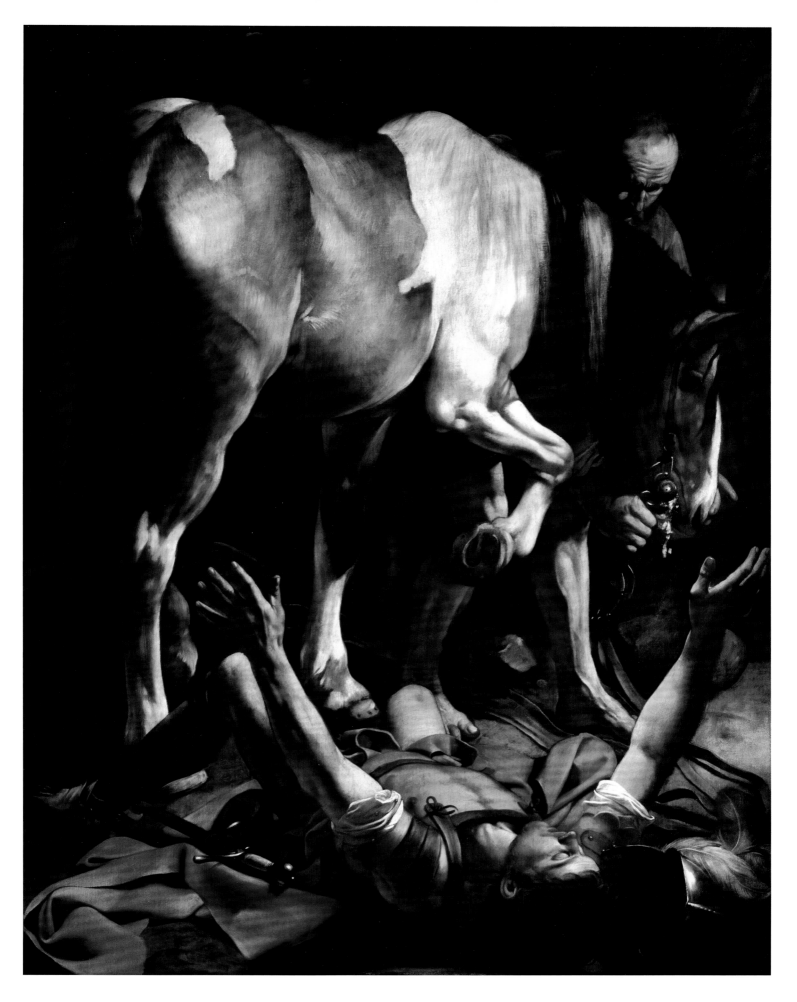

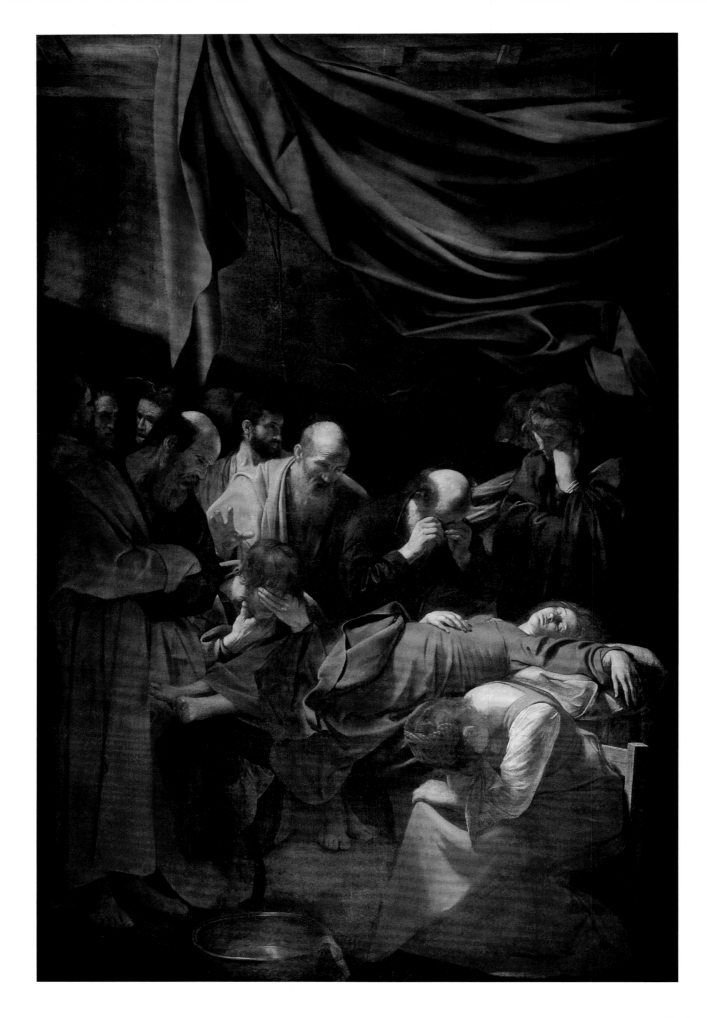

found sanctuary in the hospital of Santa Maria della Consolazione where he had to endure long treatment in order to be cured. He is said to have done many paintings for the Prior of the hospital during this long convalescence. It has been claimed that this "illness" also influenced his artistic destiny. He may also have suffered from what was known as "Roman fever", repeated and exhausting bouts of fever. Certain writings explain that when still an invalid, he was so weak while listening to the verdict in Onorio Longhi's trial with the painter Marco Tullio, that a boy had to carry his sword for him as he was incapable of holding it himself. Some historians also see in his sudden bursts of exaltation and exhaustion the repeated assaults of periodical fever due to malaria. One must note that following relapses, episodes of extravagant behaviour were more numerous and more and more frequent. His taciturn expression and the dark complexion which strike the viewer in his self-portraits are also the signs of poor health, and reinforce the hypothesis that the painter may have suffered from a chronic and debilitating disease of which the last bout may have provoked his early death without any visible exterior cause.

At the beginning of the 20th century some historians even tried to establish a link – more than questionable – between malaria and genius, even suggesting that Caravaggio's misdemeanours after 1599 may have become worse because of the recurrence of this "malignant fever".

Lionello Spada, a friend of Caravaggio and an exceptional intellectual in the artistic world of the time who modelled several times for the painter, may have participated in the writing of the verse pamphlet against Baglione. Spada, interested in scientific subjects, conceived machines to explore the bottom of the sea or to hear the human voice at a far distance, and wanted to create a telescope where one could look through an opaque screen. He would have said of his friend, this painter whose company he sought and whose development he followed with such affection, that he was "too hasty, respecting no rule, neither in painting, in his working methods, nor in his personal life."

Indeed, if one carefully observes his daily behaviour, one can easily imagine the painter's impulsive character: his escapades as a teenager in Milan and his permanent vagrancy, only partly explained by his artistic pilgrimage and the necessity of avoiding prison. His frequent changes of residence in Rome, the protection constantly sought and obtained from the prelates of Rome, his numerous bursts of anger, his threatening insults, throwing bricks and stones, and beating people with his stick, his fists or his sword are facts that reveal an unstable personality, unable to master the impulses of passion. Moreover, these irrepressible and more or less

The Death of the Virgin, 1601-1605/1606. Oil on canvas, 369 x 245 cm. Musée du Louvre, Paris.

unplanned acts contrast with the nonchalant indifference shown by Caravaggio for the small but indispensable daily tasks. He neglected washing, never changed his clothes, wearing luxurious outfits until they fell to bits, completely worn out. Morning and evening he took his meals on an old painted canvas that he used as a tablecloth and never changed.

Despite this tumultuous life that left him little time and availability, it is striking to observe the importance of the work he left, both in the number of paintings made in such a short period of time and the creativity and innovation he showed which went on to inspire a number of painters. His friend Lionello Spada, and Bellori too, attest to the *fierezza* or vehemence and virtuosity of the touch used by the painter in some paintings, such as *The Beheading of Saint John the Baptist* (p. 155), sometimes leaving the primer visible, as we can still see in the *Burial of Saint Lucy* (p. 146) for example. The constant changes of environment, forced or desired by the painter, may have influenced his exceptional ability in experimenting and renewing his art and his rapidity of execution, in particular for the paintings undertaken during his years of exile between 1606 and 1610, as if the painter, sensing his coming end, had begun painting in a kind of urgency. His years of exile certainly allowed him to work in a more liberal environment than that of Rome and the Papal States and therefore to enjoy the freedom of expression that made his success and his originality.

Contrary to Buonaorotti, Raphael, or Carracci, Michelangelo Merisi, who had, above all, such a gift for fantasy and creativity that made him constantly strive for renewal and change, did not receive commissions or did not want to undertake monumental works or frescos that required perseverance and consistency.

However, despite his antisocial personality, Caravaggio had a genuine compassion for mankind and managed to express his empathy for his fellow human beings confronted with hunger, thirst, cold, or the torments of old age, prison, and death in his work. Some of his detractors have seen in the scenes of martyrdom or beheading undertaken by Caravaggio the expression of a violent man indulging in painting bloody deeds, but this would mean disregarding the normal level of violence that occurred in Rome at the beginning of the 17th century. Indeed, during this period, Pope Clement VIII refused to pardon Beatrice Cenci who, accused of murdering her father, was finally publicly executed in 1599. The following year, Giordano Bruno was also executed in Rome. These years precisely correspond to the period during which the painter worked for Cardinal Del Monte, who welcomed Roman politicians and international representatives from the scientific and intellectual worlds and who

Saint Matthew and the Angel, 1602. Oil on canvas, 292 x 186 cm. Cerasi Chapel, Santa Maria del Popolo, Rome.

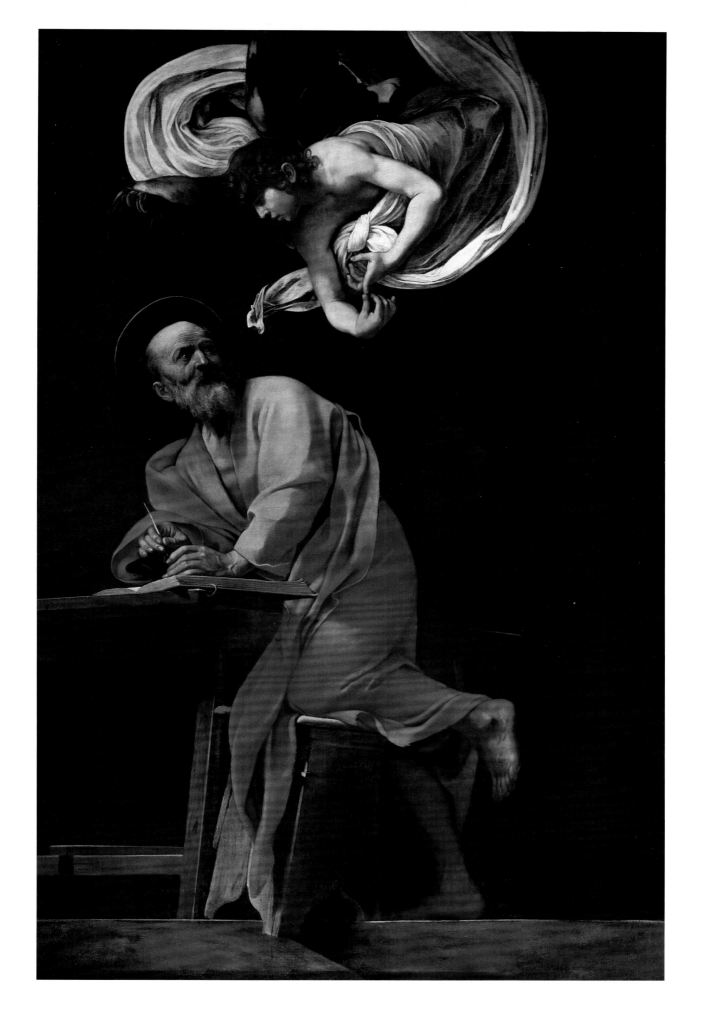

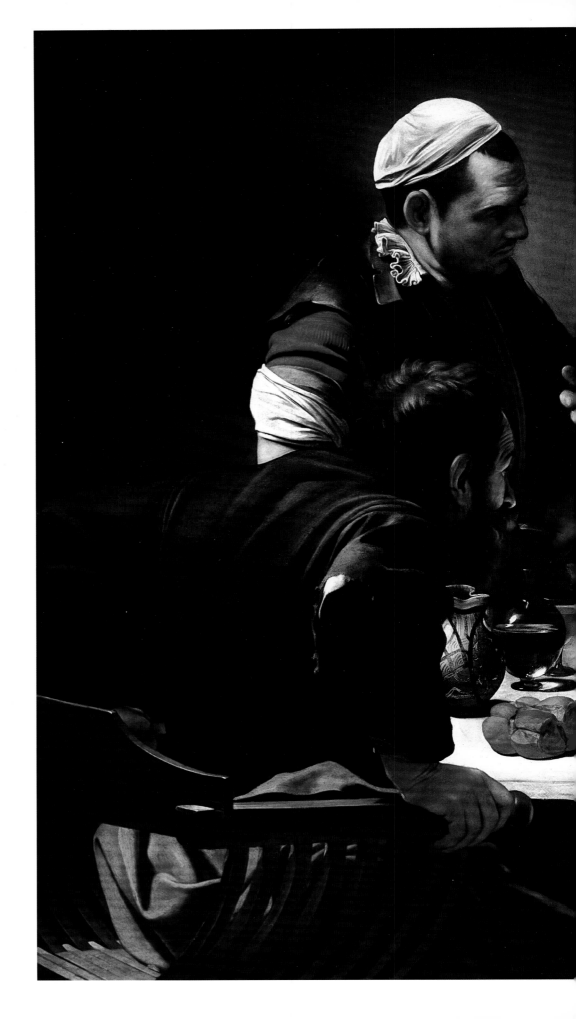

Supper at Emmaus, 1601.
Oil and tempera on canvas,
141 x 196.2 cm.
The National Gallery, London.

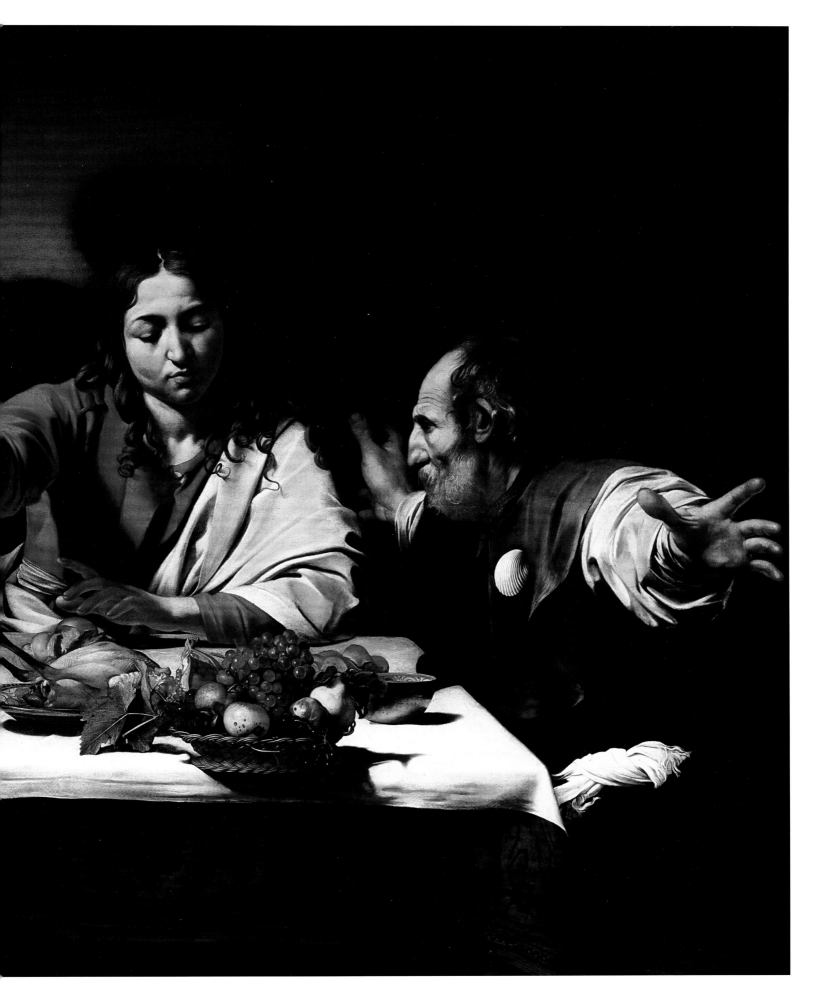

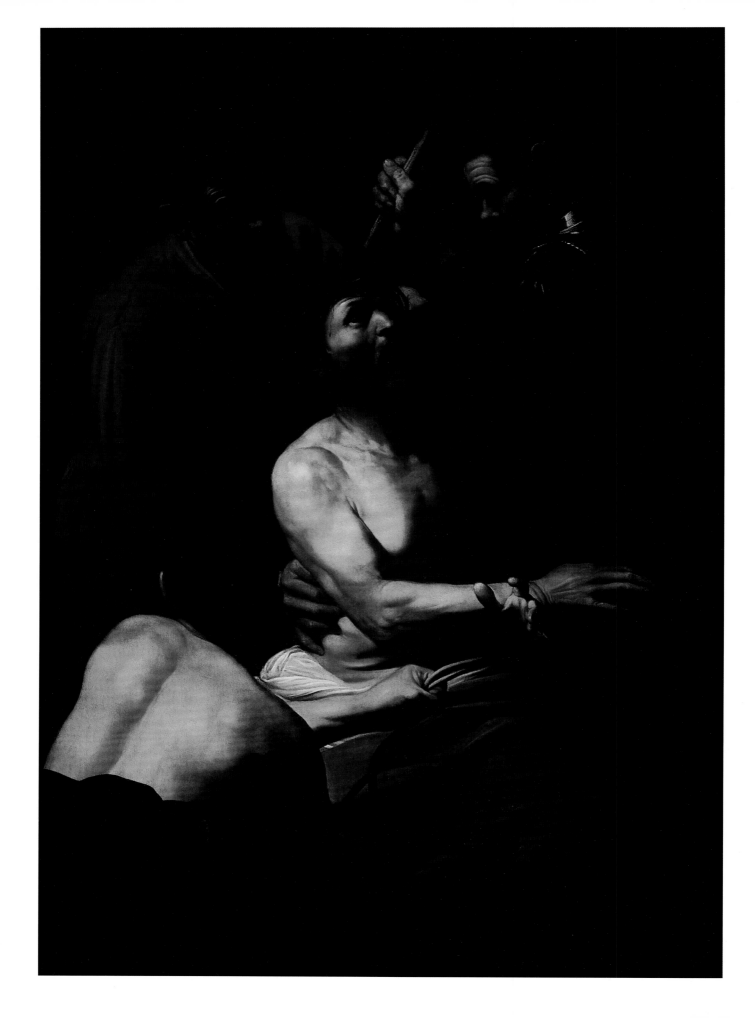

spread ideas and points of view different to the 'official' ones of the Church. The alternative hypothesis that suggests that the painter, as a witness of his time, would have tried to denounce the violence that reigned in Rome at that time by highlighting the bloody character of certain scenes of beheading or martyrdom cannot, therefore, be brushed aside.

Attentive to the tragedies experienced by mankind, he was also, as a sensitive dramatist, keen to express the human condition on earth by addressing universal themes such as love, pain, pleasure, and death. With a melancholic eloquence he undeniably succeeded in representing the human condition. Commissioned by the institution of Pio Monte della Misericordia, the painting entitled *The Seven Works of Mercy* (p. 136) evokes the acts of mercy that were practised by the community of Pio Monte, dedicated to helping the hungry, the thirsty, the immigrants, the poor, the sick, the prisoners and, finally, the dead. This work is very representative of the painter's wish to paint the life of human beings in its usual sarcastic irony with realism. He chose to paint characters from the lower classes of society, insisting on the necessity for the common people to help each other. Regarding composition, the painter achieved true technical prowess by gathering many characters carrying out seven different actions at the same time, on the same canvas, giving the whole group a vast feeling of movement.

To represent feelings, rather than using slight expressions of the face, Caravaggio preferred using the wrinkles that mark the faces of elders, like the stigmata of an exhausting life. He knew how to represent the heavy burden that pain inflicts on mankind. He did not ignore anything regarding those foreheads marked by discouragement, those stooped or prostrate bodies, those falling arms and the mouths that let deep sighs of anguish and desperate screams slip. By working so deeply on the hands and attitudes of his characters, he managed to represent and communicate to the viewer, like no other artist before him, the pictorial representations of human suffering. It would indeed be interesting to make an alphabetical list of the pains of the soul used by Caravaggio in his work. The language of mankind's suffering, reproduced with such fidelity by the painter, can only be the expression of a profound feeling for the human condition, of which he became the universal witness.

When representing sacrificial or beheading scenes he did not skimp on detail, stressing the dramatic atmosphere and not hesitating to represent severed heads and gushing blood in the foreground (*Judith Beheading Holofernes*, p. 36; *David and Goliath, p. 74*). A veil of pain also enshrouds the representations of the severed

The Crowning with Thorns,
1602-1603.
Oil on canvas, 178 x 125 cm.
Cassa di Risparmio di Prato, Prato.

heads and the blood running from them in which the painter seemed to indulge. To depict the palpable pain and terror, he multiplies the wrinkles of the old woman who holds her face in her hands (*The Beheading of Saint John the Baptist*, p. 155), or accentuates the gestures of the characters (*The Tooth Puller*, p. 183). In the same way, the face of David brandishing the severed head of Goliath, found in the Borghese Gallery in Rome, is not that of a vanquisher at the height of his pride, but an almost melancholic face, touched with a kind of humility, accentuated even more by the shade that half covers it. Caravaggio seems to have chosen a method of representation comparable to that of his master Giorgione, who painted his David as a young man racked by unexpected and paradoxical emotions. A shade of melancholy clouds some of his paintings, notably *David with the Head of Goliath* (p. 170), in which David brandishes the severed head, and *David and Goliath* (p. 74) in which the young man looks, indifferent, at Goliath's colossal face fallen to the ground like the capital of some impressive building.

Contemplating his bloody deed, Caravaggio's David seems troubled and his face shows compassion and melancholy. Caravaggio stresses David's human qualities as revealed in the Bible: humanity, humility, sensitivity, love, and virtue; and he portrays himself as Goliath, a symbol of evil. Did he want to testify to his own secret humility or was he seeking indulgence and understanding from us for the wrongdoings he may have committed? The psychological ambivalence and the confusion of feelings that assail David remind us, too, of the conflicting sentiments felt by Judith after she had beheaded Holofernes. Indeed, in the painting undertaken in Rome ten years earlier, entitled *Judith Beheading Holofernes*, he gave Judith the stature of a tragic heroine. The perfection achieved in the expression of the ambivalence and complexity of the protagonists' feelings and in the detachment of his characters when confronted with reality and with existential questioning, is the mark of an artist with heightened sensitivity and not that of a "criminal painter", as some biographers have dared describe him. Choosing this interpretation would mean indulging in a far too superficial reading of his work. The painting *Boy Bitten by a Lizard* (p. 13) is the perfect illustration of the various levels of interpretation offered to us by the painter: that of a poetic representation of the grace of youth and its ephemeral character – represented by the fruit; the passage from innocence to adulthood, and its disenchantments – symbolised by the shock of being bitten by the lizard hidden among the fruit; the inevitability of ageing – suggested by the fresh red cherries next to grey and decaying ones. The confusion that may have been felt about the bloodthirsty character of some of his paintings can be qualified as allegorical, whilst the crimes committed by the painter, which were never premeditated, have largely contributed to his poor

Amor Victorious, 1602-1603.
Oil on canvas, 156 x 113 cm.
Gemäldegalerie, Berlin.

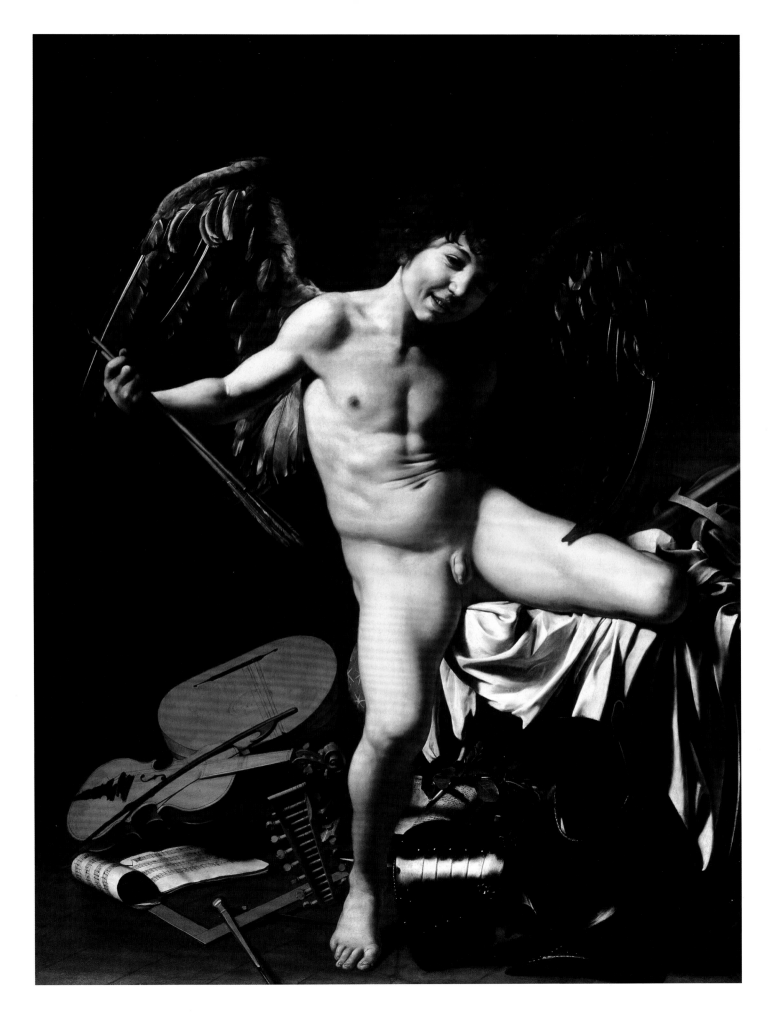

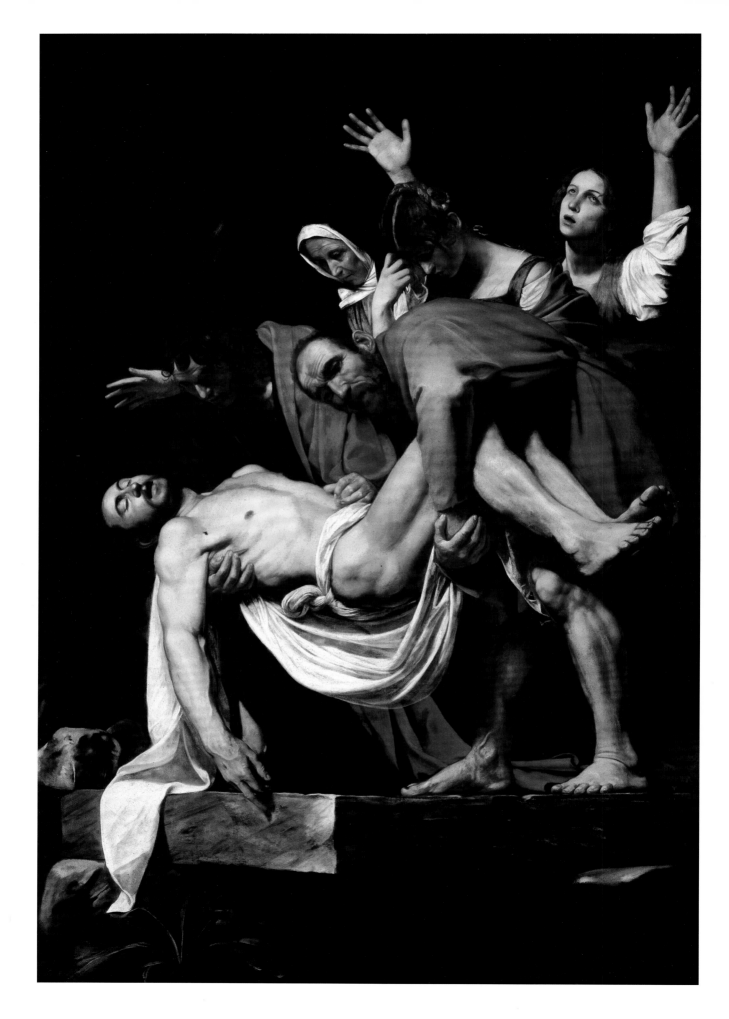

reputation. Between 1605 and 1606 he committed several misdemeanours within the space of a few months, some of which he denied involvement. Detractors from his work, in particular its subversive character, found in the unlawful and tormented life of the painter, a hotbed for the fabrication of a rough blend between Michelangelo Merisi's life and work. This situation can be explained by the difficulty in establishing a distinction between the personality of an offender, hot-tempered and passionate, and an emotional and choleric personality. Observed from another point of view, the biography of the painter can now appear to his beholders as more captivating and more revealing of his temperament and his commitment. It is up to us, with the knowledge acquired in the areas of psychiatry and psychology and of what drives artistic creation, to detail the "sad psychological depiction" made of him by his contemporaries. Therefore the frequency of his offences, of which he was the incorrigible delinquent hero, may show the pathological character of the painter's reactions when confronted with reality and the incomprehension of his contemporaries whom he could not bear and who made him suffer. The history of art has told us, as seen in major artists such as Van Gogh or Camille Claudel who suffered from a mental disturbance, that medicine was unable to cure them and that ultimately delayed the recognition of their creative genius.

If Caravaggio was indeed a "disreputable offender", how can one explain why he was so well received by enlightened personalities such as Cardinal Del Monte and Alof de Wignacourt, Grand Master of the Order of Malta? How can one understand the loyal friendship offered to him by painters such as Prospero Orsi, Cesari (the Cavalier d'Arpino) and Mario Minniti? In his legal statement during his trial against Baglione, Caravaggio began thus: "I am a painter. I think I know almost all the painters in Rome and to name the good artists first, I know Giuseppe, Carracci, Zuccari, Pomarancio, Gentileschi, Prospero, Giovanni Andrea, Giovanni Baglione, Gismondo, and Giorgio the German, Tempesta and many others." What about the architect Onorio Longhi? How can one explain why the works that made Caravaggio the most renowned painter in Rome were commissioned by prelates and high dignitaries such as Contarelli and Cesari? Why, when he was accused of a reprehensible act, did he immediately receive the protection and indulgence of princes, ambassadors, and cardinals who interceded on his behalf to the Pope?

Rather than question the links between the ardour of his temperament, his insanity, and his creative genius, it may be better to discover the foundations, the precursory signs and first manifestations of his genius and the originality of his work.

The Entombment, c. 1600-1604.
Oil on canvas, 300 x 203 cm.
Pinacoteca, Musei Vaticani, Vatican.

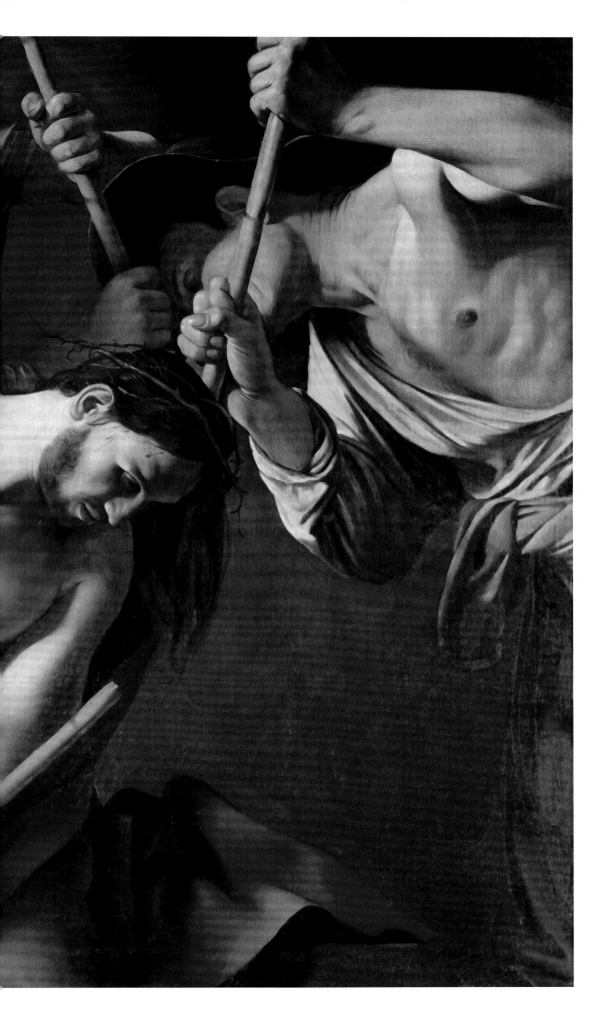

The Crowning with Thorns,
1602-1604.
Oil on canvas, 127 x 166 cm.
Kunsthistorisches Museum, Vienna.

THE BIRTH OF A STYLE

The Painter of Pleasures and Taboos

Caravaggio, as a painter of sensuality, was equally as talented in evoking the pleasures of the table. The people in his paintings are frequently eating and drinking, and even when he doesn't explicitly depict food and drink, he discreetly adds a dish or culinary accessory. The events of the painter's life which have interested historians are littered with allusions to his resentment towards the meagre meals offered to him by his hosts, to his anger at an innkeeper concerning the seasoning of artichokes, or to the brawls in which he was involved in various taverns of Rome and Naples. In the famous painting *Rest on the Flight into Egypt* (pp. 28-29), he places a large bottle of wine next to the figure of Saint Joseph. There are also the bunches of grapes in the painting of *Bacchus* (p. 25) and the self-portrait as *Sick Bacchus*, or *Bacchus with Grapes* (p. 9), and the fruit in *Boy Peeling a Fruit* (p. 14), *Boy Bitten by a Lizard* (p. 13), *Boy with a Basket of Fruit* (p. 10), and *Basket of Fruit* (p. 26) in the Ambrosiana Gallery. In *The Lute Player* (p. 61), in St Petersburg, the pears, figs, and fennel are combined with daisies, lilies, and jasmine. All the gifts of God are present on the table of the hedonist Bacchus and of *The Musicians* (p. 20) who invite the spectator to taste the pleasures of earth and in particular the pleasures provided by music. It is difficult to describe the second version of *Supper at Emmaus* (pp. 174-175) as spiritual or mystical. This is not because the grapes are out of season, nor because of the sumptuous roast on the table or the appetising *pâté en croûte*, but because the faces of the innkeeper and the waitress in the composition are equally as important as that of Christ.

Victual platters and flasks are often present, even in the tragic scene of *The Crucifixion of Saint Peter* (p. 65) in which the executioners have the right to eat

Pilgrims' Madonna or *Madonna di Loreto*, 1603-1605.
Oil on canvas, 260 x 150 cm.
Basilica di Sant'Agostino, Rome.

before and after having carried out their difficult deed. What an opportunity for Caravaggio when he illustrated the divine words "relieving the thirsty" in *The Seven Works of Mercy* (p. 136). He dedicated himself with evident pleasure to imagining this caricature of a rapacious drinker.

Where certain agreeable painters found their satisfaction in painting, like a pseudonym, vegetable or animal poetic emblems (notably the ducklings of Marco Palmezzano, the sparrows of Passerotti, and the carnations of Benvenuto Ferrarese) Caravaggio preferred the accessories of the cook and the wine merchant, using the bowl or the flask as a signature. The verbascum, or mullein, bushes are both distinguishing features of the painter's work (see *Rest on the Flight into Egypt*, pp. 28-29, *Saint John the Baptist*, p. 103, and *The Entombment*, p. 90). It is not surprising that Caravaggio had a penchant for them since they reminded him of cabbage or lettuce.

His famous *Bacchus*, far from being a conventional representation of a pagan god, is an androgynous and rounded figure with a radiant complexion who, leaning on a day bed, holds out a cup of wine towards the viewer and invites him to enjoy the terrestrial pleasures. The mastery of still life he shows in painting the transparency of the glass, the reflections on the carafe, the basket of fruit, the fig-leaves in his hair and the draped movements of the toga, the mastery of the naked figure illustrated in the god's luminous complexion, the redness of his cheeks and hand, the sensuality of his gestures, and his lascivious attitude, all render homage to Hedonism and reach their climax here, demonstrating why this painting is one of Caravaggio's most famous works. It seduces any viewer contemplating it, so that under the charm of the natural and bewitching sensuality of the pagan god, the viewer is willing to follow him and be swept away by joyful bacchanals.

There is also another pleasure that features significantly in Caravaggio's works: gaming. Games and gambling played a very specific part in his paintings. He created several paintings on this theme in which one can see groups of players with cards, chess, or dice. One of the first altarpieces he made, *The Calling of Saint Matthew* (p. 53), caused a stir in Rome because the five characters were seated at a gaming table. One of them, seeing Jesus entering the room to announce his mission to Matthew, seems to take back the coins he has just won as if he had seen a thief coming in. In the *Denial of Saint Peter*, three soldiers deeply absorbed in a dice game divert the attention of the viewer from the eloquent face of the old man (the principal figure in the painting), which is very characteristic of Caravaggio's work. To this series is added the famous painting *The Cardsharps*

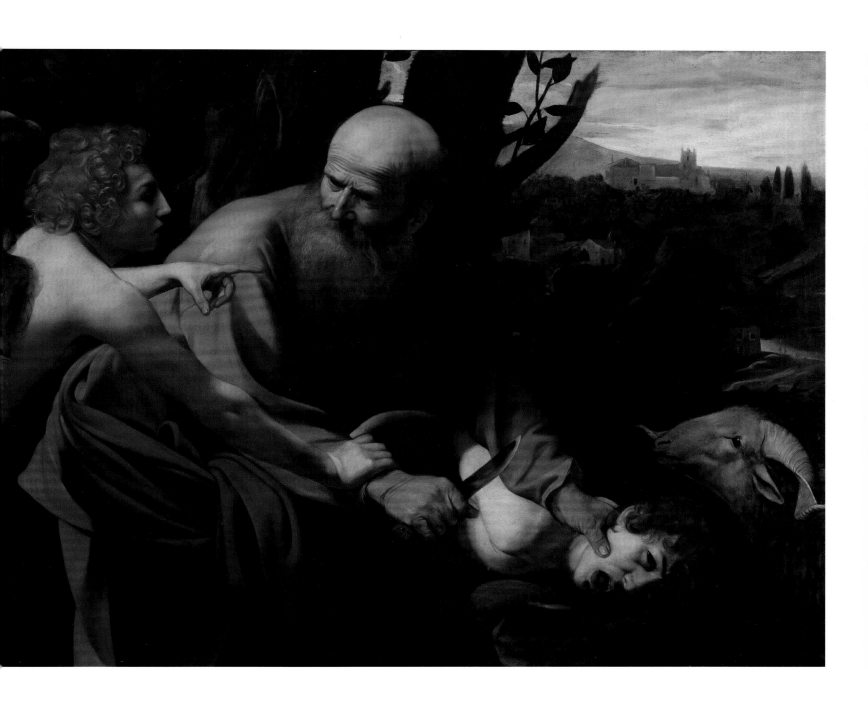

The Sacrifice of Isaac, 1601-1602.
Oil on canvas, 104 x 135 cm.
Galleria degli Uffizi, Florence.

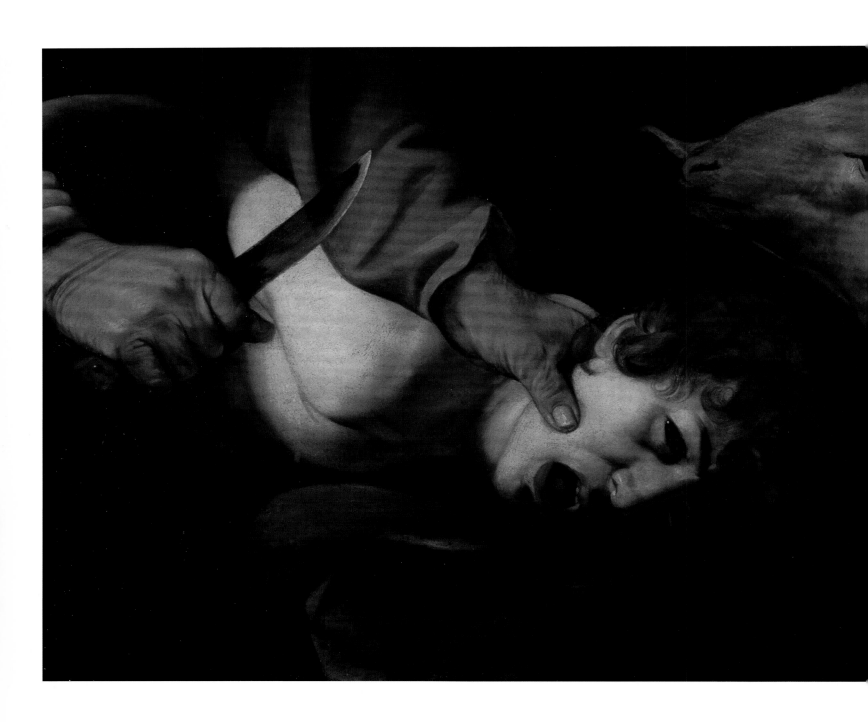

The Sacrifice of Isaac (detail),
1601-1602.
Oil on canvas, 104 x 135 cm.
Galleria degli Uffizi, Florence.

(pp. 18-19). The theories developed by the painter on realism are not sufficient to explain why so many gamblers frequented his studio and only his marked taste for gaming can explain the presence of these gamblers in his work. Caravaggio had a passion for gambling and often practised it like so many of his models. The heroes of spades and clubs seemed to him worthy of the kingdom of beauty, not because of his revolutionary ideas about art, but more because of his fascination with gamblers. Respect for the rules in gaming was of prime importance for the painter. Caravaggio thought that, morally, cheating was the most reprehensible wrongdoing of all. Stabbing an enemy in the back, insulting someone, attacking weak and defenceless women, or stealing a fellow's purse were venial faults according to him. But cheating at cards or betraying the solidarity with a companion in a bar was the height of cowardice and abjection. In his work, he treated fraudulent players with contempt, giving them unpleasant expressions from which one can read the severe and reproving judgement of the painter. The disagreeable faces of the cheat and his accomplice are therefore meant to inspire fear and distaste. On the other hand, the faces of honest players are like those of angels. Caravaggio himself may have incurred losses in gaming and among all the forms of revenge he used (he was not the kind to spare the offender), only the noblest and least terrible has remained.

Likewise, he surely appreciated literature, otherwise how could he have written poems and been friends with Cavalier Marino, even if he had a certain aversion for Classicism and distrusted the Muses and the Parnassus? But music was certainly the art form he most appreciated after painting and it inspired him, as soon as he arrived at the home of the great music lover Cardinal Del Monte, to produce several works on the theme of music. The paintings he created on this subject convey a sense of harmony, joy, pleasure, and serenity, sometimes melancholy, and combine the figures of young musicians placed in a realistic setting where the evocations of the ephemeral pleasures of terrestrial life abound (depicted with flowers, fruit, vegetables, and wine) and in which resonate the echoes of the pleasure provided by music (*The Musicians*). His work must be placed in its historical and cultural context to understand why Caravaggio asked young men to model for paintings with music for their theme. Indeed, in the Baroque era, women were excluded from public performances. In church, priests asked young musicians, often trained by them, and young castrati to perform the vocal parts in their repertoires, like the famous castrati of the Sistine Chapel. The privileged place that music held in Caravaggio's life and in his work also deserves to be highlighted. Many of the singers and musicians give life to his paintings, even when they are not the main subjects. Paintings such as the *Guitar Player*, *The Lute*

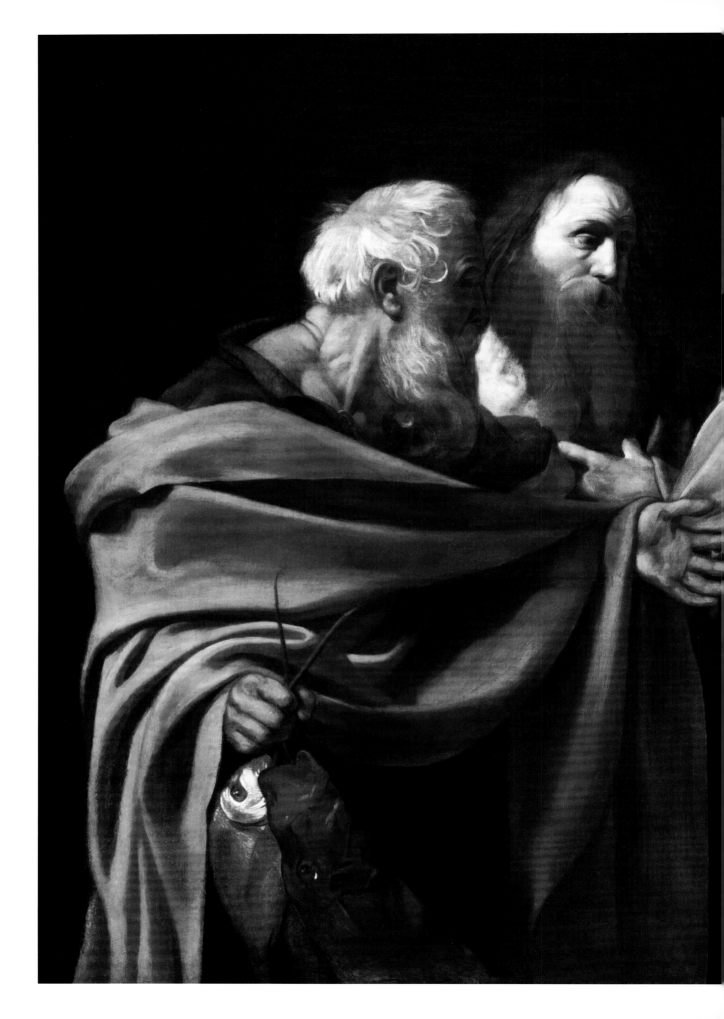

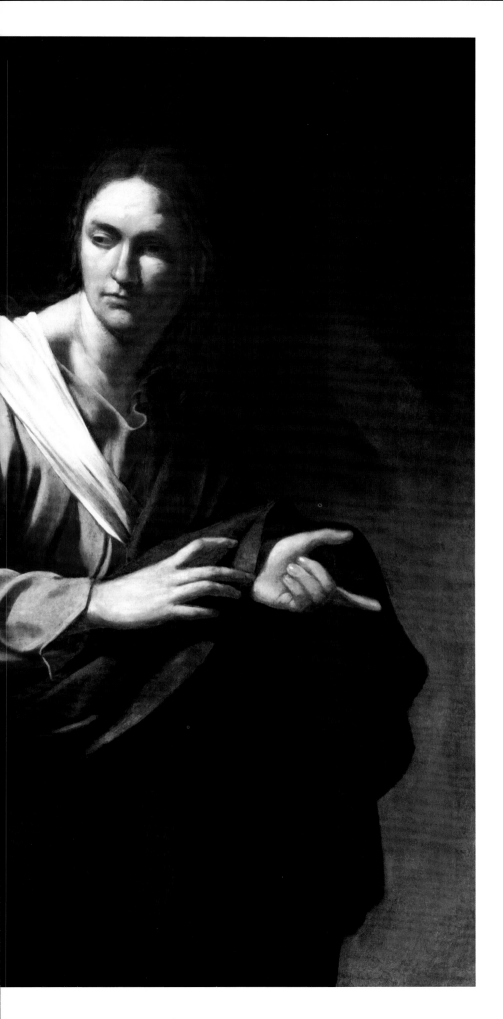

The Calling of Saint Peter and Saint Andrew, c. 1602-1604.
Oil on canvas, 140 x 176 cm.
The Royal Collection, London.

Player, the ecstatic *Saint Cecilia*, *The Musicians*, and *Amor Victorious* (p. 89), in which orchestral instruments are included, are more than just virtuoso portraits or fortuitous series of musical subjects; they probably reflect the inner images of the dream-like world of this painter who was very sensitive to music. The poetry conveyed by the unexpected presence of the angel musician playing the violin in the *Rest on the Flight into Egypt* seems to confirm this hypothesis. In this painting, the Madonna and Child are dozing while Saint Joseph is patiently reading the musical score, and the long-eared donkey seems to be an attentive and privileged listener. This delightful work shows the passion of its author for music and his taste for humour and satire.

In the work of Caravaggio, melodic notes join the characteristic tinkle of the jester's bells. If the painter adds some joke, even within the seriousness of drama or the majesty of history, legends, or religious mystery, it is to distract attention from its primary meaning.

The work of Caravaggio also has a subversive dimension that manifests itself through humorous inventions. His jokes were not the placid laughter of those who satisfy themselves with a limited well-being in terms of their destiny and their fellow human beings, but were more of a satirical outlet for an irritable personality, always on the edge of a nervous breakdown; for a rebel fighting without faltering against men, life's setbacks, and school traditions. Each burst of laughter was a mocking grimace, a vengeful insult, more or less disguised, and perhaps simple scorn. Here he mocked the ungenerous host, there he wrote a mordant verse against Giovanni Baglione, here again he mocked commissioners, whether it be the religious patrons of San Luigi dei Francesi or the brothers of Santa Maria della Scala. Elsewhere, he might utter some gratuitously coarse words directed not only against conformism, but also against religion and fashion. His work was intended to shock and irritate orthodoxy, the Academy and the socialites of the time, and he secretly rejoiced as he advanced.

This painter of earthly pleasures also knew how to be the champion of love. If certain paintings allow us to think that the painter admired gracious figures – for example the young blonde girl crying in *The Entombment* – the majority of his works attest to his predilection for strong and curvaceous figures. The young mother chosen as a model for the painting of Sant'Agostino is the perfect example of a beautiful woman whose sensuality embodies humanity. Caravaggio, who was an advocate of amorous pleasure, had an instinctive

Saint John the Baptist in the Desert, 1604-1605.
Oil on canvas, 172.7 x 132.1 cm.
Nelson-Atkins Museum of Art, Kansas City.

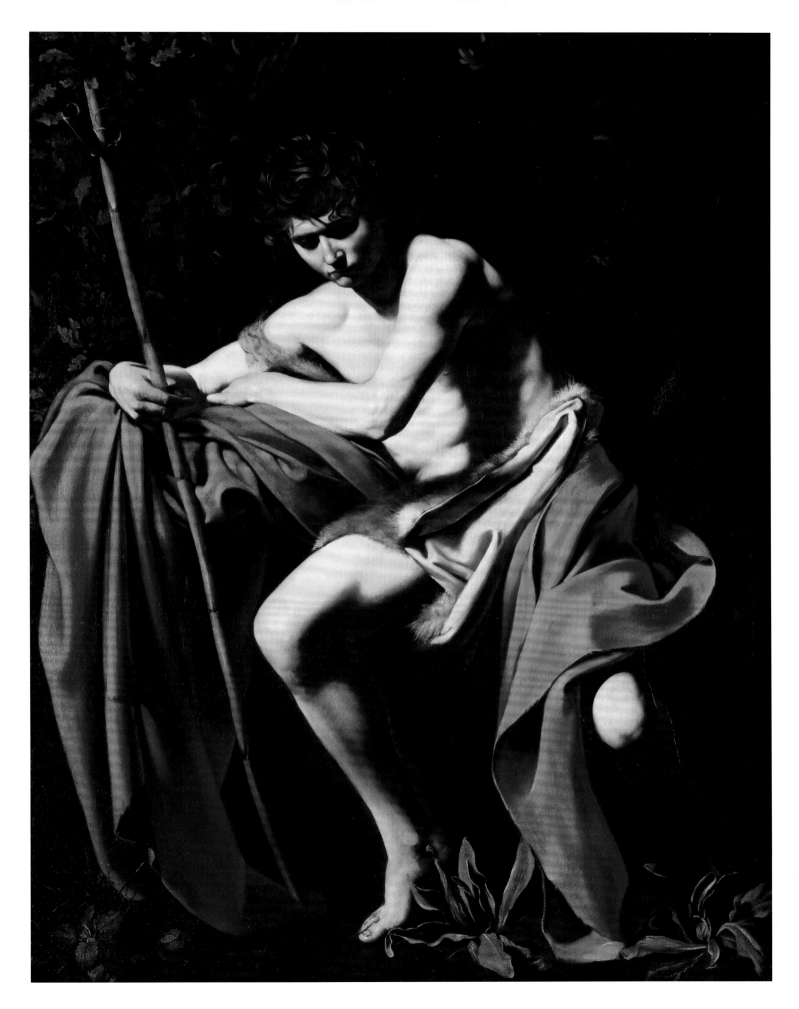

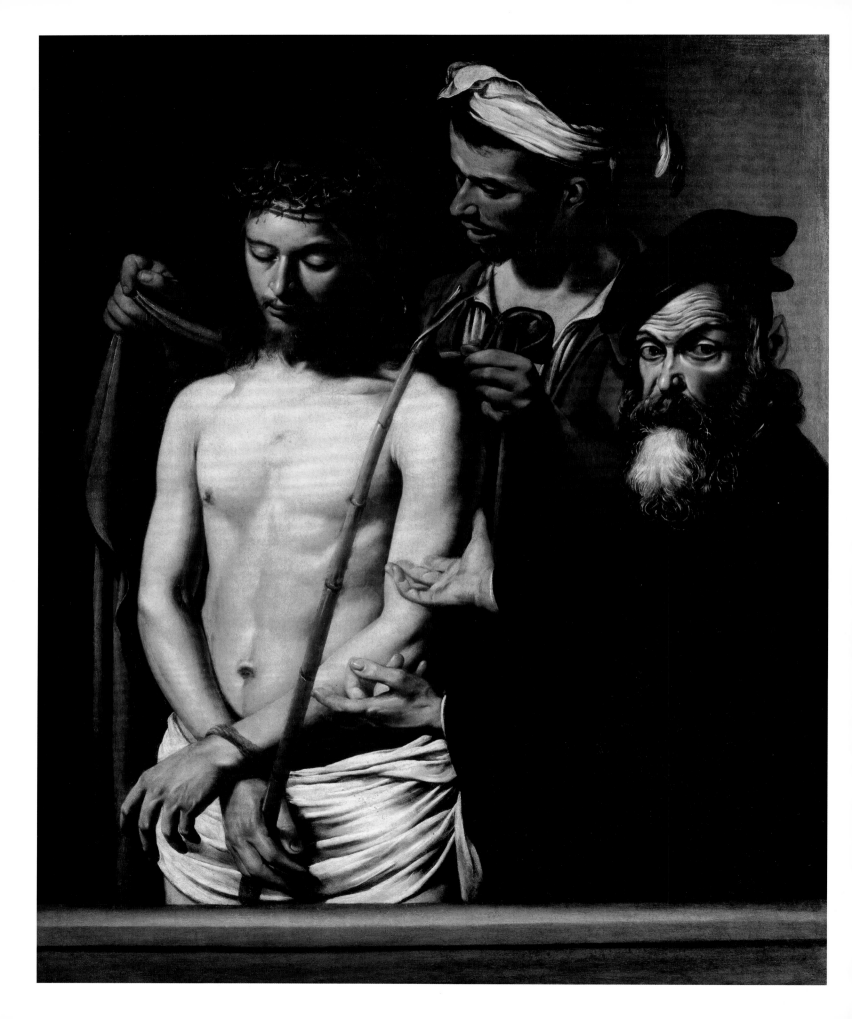

devotion to all women and behaved as a gentleman towards them in his inner self. Throughout his life he showed great nobility when defending the weak or when amongst the young people with whom he mixed while training with arms or for affairs of the heart. If in him the innate male disposition to court women was in conflict with the demands of another type of sentiment, the latter largely took over. Indeed, throughout his life, the painter often chose a delicate representation of femininity which offered him great possibilities aesthetically, while it seems that in reality he preferred partners of his own sex, as attested in one of his best works, *Amor Victorious*, in which the tyrannical character of love is symbolised in an exalted manner.

Caravaggio was not a slave to his amorous activities and he mostly had the penchants of an honest young man. His work clearly shows that he did not undertake anything excessive in this domain. But the Naturalism praised and initiated by him has inspired certain temperaments to lean heavily towards sexual excess. Some examples can be found in the painting by the painter Simon Vouet, a disciple of Caravaggio, entitled *The Temptation of Saint Francis*, in the Church of San Lorenzo in Lucina, in which a prostitute is undressing near a bed in a whore house and is lifting her skirt as did the famous Caterina Sforza. She is watched by a priest who is violently tormented at the sight of such a spectacle, and Vouet represents the scene frankly. How many artists have since been inspired by this very audacious duo to represent the "temptation of the saints", a very fashionable subject at the time. It is clear that Caravaggio, the father of pictorial *verismo*, never indulged in this type of sensual exuberance. His imagination did not lead him to the fantastical excess that one can see in the numerous depictions of the temptations of Saint Francis and Saint Anthony. If he sometimes portrayed a female sinner, he has always draped her arms and chest with a heavy shirt. It never occurred to him to represent Venus, Galatea, or Andromeda, any more than Salome performing a provocative dance or the scandalous Suzanne at her bath. Neither does he depict Lucretia or Cleopatra with naked breasts, an idea that nevertheless seduced Guido Reni.

It is not his lack of technique in painting the nude that is responsible for this absence of nudity. We know how successfully he reproduced the lines and textures of the human body, of children and angels, going as far as rendering the quivering and tensed breast overflowing with maternal milk.

One cannot accuse a rebel of his calibre, who did not hesitate to reproduce feminine and masculine anatomy, of being afraid to scandalise the religious figures

Ecce Homo, c. 1605.
Oil on canvas, 128 x 103 cm.
Palazzo Rosso, Genoa.

and the laymen for whom he undertook commissions. On the contrary, he amused himself by risking the refusal of his patrons, even if it did not prevent him from being upset at the withdrawal of one of his masterpieces censored by the clergy. The relative chastity of Caravaggio's art magnifies the needs and the fundamental feelings of mankind.

He banished pagan Venuses from his work not only because he wanted to fight against Mannerism and the systematic recourse to mythological themes but, above all, because he subscribed to a more realistic style of painting, following in the wake of Raphael, Correggio, and his most influential master, Giorgione.

His reserve is as genuine as his honesty. The actions, poses, and gestures of Caravaggio's characters are always decent, even when proud and ordinary. They can scandalise and make the viewer shiver but they never provoke nausea.

The almost total absence of contact with his family can be explained by the gap which separated Michelangelo from his brother and sister; Caravaggio's few religious convictions conflicted with the faith of his siblings, who both entered holy orders. Caravaggio was guilty of a strange affective amnesia towards his brother, who came to visit him on the initiative of Cardinal Del Monte. The cynical equanimity and oppressing silence he showed before the touching evocations of the good clergyman and the mention of his faraway sister reveal the hatred, more than the indifference, he may have felt for his family.

The abbot, who feared that his brother Michelangelo, now growing older and showing him little by way of affection, might have a certain reluctance towards the idea of fatherhood and might avoid marrying and having children, talked to him with affectionate words evoking his possible line of descent. This shows that the abbot had little knowledge regarding the painter's feelings towards children however much his work reflected a vibrant sympathy for them. The dark image he gave us of himself is therefore suddenly illuminated. Caravaggio excelled in portraits of young men whose beauty and grace he celebrated. The tenderness of Christ's gesture, his hand caressing the chin and lips of Saint Anthony of Padua, testifies to this. We are touched by the tenderness of the angel in the *Rest on the Flight into Egypt* which offers the child the protection of his arms and his large wings. It is difficult to imagine that these young creatures are born from the paint brush of an artist who did not like children, under the pretext of his tumultuous relationships with a brother and sister both in holy orders.

Saint Jerome in Meditation, 1605-1606.
Oil on canvas, 118 x 81 cm.
Museu del Monestir de Santa Maria, Montserrat.

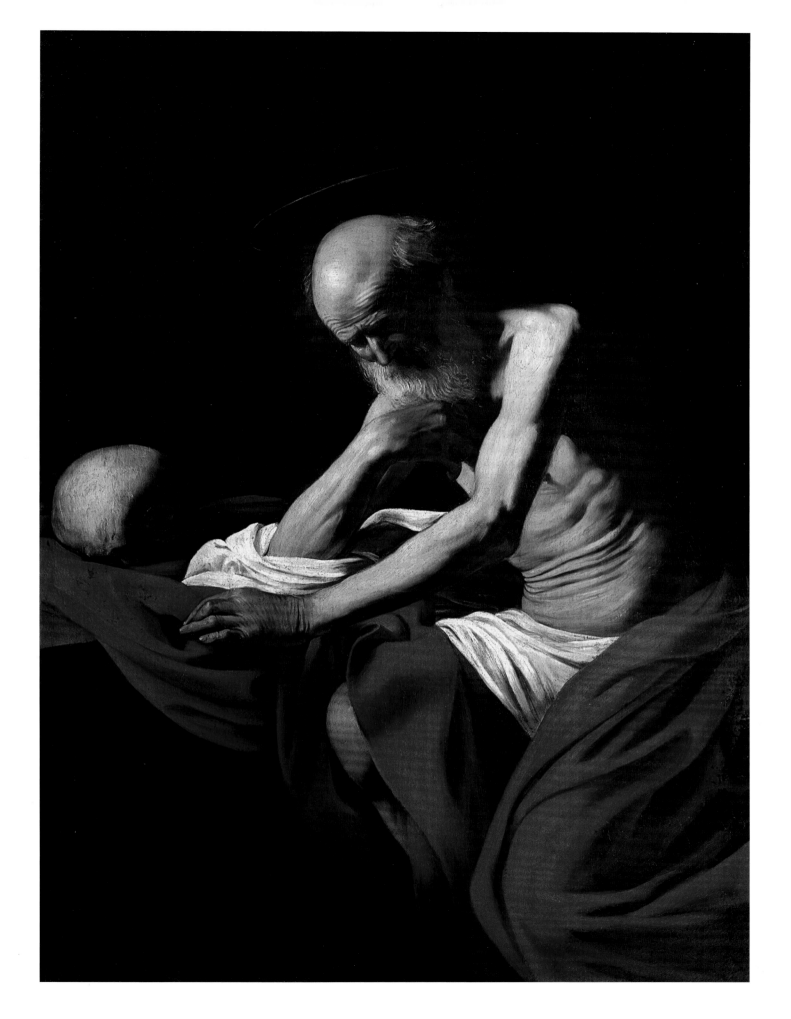

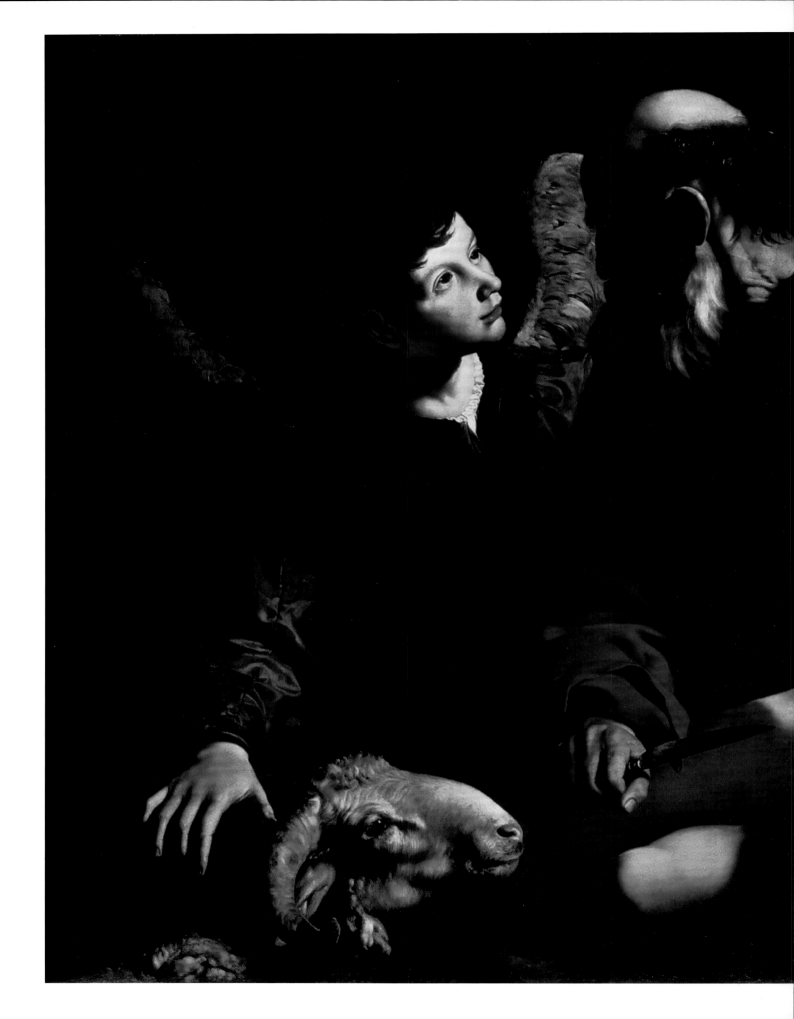

The Sacrifice of Isaac, c. 1605.
Oil on canvas, 116 x 173 cm.
The Barbara Piasecka Johnson
Collection, Princeton.

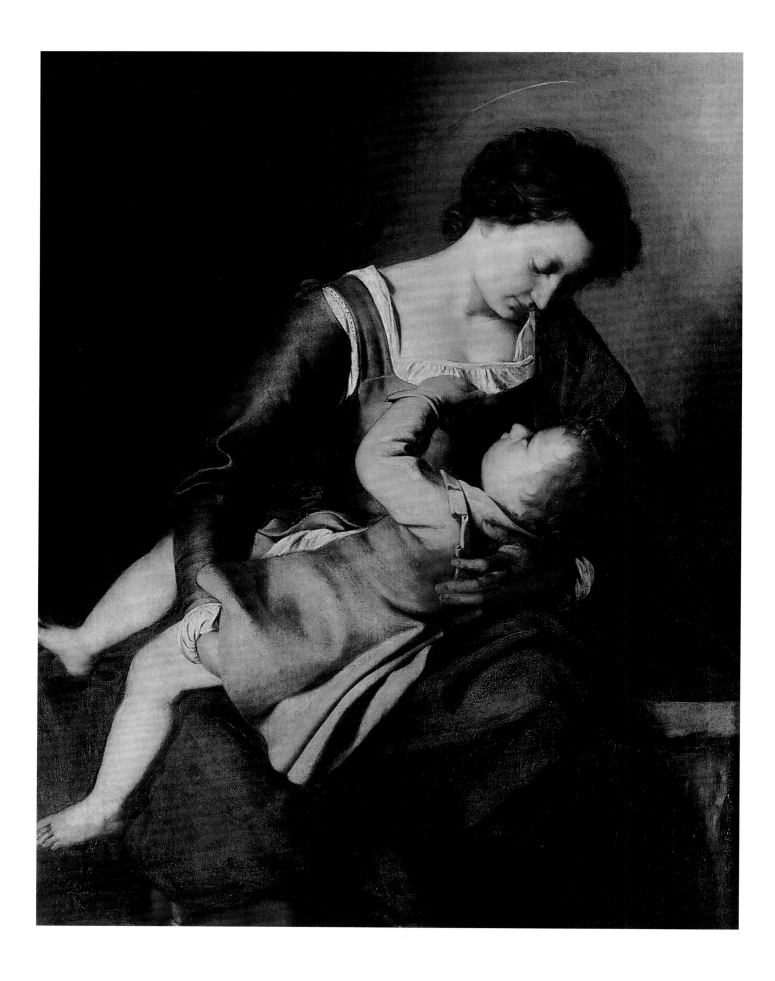

The movements of the arms of the newborn baby, as well as the attention and tenderness showed by his mother in the *Nativity with Saint Francis and Saint Lawrence* (p. 169) in Palermo show that the artist had a profound knowledge of the maternal relationship. In the *Adoration of the Shepherds* (p. 163) in Messina, Caravaggio chose to represent a young woman clutching her baby to her rather than a more conventional Madonna kneeling in adoration in front of the divine infant. Any art critic can be sure to find the precursors of this graceful procession of young children in works by such painters as Lorenzo Lotto and Correggio, by whom Michelangelo Merisi may well have been inspired in his pose for the infant Jesus.

In addition, one cannot deny that Caravaggio had a preference for children playing major roles in his paintings. He often represented their nakedness rather than that of women. Angels with the willowy body of an adolescent replaced the elegant forms of the Venuses that adorned the paintings of his contemporaries. His gaze and his desire lingered on elegant young bodies and young faces, whether shy, happy, or mocking, with the satisfaction of the aesthete indulging in a certain complacency. He was seduced by the two young boys with alarmed faces, one in the *Rest on the Flight into Egypt* (pp. 28-29) is frightened by the persecution, while the other in the *Madonna dei Palafrenieri* (p. 112) has not the courage to tread on the viper even if his mother's foot intervenes. At the same time, this adored son bowing down to implore the *Madonna of the Rosary* (p. 115) seems to embody the memory of a gracious infantile expression, more imagined than actually seen by the painter.

Madonna.
Oil on canvas, 131 x 91 cm.
Galleria Nazionale d'Arte Antica di
Palazzo Barberini, Rome.

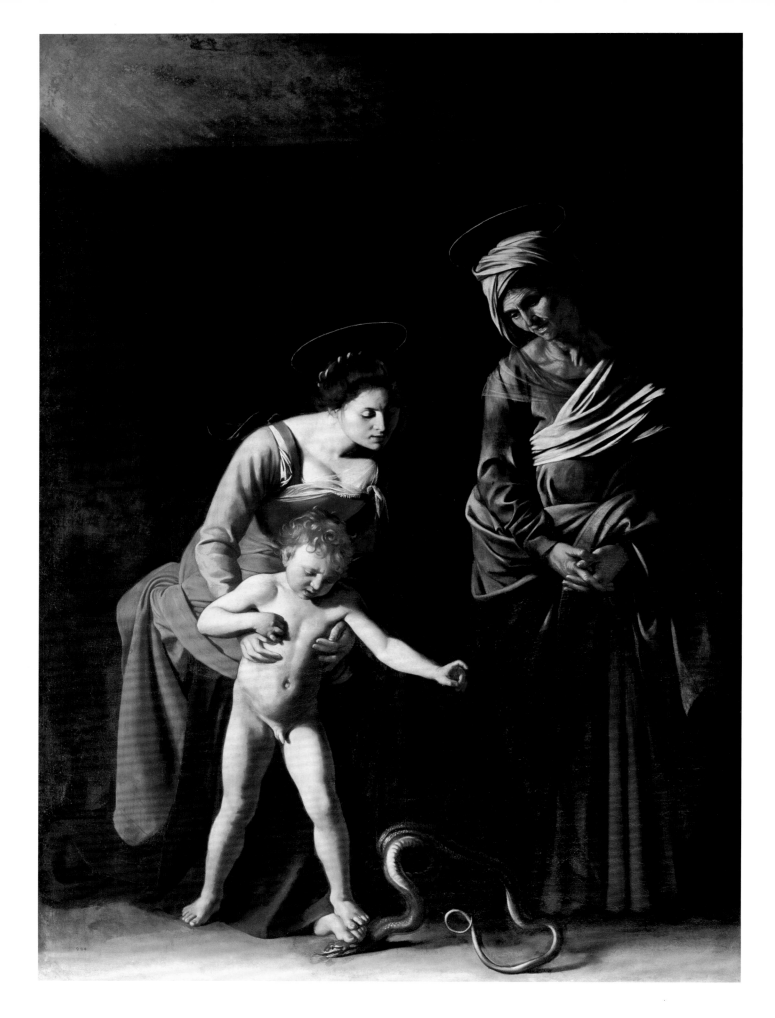

Caravaggio or the Aesthetic Revolution

One of these signs of his incredible genius was the precocity of his talent. The technical training necessary for practising such an art as painting generally requires many years. Yet Caravaggio showed a great mastery of technique as early as twenty-two years old. During this period of his career, his manner of treating light and colour, characteristic of his *chiaroscuro* palette, as well as his pictorial trend towards Realism had already manifested. Many established facts sap the strength of the words of certain critics who have focused on the lack of education of the young painter or his difficulty to meditate, as he was obliged to work for a living and was deprived of any contact with enlightened and educated men. Just four years after arriving in Rome, Caravaggio was living at Cardinal Del Monte's, his mind keen for knowledge and scientific discoveries which the Cardinal's protection could offer him. It was at the Cardinal's that the intellectual reflection of the painter took shape and that his pictorial work began to be directed towards Rationalism.

This is how the great painter's aesthetic revolution took place; a man in love with music and the darkness, a quarrelsome criminal, gambler, and a rebel who on many occasions proved himself incapable of submitting to social and moral constraints, and who, despite everything, lived as one who did good and had no burden on his conscience.

Caravaggio led against the unreality of myths and traditions the same satirical battle as the one fought at the same moment by Miguel de Cervantes in the fabulous and chivalrous poems of his *Don Quixote*. Even if his followers may have attributed the same merit to him, that is a reaction against the abuse of Classicism, the connection between art and life, the distrust for the predominant Greek and Roman aesthetics that Boileau denounced: "who will deliver us from the Greeks and the Romans?" Why not pay this tribute to him – here is Caravaggio's talent who, first and foremost, promoted such a rebellion in his painting.

He was not only pursuing the "realism of form", to which many of his precursors may have dedicated themselves, but was expressly searching for the "realism of facts" which made him unique in comparison to other artists of his time or those who had

Madonna dei Palafrenieri or *Madonna of the Snake*, 1606.
Oil on canvas, 292 x 211 cm.
Museo e Galleria Borghese, Rome.

preceded him. His mind, which some have called rough, regarded history and the world from the critical point of view of a philosopher. Any distortion of facts, events, and personalities due to mythology, legends, illusion, or the simple exaggeration, in which an impetuous human being indulges, was rejected by him and mocked, cast off or sent back to its real dimension. Escaping the persecution perpetrated by Herod, the Holy Family abandons itself to the deep sleep that is shared by all tired mortals, a sleep that cannot be interrupted by the angel's violin music (*Rest on the Flight into Egypt*). Like all human beings, the Holy Family eats bread and salad and drinks wine. Death gives Christ's body the same pallid colour as any other corpse and foul-smelling putrefaction exudes from the belly of the dead Madonna (*The Death of the Virgin*). In the same way, Saint John, Saint Peter, Saint Paul, Saint Thomas, and Mary Magdalene could not be more devoid of holiness (*The Crucifixion of Saint Peter*, *The Conversion of Saint Paul*, *The Incredulity of Saint Thomas*, and *Mary Magdalene in Ecstasy*). The proximity of Christ with mankind is clearly shown in the crucifixion scene exhibited in Cleveland (*The Crucifixion of Saint Andrew*, p. 140).

Though he sometimes represented Christ in majesty, he did not surround him with musicians, nor even with doctors of the Church followed by a cortege of saints, but with a circle of human beings confronted with the harshness of life (*Madonna di Loreto*) and with characters who seem to beg that an end is put to their long misery (*Madonna of the Rosary*).

In the work of Caravaggio, the Holy Trinity itself is disrespectfully thrown down to earth. In *The Annunciation* (p. 157) in the museum in Nancy, or the *Nativity with Saint Francis and Saint Lawrence* (p. 169), he did not add any kind of halo above Mary's head. His angels show very visible roundness and strong muscles (*The Seven Works of Mercy*), suggesting that these divinities were born human.

Far from simply copying reality, Caravaggio was a coherent thinker about truth, which he defended in the most unfavourable conditions, even against the taste and thinking of his time.

The in-depth study left to us by the historian Baldinucci is therefore rich in teachings on the academic filiations of Caravaggio, a forerunner of the Naturalist movement. Michelangelo Merisi, with his critical, independent, and creative mind and strong personality, was unable to conform to the work of a school which required the artist to submit and reproduce with application and faithfulness the masters who preceded him. It is vain and artificial to question the respective value of the work of Carracci and Caravaggio or to try to contrast them. It would be fairer to admit that these two

Madonna of the Rosary, 1607.
Oil on canvas, 364.5 x 249.5 cm.
Kunsthistorisches Museum, Vienna.

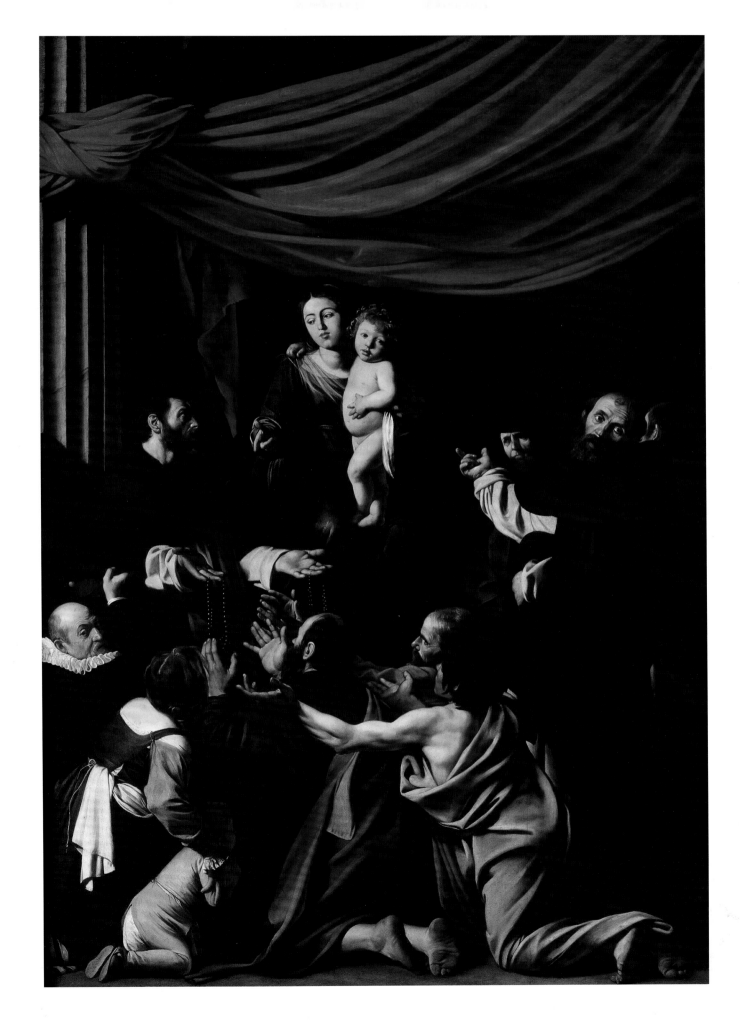

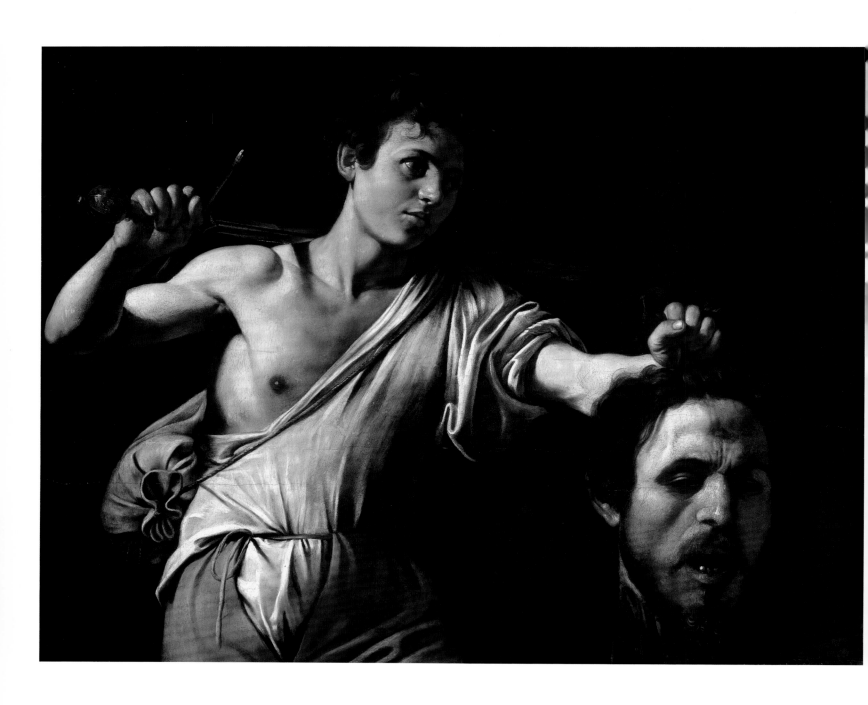

David with the Head of Goliath,
1606-1607.
Oil on wood, 90.5 x 116 cm.
Kunsthistorisches Museum, Vienna.

artists developed different styles based on a common heritage. Although he studied with Carracci, Michelangelo Merisi abandoned traditional orientations, opened a new way and initiated a movement that would span several centuries and have an impact abroad to finally find recognition with the arrival of Rembrandt's work.

The anecdote quoted by Bellori according to which Michelangelo Merisi, pointing at a gathering of people, declared that he preferred the models offered by Nature to the statues of Phidias or Glicone, reveals to us, like his legal statement during Baglione's trial, one of his concepts about painting. Indeed, when the judge asked him if he knew the painters active in Rome at the time, Caravaggio answered:

> Almost all the painters I mentioned above are friends of mine, but they are not all good. By 'good' I mean sometimes having a good mastery of his art and by 'good painter' I mean a man who can paint well and knows well how to imitate the things of Nature. Good artists are those who understand painting, they will consider as good painters those I have judged as good and bad [as those I have judged as bad] but bad and ignorant painters will judge as good those who are as ignorant as they are … I don't know any painter who considers Giovanni Baglione a good painter.

During the trial, Caravaggio may not have been able or may not have wanted to start a long demonstration on the meaning of painting. Probably the painter, fearing being misunderstood or judging it useless to expose his ideas in detail, may have remained circumspect. One should not think that the few words quoted above are sufficient to define his work and to reduce his realistic aspirations to the simple readiness that consists of always using models and scrupulously copying Nature, liberating himself from the torments of choice and from symbolic synthesis, composition, and visual construction. Studying his whole body of work can provide us with more information on the complexity and coherence of his pictorial reflection and approach than the simple sentence he pronounced with reserve in front of the judge.

He was wrongly reproached for reproducing indistinctly on the canvas whatever he saw. The "general concept" he forged for himself, according to which truth is beauty, guided him but did not deprive him of the faculty of choosing his compositions, his characters, and the symbolic elements of his paintings. He was surely aware that the intentional exaggeration of a technique could produce an effect contrary to what was expected, that the fact of launching a new movement could succeed in convincing his detractors. As a witness of his time he tried to use elements from real life and the

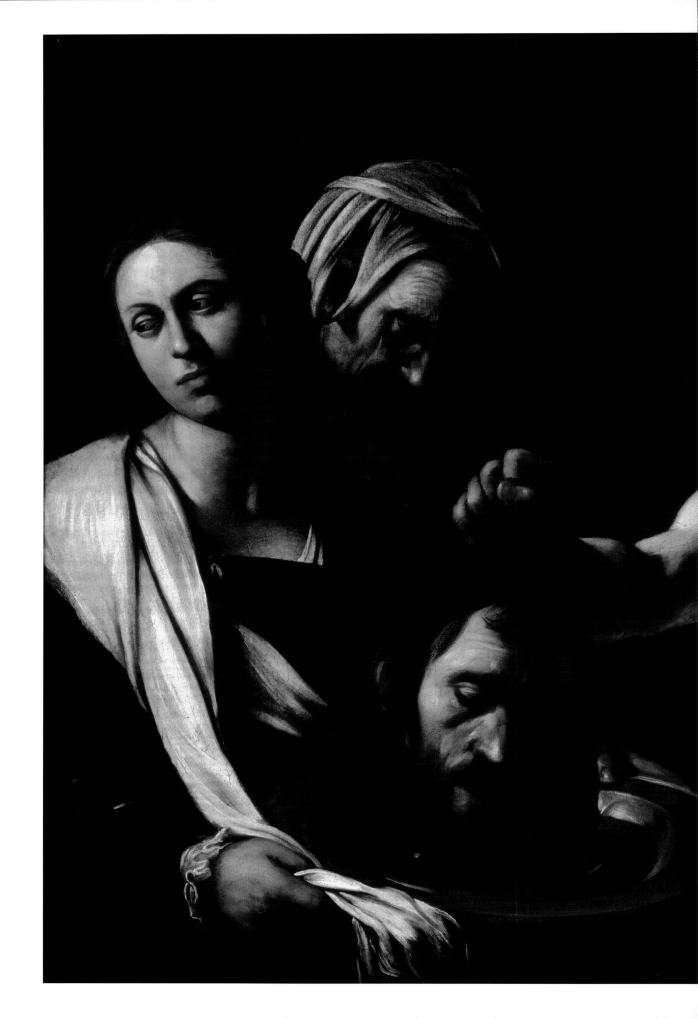

Salome Receives the Head of Saint John the Baptist, 1607-1610.
Oil on canvas, 91.5 x 106.7 cm.
The National Gallery, London.

human condition when representing universal themes such as love, death, life, and pleasure, contrary to other contemporary painters who turned away from them. His sense and resolute quest for the real can be seen as a sign of his superior intelligence.

Caravaggio's art is steeped in reality as dreams are with the images of the day. By mixing and transforming them into an unexpected fiction, he managed to create an ideal synthesis. His work offers two levels of interpretation: that of the artist's reflection on the act of painting, and that of his point of view – full of subjective sentimentality – about the world and about the human condition. In masterpieces such as *The Entombment* and *The Death of the Virgin* – two hymns to human suffering – one cannot find the echoes of what the painter actually felt, but rather the universal feelings that his genius allowed him to express by liberating him from the boundaries of his own individuality. But his paintings are not deprived of the resonance of the passions and emotions he felt. Even though we have very few documents actually written by him, the draft that has been made of his passionate personality, his biography, and his artistic concepts placed in their historical context allow us to imagine more precisely on what basis Naturalism was founded.

His ability to comprehend the phenomena of the outside world, the sensory capacities that were at the origin of his talent, were not at all distinct from his ability to combine images from reality with images born in his dreams and to reject "this beautiful idea" of which the defenders of orthodoxy said he was missing. He knew how to re-interpret and renew themes treated so many times and now somewhat worn out, such as those of *Saint John the Baptist*, the *Penitent Magdalene*, and the *Rest on the Flight into Egypt* and to give them relief and new interest. Therefore, in his painting *Madonna dei Palafrenieri*, he evokes the education of Jesus as a child by representing a picturesque and symbolic scene with admirable creativity and beautiful workmanship.

The painter, it seems, had not yet perceived that truth could not be the focal point of all the aspirations of art. One century later, Stendhal, in his *Promenades dans Rome* described the working methods and the innovative approach of the painter:

> One day, as he was standing in the middle of a crowd with one of his friends, showing him an Antique statue, inviting him to study it, Caravaggio suddenly turned towards the crowd, pointing to it and saying it had plenty of models to offer. He called over a Bohemian woman who was there by chance, and after taking her to his studio, painted her reading the palm of a young man. These two half-figures reproduced Nature with such fidelity that this painting seemed to

Salome Receives the Head of Saint John the Baptist (detail), 1607-1610. Oil on canvas, 91.5 x 106.7 cm. The National Gallery, London.

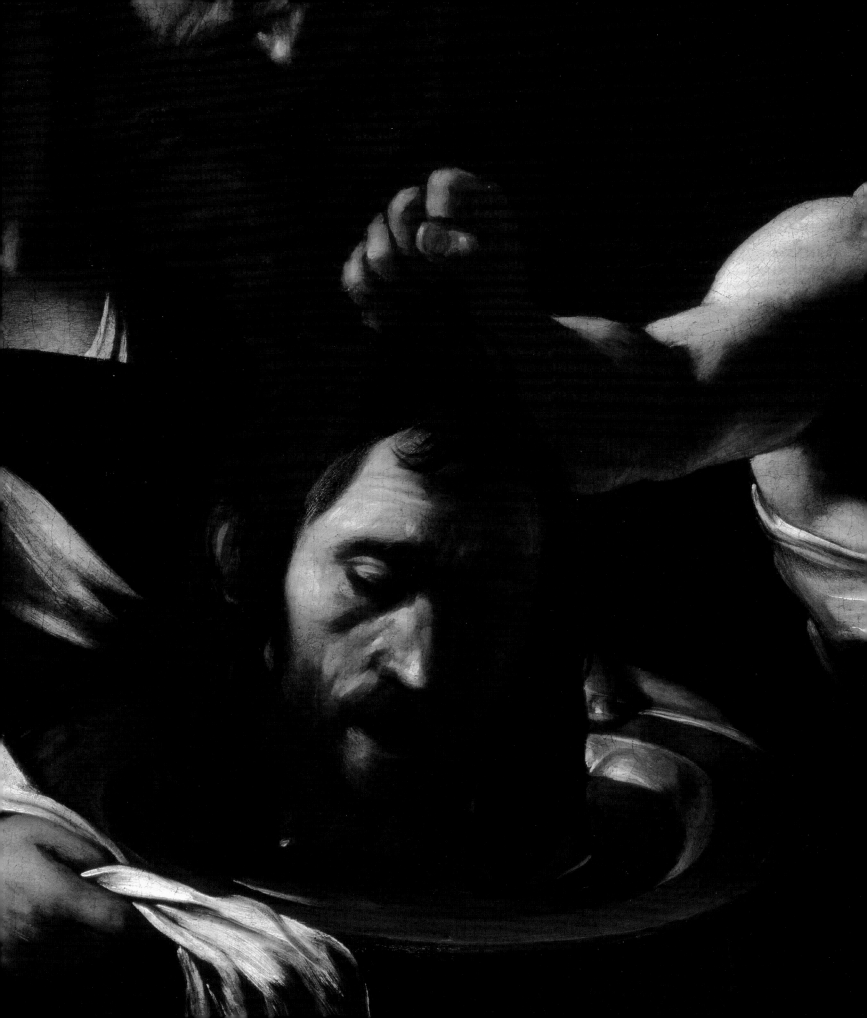

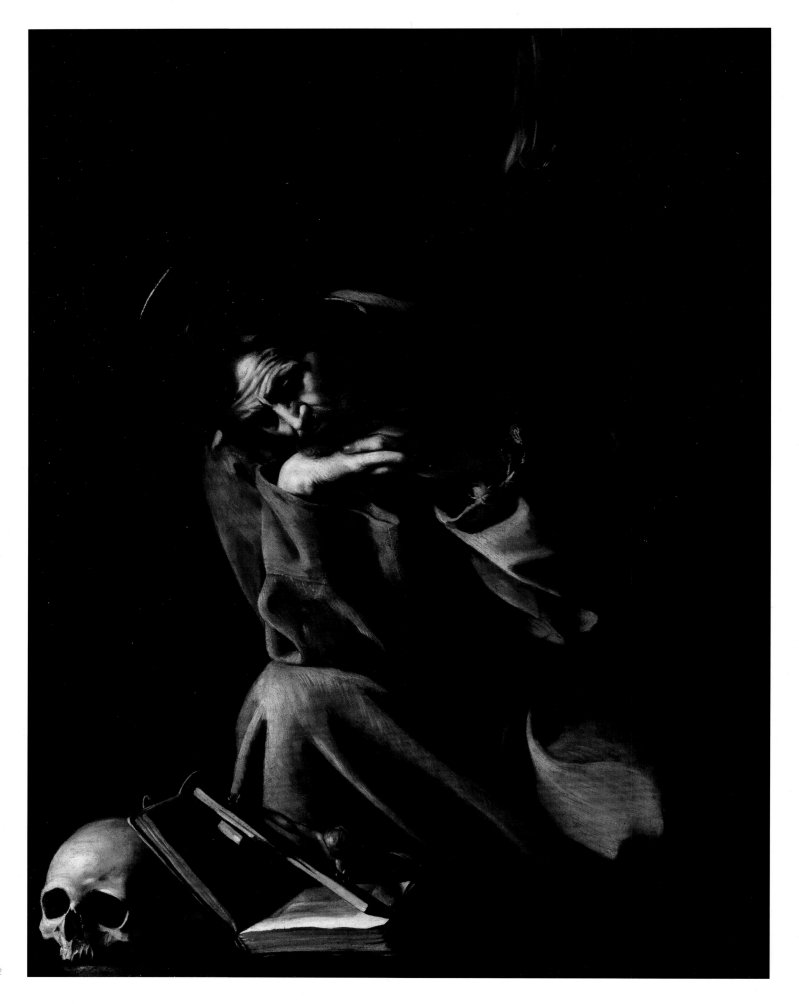

prove his point of view. At the time, he was only searching for true colour without bothering with other goals that art can reach.

Regarding this "true colour", it would be difficult for us to describe the wideness and richness of the painter's chromatic palette, if, as affirmed by the historians of the 17th century, it was true that Caravaggio did not use vermillion red or azure blue, considered by the painter the poison of colours, or if he had used them only exceptionally and in very faded tones. But a rapid inventory, carried out for technical purposes, of the colours observed in some of Caravaggio's paintings we see that the first and sixth colours of the spectrum were frequently used, contrary to what Bellori suggested with the word "sometimes", and far more often than a rough examination of his work could have revealed. His biographer therefore declared "that he has never painted the sky with a dark or clear blue", but this affirmation is negated both by the sky in the painting *David and Goliath* and the bucolic scene of the *Rest on the Flight into Egypt*. Blood flows and impregnates too intensely the clothes of Saint Matthew in his martyrdom and drips too abundantly from Medusa's neck to admit the painter's aversion to red. After an in-depth examination of his work, it appears that the chromatic sense of the painter was, with its diversity and richness, perfectly normal. The recent attribution of *The Calling of Saint Peter and Saint Andrew* is partly due to the recognition of his chromatic scheme. Buried under thick layers of grime and varnish, this work was found in the storeroom of the Royal Collection, where it had been for many years on the assumption that it was a pale copy, the master's colouring barely recognisable. On close examination, it proved to be by Merisi's hand. The work may well have been painted during his Roman period, around 1602-1604.

"The painters who preceded him or who were his contemporaries exposed the clothes of their characters to the light of the sun"; they were doing the same as Nausicaa, the pretty laundry-maid in the *Odyssey* who put her laundry out to dry on a sunny beach. Between the hollows and reliefs of the folds of a coat, exposed directly or not to daylight, a gradation of tones between sun and shadow could always be observed. For example, in the famous fresco of his rival Guido Reni entitled *Aurora, the Veils of the Hours and the Coat of Apollo* – on which the seven colours of the rainbow can be seen – shows different degrees of intensity for each colour in both well-lit and poorly-lit areas.

Such variations were forbidden to Caravaggio, who preferred to paint his heroes in taverns. Nevertheless, it would be simplistic to think that because he painted indoors, Caravaggio did not manage to seize the smallest gradations of tone and

Saint Francis in Prayer, c. 1606.
Oil on canvas, 130 x 90 cm.
Pinacoteca del Museo Civico Ala
Ponzone, Cremona.

the most subtle nuances of colour. The evidence is there in his paintings and to observe for example in *The Death of the Virgin*, the barely perceptible trace of red that appears on the unfolded arm of the dead woman and up to her chest where the coat, fully lit, reveals the kneeling apostle. In *The Lute Player*, remarkable brown tones can be seen to the left and right of the musician, and gradations of green in the folds of his silk shirt, reminding us of a veined leaf. In the *Rest on the Flight into Egypt*, the folds of Mary's skirt and of Jesus' tunic meet without merging and, to separate the two garments, the painter used a subtle gradation of two different reds. Michelangelo Merisi draped his numerous characters and dramas with humble rather than luxurious fabrics, and he knew how to magnificently reproduce the range of muted or darkened tones, managing to create the illusion of such neutral materials as wood, terracotta, leather, etc., proof that his retinal sensitivity allowed him to differentiate subtle nuances of colour.

Bellori, one of his admirers, and Carracci, one of his adversaries, have both given his creative genius the merit of having given life to his figures by avoiding prettiness and of having painted "living nudes made of flesh and not painted colour". Through what alchemy did he achieve this miracle? It was chiefly thanks to his amazing abilities that allowed him to perceive, express, and oppose subtle gradations of vivid and light colour.

Moreover, one of Caravaggio's greatest contributions to painting is the technique of *chiaroscuro*. The main figures of his scenes or portraits are placed in front of a dark or obscure background such as a barely-lit room, an outdoor setting at night or even an abstract setting without any scenery. A bright light coming from an elevated point situated above or to the side of the painting illuminates the characters like a spotlight on a theatre stage (*Denial of Saint Peter*), lighting up some faces and leaving others in shadow. The centre of the painting, particularly well-lit, gives the scene contrasts and reliefs that convey a mysterious or dramatic atmosphere. The critics and art historians who studied the techniques used by Caravaggio to treat light and colour were like the clocks of the Holy Roman Emperor Charles V: one declared that his manner directly came from Giorgione, a second that he had inherited it from Lorenzo Lotto, and a third from Tintoretto, while they all remained silent regarding his methods of creation. Equally as hastily, they described the influence of the master on his followers as if it was the simple reflection of a beam of light on an inanimate reflective surface, but they forgot that the receptive organ of this light – the eye – is alive and complex and that it is therefore specific to each individual and plays a major role in the reproduction of light effects on the canvas. Nevertheless, his emotional life may have influenced the development of his very

Saint Francis in Meditation, c. 1606.
Oil on canvas, 125 x 93 cm.
Galleria Nazionale d'Arte Antica di
Palazzo Barberini, Rome.

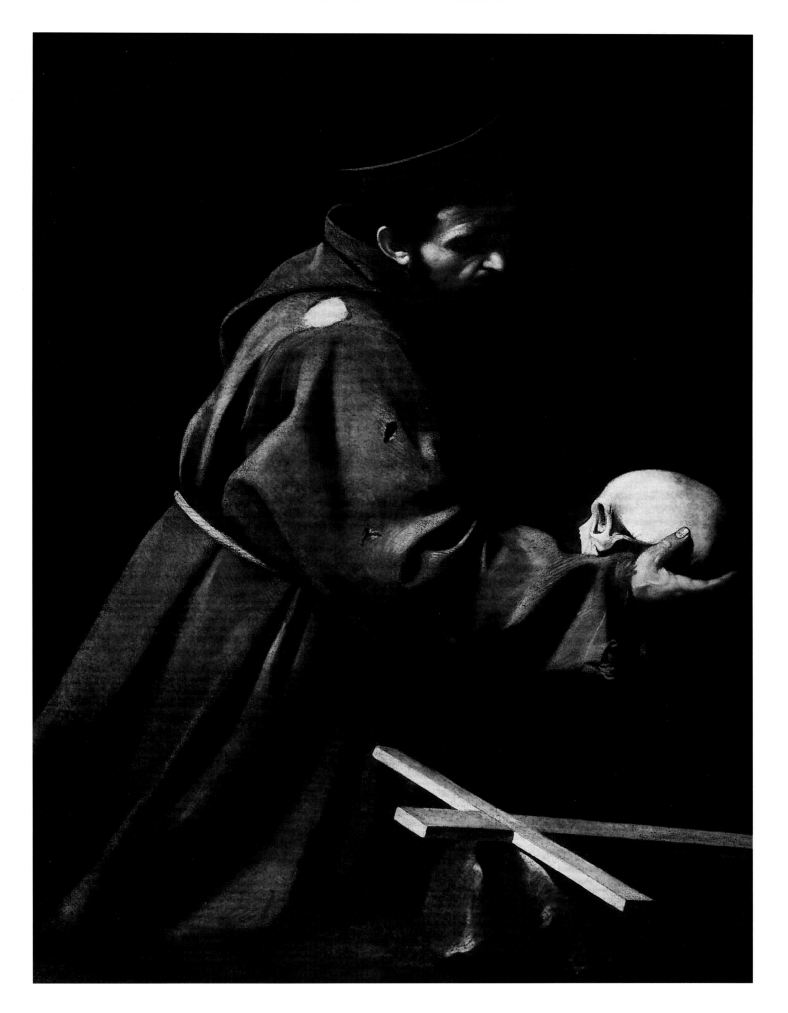

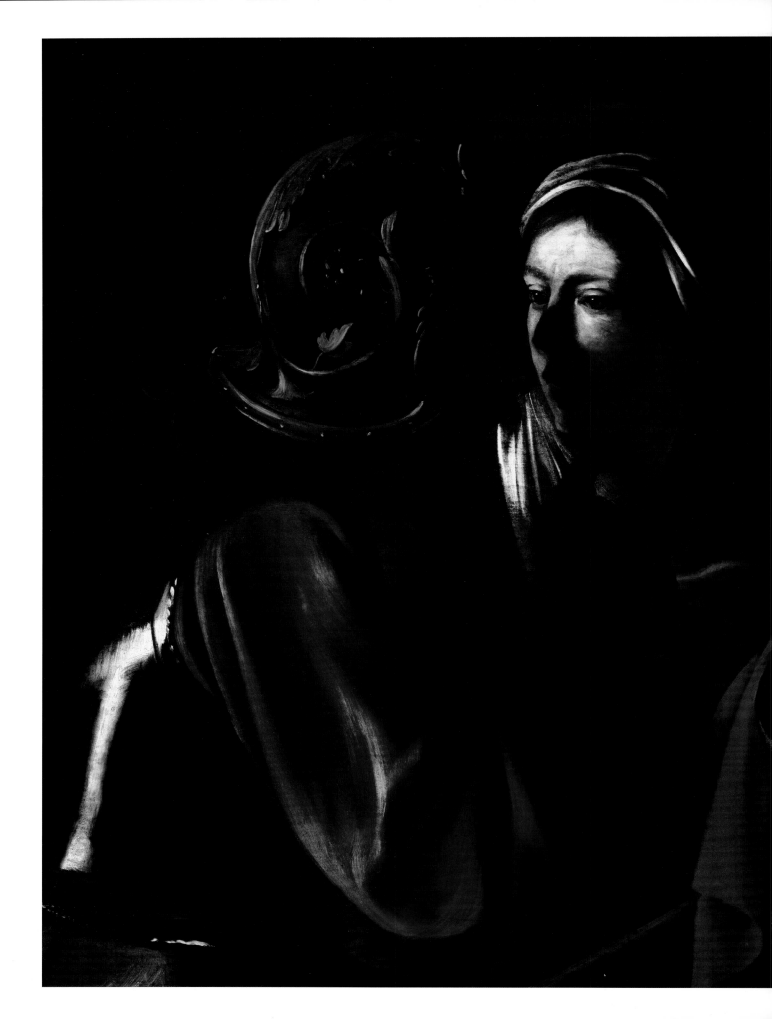

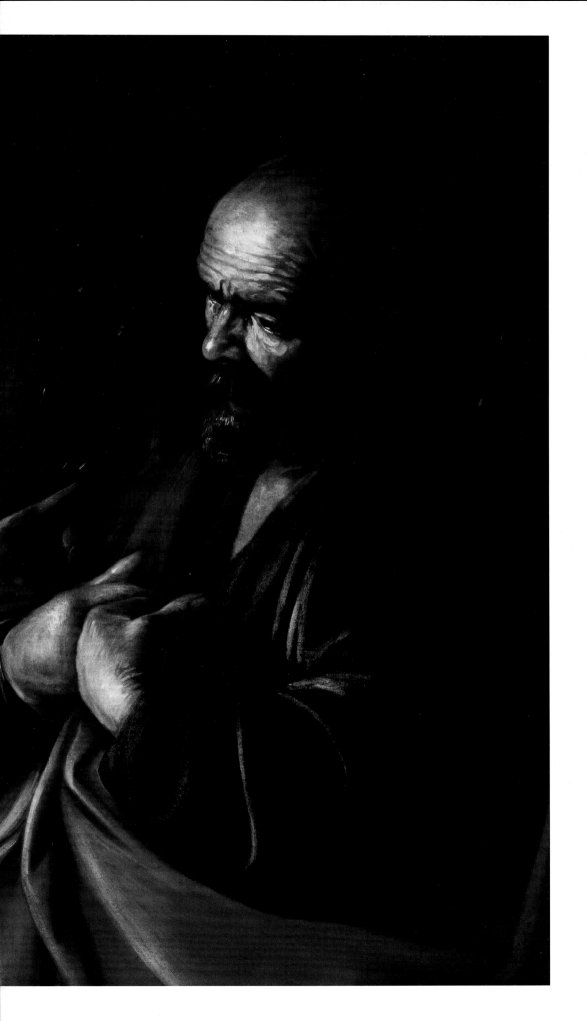

Denial of Saint Peter.
Oil on canvas, 94 x 125.4 cm.
The Metropolitan Museum of Art,
New York.

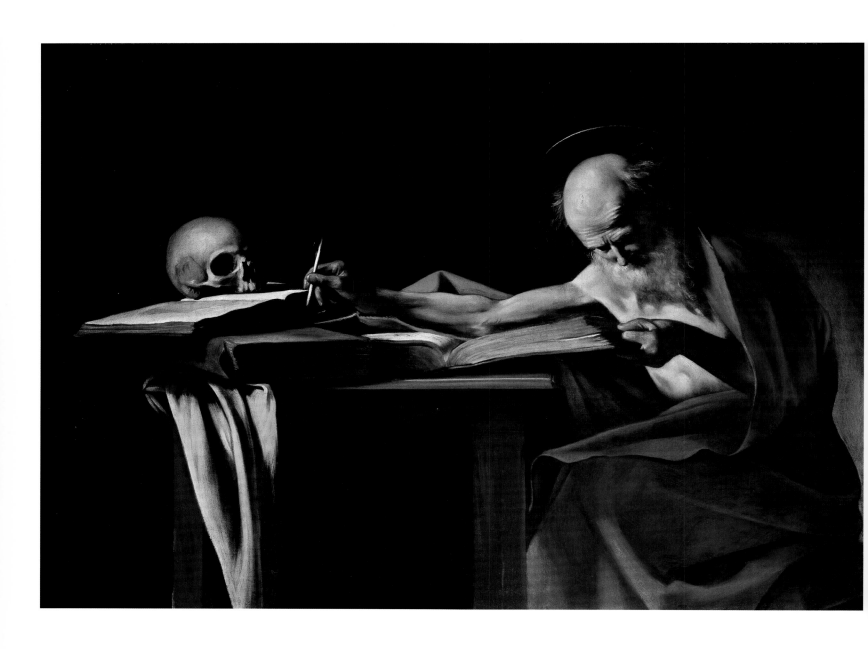

Saint Jerome, c. 1606.
Oil on canvas, 112 x 157 cm.
Museo e Galleria Borghese, Rome.

personal manner of painting the contrast between light and shadow. But as this technique of *chiaroscuro* appeared even in his first paintings and was used throughout his working life, it seems pertinent to attribute its origin to a specific sensory ability, that is to say, his exceptional retinal faculty for perception, which allowed the painter to receive and memorise exact nuances, colour combinations and oppositions between white and black, giving him the flair to reproduce them with ease and perfection. He could then easily and accurately follow a ray of light in its detours and deflections, whether it was reflected or refracted, and when the contours of long and oblique shadows were highlighted on a lighter background. Like no one before him, he knew how to seize the vibration of light when it illuminated warriors' silver breastplates or the scales of a snake (see *The Taking of Christ, Portrait of a Knight of Malta, Portrait of Alof de Wignacourt, Amor Victorious, The Raising of Lazarus, The Denial of Saint Peter,* and *Medusa*), when it sparkled on the blade or the hilt of a sword (see *David and Goliath, The Fortune Teller*), when it shone on the page of a book, on a table, or on a mortuary cloth (in *The Calling of Saint Matthew, Supper at Emmaus,* and *The Seven Works of Mercy*), when it revealed the convexity and marks on the wood of a sound box or sharpened the corner of a table (see *The Musicians*), when it polished a halo, a bishop's crosier, or a horse's bridle (*Burial of Saint Lucy* and *The Conversion of Saint Paul*), when it twinkled on the curve of nail or on a joint of the body (*The Cardsharps*), or when it created an effect of relief on the edge of a copper basin (*The Death of the Virgin,* and *The Beheading of Saint John the Baptist*).

Caravaggio worked with the increasingly piercing vision of a wise man, while he gave life to the reflections of the refracted beams of light as he sought to seize the progression of light through diaphanous objects and materials. "He sprinkles the freshest flowers with dew and other paintings undertaken with such excellence in imitation," wrote Bellori. The painter reproduced the natural and capricious reflections of the sun on vases of lilies and daisies on Cardinal Barberini's table in *The Lute Player* in the Hermitage Museum. A crystal flask containing perfume is placed at the feet of the saint in *Penitent Magdalene*. No photographic technique could have better pinned down the effect of light on glass and the liquid surface or the image of the reflected pearls than the artist's eye. Narcissus, gazing at himself in the undulating stream, is afraid that the fascinating image of his face and eyes, capturing the smallest oscillation of light, may vanish (*Narcissus*). In his palette, Caravaggio had a whole range of greys at his disposal and he used them to paint folds, wrinkled linen fabrics, or uniformly white cloth. That is how he managed to give the illusion of truth to the dazzling white robes of Saint John or the Child in the *Pilgrims' Madonna*, and to the elegant shirts or tunics worn by the figures in such compositions as *Narcissus,*

David with the Head of Goliath, *Mary Magdalene in Ecstasy*, *The Musicians*, *The Fortune Teller*, or the clergyman in *The Seven Works of Mercy*.

As time went by, he played with light with a rarely-equalled genius, using only black and white. Adding not only to the tragic and mysterious atmosphere of the scenes (*Saint Francis in Prayer*), *chiaroscuro* also gives these paintings an impressive construction and relief by suspending time (*Burial of Saint Lucy*, *The Calling of Saint Peter and Saint Andrew*, and *David and Goliath*). The strange shadows that play on the instruments of *The Musicians*, those that invade the musical scores and the men's faces or the silhouette of the strongly-lit hand that falls on the lute are illustrations of his virtuosity (*The Lute Player*). Contemplation of this detached dark hand on a dark background reminds us of a detail of *The Night Watchmen* by Rembrandt, where Captain Banning Cock's left hand is projected onto the golden jacket of the lieutenant. What is for us only an obvious mental association was perhaps for the Dutch painter a reminiscence that imposed itself onto an indirect disciple or a fervent admirer. The harmony or antithesis between light and shadow is the fundamental point of the large painting that decorates the church of Pio Monte della Misericordia in Naples (*The Seven Works of Mercy*). The funereal face at the centre of the work diffuses a large sparkling sphere that shines in circles of light and fades progressively, and is the central flame of the story being told. The face becomes the true protagonist of the scene. The creator may well have been proud of the perfect mastery of this work which must have deeply modified southern painting and which became a reference point for many artists. On a large, dark altar in Naples this luminous creation that underlines masses, faces, and the life of the Neapolitan streets is conserved. This is the work that inspired Honthorst, Rembrandt, and many of their followers. It survives there, forgotten and barely decipherable, representing one of the most precious early works of "Illuminism". The parallel that has been made between Caravaggio's *chiaroscuro* and the manner of Rembrandt, whose name evokes the night, has indeed provided material for reflection for many modern literary critics. The numerous comparisons made between Caravaggio's style and the characteristic lighting of the painter of *The Night Watchmen* have always forgotten to mention that the essential difference was of a psychological nature. The manner used by Gherardo Honthorst and Rembrandt, more or less close imitators of Caravaggio, to paint shadows is an approach learned at school, while that of the Lombard painter, being more spontaneous, is of an emotional nature.

In the aesthetic expressions of the artist, a man who was involved in bloody crimes, the fine note of blood-like vermilion contrasts strongly with the brown of the darkness. Jacob Burckhardt, the illustrious guide, upon encountering *The Martyrdom of Saint*

Saint Jerome (detail), c. 1606.
Oil on canvas, 112 x 157 cm.
Museo e Galleria Borghese, Rome.

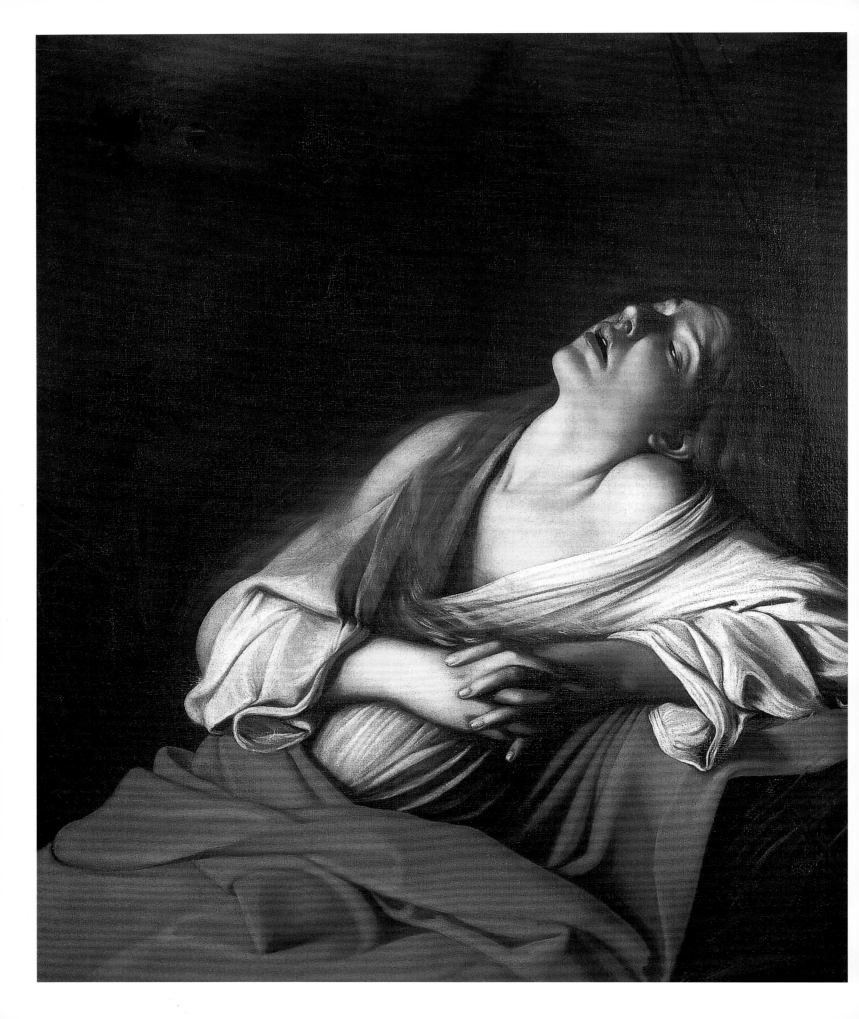

Matthew in the Contarelli chapel of San Luigi dei Francesi, would have said that Caravaggio's desire to frighten the public by so realistically imitating shed blood attracted ridicule. But to attribute this detail and others to an intentional volition of the painter, fully conscious of the effect obtained, rather than to a purely instinctive inclination, results from excessive intellectualism. To claim that the sight of red blood was an obsessional theme for this quarrelsome artist, guilty of homicide, would without a doubt be going too far, though one cannot exclude the hypothesis that he may have basked in these violent representations. Indeed, a dozen times he indulged in representing beheading, decapitation, throat cutting, and other scenes of the same type in which the stain of bloodshed was glowing conspicuously on the canvas. The numerous whimpering heads of the dying Goliath and Holofernes, the sinister decapitations of Saint John, the terrified face of *Medusa* in the Uffizi Gallery and Isaac's terrorised expression in *The Sacrifice of Isaac* all belong to his world. Who could better express the reality of the instant when a woman's severed head bounces off the killer's heel than Caravaggio? This figure, painted on a round, convex shield, represents the Gorgon killed by Perseus with her mouth open and her eyes bulging, right after her beheading, as blood is still pouring from her neck. To the Gorgon who could petrify any human who looked into her eyes, the painter gives a harmonious face with the complexion of a young woman that contrasts unusually with her monstrous hair of snakes. Her eyes, full of terror, plunge us into the silent reality of this mysterious passage from life to death. With a virtuoso hand, Caravaggio succeeds, through a subtle combination of shade and light, in giving the illusion that the Gorgon's head springs up from a concave background while the viewer knows perfectly well that the shield is convex. Isaac's gaze, as he feels the blade on his neck, also evokes human dread in facing a terrible end in *The Sacrifice of Isaac* undertaken for Cardinal Mateo Barberini.

The extenuation of tones and the softening of colour that was attributed to him, which to the great displeasure of Venetian colourists he would have set as a standard, confirm the delicacy of his chromatic sensitivity. For Caravaggio's predecessors and contemporaries, the rule was to go out of their studios and paint the clothing of their characters in the sunlight. Caravaggio did not allow such deviations. Gathering his own heroes in taverns, prisons, and other reclusive places, he needed more softened nuances of colour (*The Annunciation*), so that under the transcending effect of the beam of light that traversed the scene, the subtle discrimination of very close tones could operate. In other words, the chromatic "differential sensitivity" that was his signature could come into play. The famous painting of *The Death of the Virgin* that, no sooner than it was completed, was removed by the monks who thought that the Virgin resembled too closely a

Saint Mary Magdalene (copy),
c. 1606.
Oil on canvas, 106.5 x 91 cm.
Private collection, Rome.

common woman, is characterised by the rather marked use of red for the central figure in the drama (see also *Saint Jerome* and *The Crowning with Thorns*). Caravaggio occasionally used complementary colours as in *The Entombment* or a harmony of slightly dissonant tones as in the *Rest on the Flight into Egypt* in which the Madonna's blue coat contrasts with her red jacket. In *The Cardsharps*, the painter harmoniously decorated the yellow jacket of the cheating player with black bands. When he dressed his red-haired Narcissus in dark blue trousers and a celestial damask corset before the azure blue of the mirror-like water, he could obviously feel the harmony found in a gradation of the same colour. His subtle chromatic sense may have allowed him to successfully use the trick – probably inherited from Giorgione or Titian – of using red in the foreground as "it makes things appear nearer" and blue and violet in the background as they "make things appear further away".

Certain critics reproached Michelangelo Merisi for neither mastering perspective nor the proportions of the human body and for doing away with preparatory work such as drawings and sketches carried out outdoors, which they judged indispensable. Michelangelo Buonarotti, his namesake, talked about the genius of certain artists saying "that they were born with a compass in the eye" but such a praise could hardly concern Caravaggio. One of his first graphic pieces, *The Fortune Teller* (dedicated to Cavalier d'Arpino), resembles an official act, almost a test that would have required the young Merisi to prove he could use certain prerequisites that had to be mastered by a young painter. In this painting one can clearly see that he had not yet completely mastered proportion. The hands of the old bearded man leaning on the knight's shoulder seem to be those of a subject suffering from acromegaly, or gigantism of the extremities. The silhouette of the scoundrel who is running away with the purse he has just stolen also lacks proportion. The mistake could be explained by the improvised technique he applied of making incisions on the canvas before painting it. In the same way, the painting of the Madonna belonging to Caravaggio's landlord "Monsignor Insalata", which features great beams of light, can be classified among the works of his youth. The celestial messenger who brings palm fronds has the fist of a grown man, as does David brandishing Goliath's head. These poor proportions reappear in some of the more mature compositions. For example, the hands of the gypsy fortune teller are enormous and deformed and the length of the arms of the figures in *Narcissus* and *The Beheading of Saint John the Baptist*, as well as the arm holding a weapon in *The Martyrdom of Saint Matthew*, are also out of proportion.

His contemporaries reproached him for not mastering the fundamental basis of perspective, though many details in his works prove his ability to represent figures

Saint John the Baptist at the Fountain, 1607-1608.
Oil on canvas, 73 x 100 cm.
Bonello Collection, Malta.

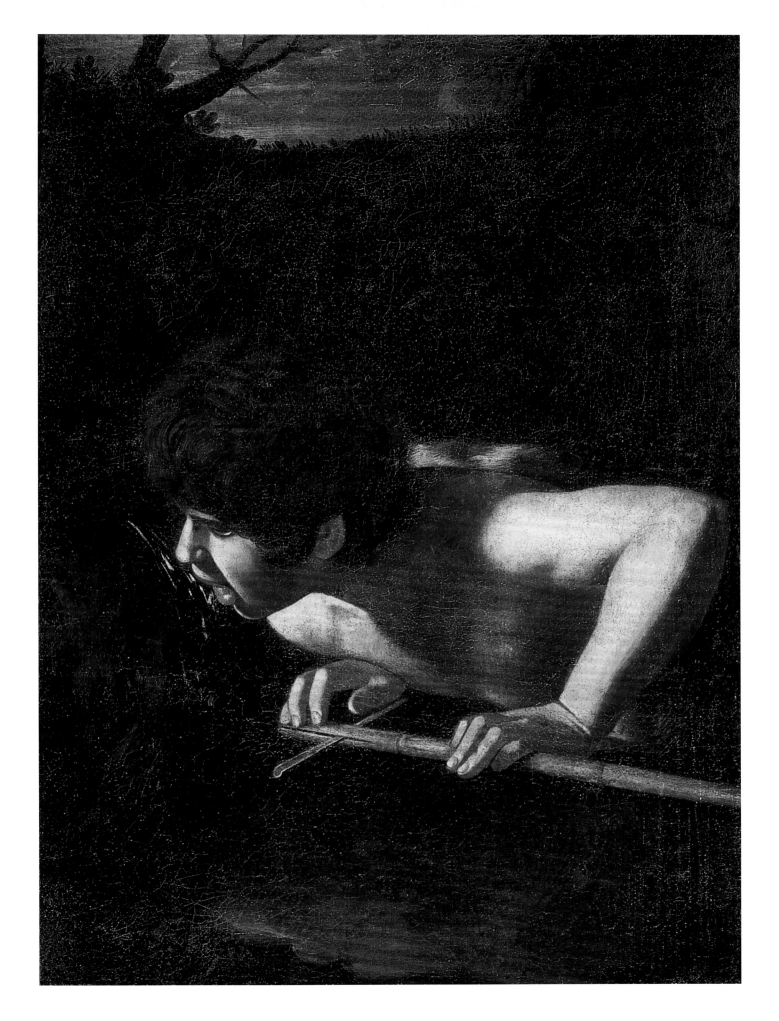

135

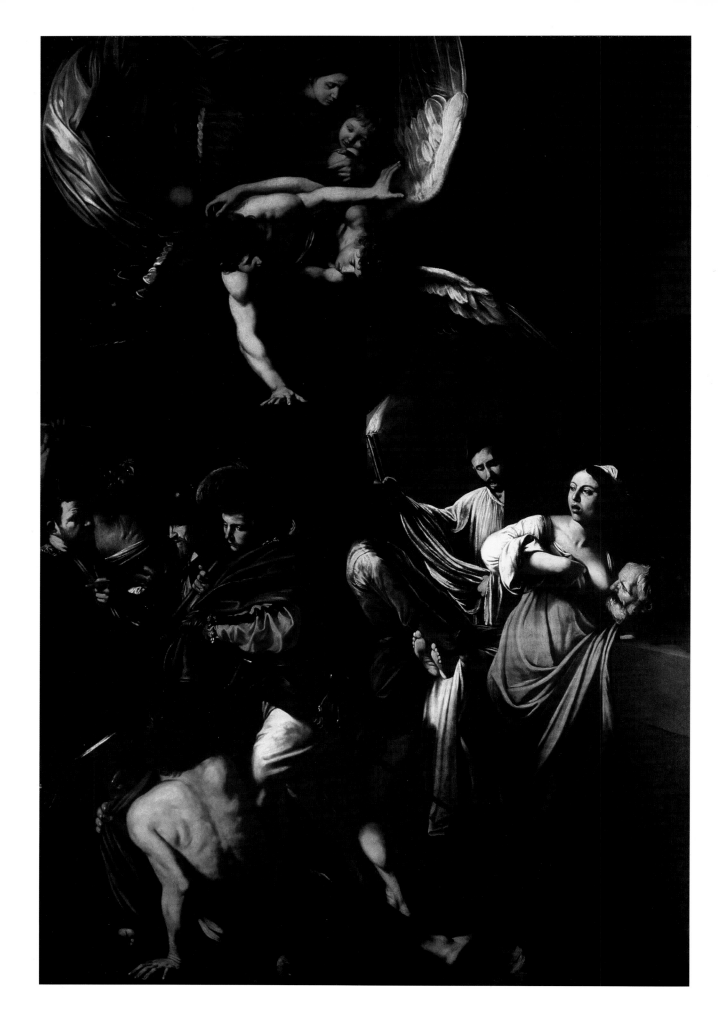

using this technique. The best illustration of his ability to use the principles of perspective is the ceiling painted in oil directly onto plaster in Cardinal Del Monte's villa entitled *Jupiter, Neptune, and Pluto*, which was only discovered in the 20th century. Caravaggio was presumably inspired by the work of Giulio Romano, who had undertaken one of the famous decorated ceilings of Palazzo del Tè in Mantua.

In the painting *Saint Matthew and the Angel*, Caravaggio achieved complex foreshortening in the angel's arm that guides Saint Matthew's quill, as in that of David lifting the severed head of Goliath (*David with the Head of Goliath*) and in the sword held in the left hand of the supper guest in *Supper at Emmaus*, which seems to pop up perpendicularly to the plane of the canvas and to advance towards the viewer. All these examples contradict the criticism wrongly addressed to him. He was also reproached for working without preliminary studies, therefore denying the importance of drawing. By scoffing at the rules of the institutions, he provoked the wrath of his contemporaries.

His representations of anatomy were by no means scientifically accurate, as Unger suggests: "For anatomical purposes, Caravaggio as well as Ribera quite often made the mistake of depicting the skin stretched too tightly, because they were more concerned about what was beneath."[74] We can accept such things to a certain extent in his youthful figures, such as his Cupid in his allegories of love, the angel in *The Inspiration of Saint Matthew*, the shepherd with the ram in the painting in the Capitolinian Collection, and also in the faces of older figures such as Saint Matthew in the paintings in San Luigi dei Francesi or Saint Peter in the Cerasi Chapel in Santa Maria del Popolo if we only remember that the charming impression created by the physical anatomy compensates for the impossible aspects of the events represented by taking them apart. The extreme roundness of his figures that Caravaggio, as we have seen, on occasion sought to increase with a reflective complexion in order to emulate polished marble sculptures, has to be recognised as a fundamental impact of his work. When there are several figures within his works, the principal composition should be assessed in a similar way. Baglione's censure of his inability "to place two figures together", which is understandable in view of the Carraccis' art[75], is dismissed by the extreme expressiveness of the composition of the figures in Caravaggio's paintings. The refreshing irrationality of the grouping, which is so strongly expressed in *The Entombment*, is repeated in all his works, probably most strikingly in one of his later paintings, the *Madonna of the Rosary*. This work demonstrates an equalising counterbalance through its colouring as well as its lighting, which brings a greater richness of movement and counter-movement into the picture than was ever achieved by the Carracci through their rules of *contrapposto*.

The Seven Works of Mercy, 1607.
Oil on canvas, 390 x 260 cm.
Pio Monte della Misericordia, Naples.

This distinctive gesture, which can be pursued beyond the School of Naples to *The Surrender of Breda* by Velázquez, merits this accolade. If we look for similar efforts in the field of the developing of Baroque sculpture itself, the comparison would most likely lead to the works of Taddeo Landini.[76] In the youthful figures of the *Turtle Fountain* in Rome, a direct parallel with Caravaggio's figures can be seen, such as those of Cupid, the angel in the cycle of Saint Matthew, or the shepherd. All these figures, both in the sculpture and in the paintings, tend to represent the human body as slim and extraordinarily flexible. But from the year 1585, Caravaggio adapted Landini's soft, elegant forms to the principles of his own art, and changed the melodious lines of the sculptor's whole composition into harsher contours.

Although he was without doubt endowed with great sensuality in his work, Caravaggio acquired the virtuosity of the best Venetians in his manner of reproducing various materials such as items of clothing, curtains, furs, and feathers, and he excelled in the representation of hair and flesh. Due to this, he received the appreciative insult of "meat mincer" from Annibale Carracci and, from the public, the favourable judgement of having achieved, in *The Calling of Saint Matthew*, "one of the most beautiful representations of modelling". Having worked a lot as a young painter in the still-life genre, he treated the nude in a corresponding manner, always trying to stay "faithful to reality".

In addition to his extraordinary capacity to paint reliefs, an expertise shared by most painters, sculptors, and architects, Caravaggio must also have been endowed with an exceptional kinaesthetic acuity judging from the sculptural character of his figures and highlighted even more by the magic of the *chiaroscuro* that he invented. The figures of Saint John the Baptist and the infant Jesus in the *Madonna dei Palafrenieri* are modelled in the round; our hands as well as our eyes are invited to caress their contours. In *The Beheading of Saint John the Baptist* painted in Malta, the power that emanates from the naked torsos adds to the dramatic character of the scene.

Regarding the human body, Caravaggio knew how to capture and reproduce not only the vivid colour of blood and the plasticity of living human flesh, but also the somewhat transient displacements that gestures provoke on the torso and limbs (see *Saint John the Baptist* and *Supper at Emmaus*). He managed to seize, with the precision of a camera lens, the moving groups of muscles that suggest a series of gestures and movements of the characters in space or the slight contraction of groups of muscles. The painter favoured powerful movements of the arms and legs, gestures, impulses, and tension at the expense of the pose, of peaceful and graceful attitudes and fixed facial expressions.

The Seven Works of Mercy (detail), 1607.
Oil on canvas, 390 x 260 cm.
Pio Monte della Misericordia, Naples.

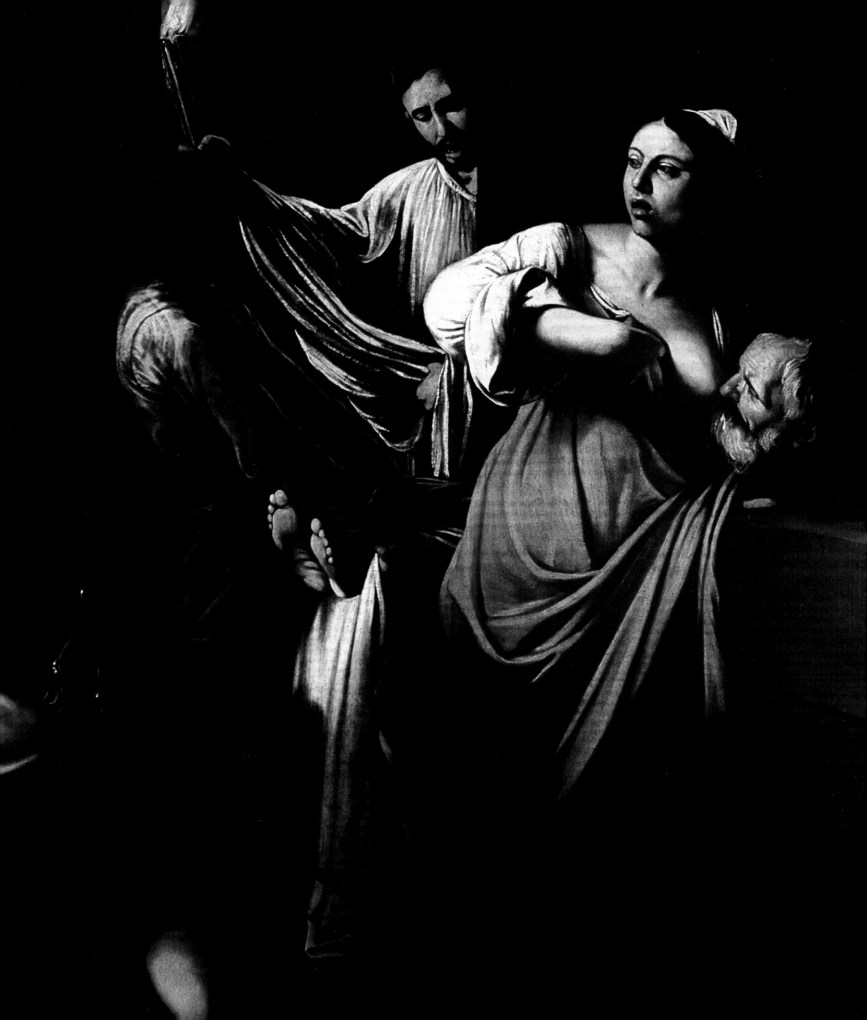

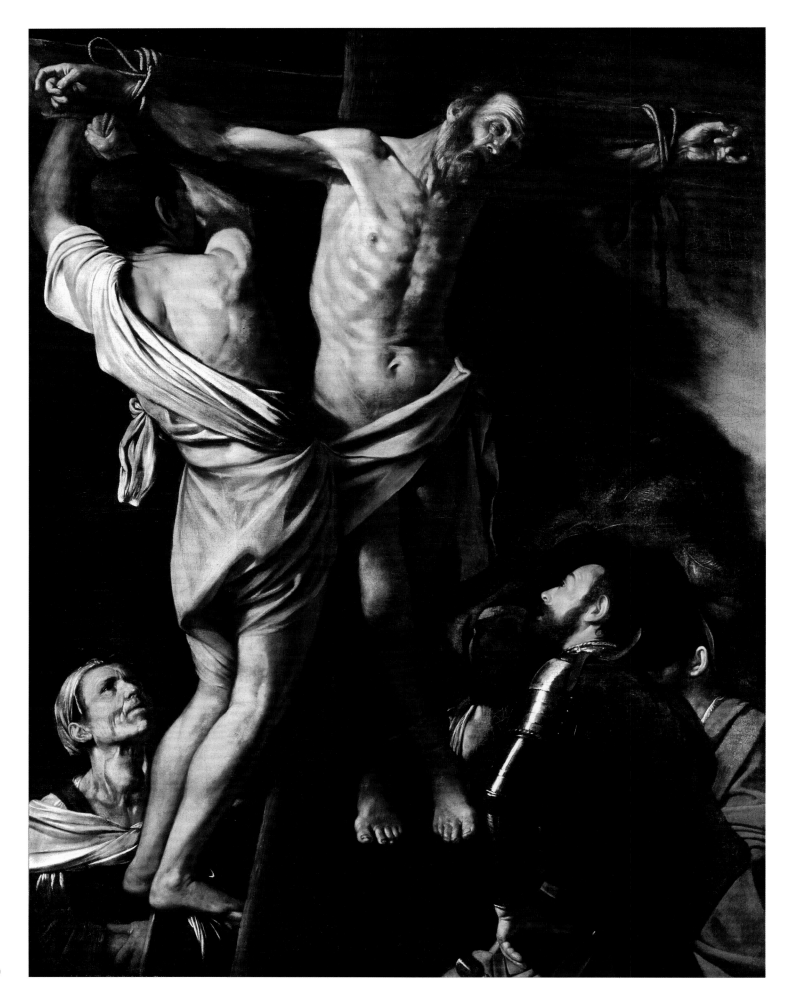

A great sensuality emerges from his *Boy with a Basket of Fruit* and his *Bacchus*. Not limiting himself to a simple representation of the body from nature, the painter explored the representation of "the movements of the soul", succeeding in animating his characters with extreme feelings such as pain, joy, fear, and metaphysical anguish (seen in *Saint Catherine of Alexandria*, *Sick Bacchus*, *Amor Victorious*, *Boy Bitten by a Lizard*, and *Saint Francis in Prayer*). The ambiguity of some of his figures, such as John the Baptist (*Saint John the Baptist* and *Sleeping Cupid*) is intended to lead us to a metaphysical questioning, which explains the lack of understanding on the part of others that affected the artist in his lifetime. In 1608, Caravaggio received from a Knight the commission for a painting on the theme of love. According to documents of the time, the challenge for the painter seems to have been to undertake the replica of a sculpture by Michelangelo, now lost. The use of *chiaroscuro* allowed him to create a young Eros in astonishing relief, comparable to that obtained in a sculpture in the round. Contrary to his *Amor Victorious*, in which the figure is radiant, beaming, and smiling, the painter chose, not without irony, to represent the mythological figure of Eros with the ungraceful features of a plump child sleeping with his mouth open in a nonchalant way. Was this sleeping Cupid an allusion to the celibacy to which his commissioner had devoted himself or did the painter wish to evoke the ephemeral character of amorous desire using the features of an apparently sick child?

In the same way, the introversion of Mary Magdalene struck by Grace, who the painter portrayed in her profound contemplation and in her gestures directed inwards, engages and touches us; we can feel the texture of Mary Magdalene's hands, and the naturalness of her acceptance moves us. It is easy to imagine that Caravaggio, rather than simply looking at the model, sometimes enjoyed caressing and touching her, repeating the legendary gestures of his great namesake Michelangelo. What lightness in the gradation of tones he used to paint the natural skin complexion and the tone of the muscles!

The *Madonna of the Rosary*, probably painted for a Dominican Monastery, was acquired for the Dominican Monastery of Saint Paul in Antwerp, where it remained until the beginning of the 19th century. From there it went to Vienna. It depicts the handing out of the rosary to Saint Dominic and Saint Peter the martyr. To the right we see a kneeling Dominican prior, probably the donor of the painting, whilst to the left a mother with her boy is seemingly watching the scene as if from afar as a representative of the devout crowd. The flood of figures has been included in a spatial-poetic context, as can frequently be seen in Caravaggio's paintings, though in this case only in the form of grandeur. That which he developed gradually in the painting of *The Beheading of Saint John the Baptist* in Malta, and in the altar-piece

The Crucifixion of Saint Andrew,
c. 1607.
Oil on canvas, 202.5 x 152.7 cm.
The Cleveland Museum of Art,
Cleveland.

Burial of Saint Lucy in the Bellamo in Syracuse, as a further stylistic development of *The Death of the Virgin* from Santa Maria della Scala, comes out as a consciously artistic deed in this work of art, rendering the content even more important than could ever have been achieved with a composition purely dedicated to modelled figures. Now the flood of light that fills the painting does not glide vertically through the group of figures, but emanates from the depths, where the Madonna appears, to the front and then flows back to whence it came. The hues are also distributed accordingly throughout the picture, included in such a way that they seem to bring life to the whole charm of Caravaggio's palette.

According to authenticated sources he did not finish the painting. The donor's head on the right was later painted into the picture by Anthony van Dyck, who created his large rosary painting for the Oratorio del Rosario in Palermo in 1623.[77] The inferior composites of the work, which contribute to the Madonna's majesty, have as important a role as the principal elements, and the communication between the characters as well as the supplication of the men occurs essentially in the positioning of the fingers. In the *Nativity with Saint Francis and Saint Lawrence* of Palermo and *The Seven Works of Mercy* in Naples, the great angels descending from the sky are presented in a perfectly harmonised movement. The painter also excelled in reproducing the lifelessness of a figure who sleeps deeply (*Rest on the Flight into Egypt*) or in ecstasy (*The Ecstasy of Saint Francis*), as well as the rigidity of dead bodies (*The Death of the Virgin*) or the tension of muscles in movement (*The Conversion of Saint Paul*).

This vision of human movement, which is embodied in Caravaggio's characters preserved from the influence of the exterior world, is attributed by art historians to the intellectual heritage of a school that promoted the style of imitation. During his years of training in Simone Peterzano's studio, Caravaggio had time to absorb the principles of his master. There, he acquainted himself with this painting "faithful to reality", in which Lombard realism and the influence of the Venetian school in the treatment of light and colours were combined. These art historians consider the precursors of this style to be Jacopo Robusti, Michelangelo Buonarroti and, before him, Jacopo della Quercia. It is difficult to confirm a further origin of this manner of painting. Today, instead of constantly searching for the paternity of Caravaggio's expressive methods in his predecessors, it would be more judicious to search for this origin within his own mind.

The Holy Family, c. 1607.
Oil on canvas, 117.5 x 96 cm.
Clara Otero Silva Collection, Caracas.

We cannot deny the talent with which the painter gave life to his characters by means of expressive movements, which seem to have been undertaken and felt by the artist

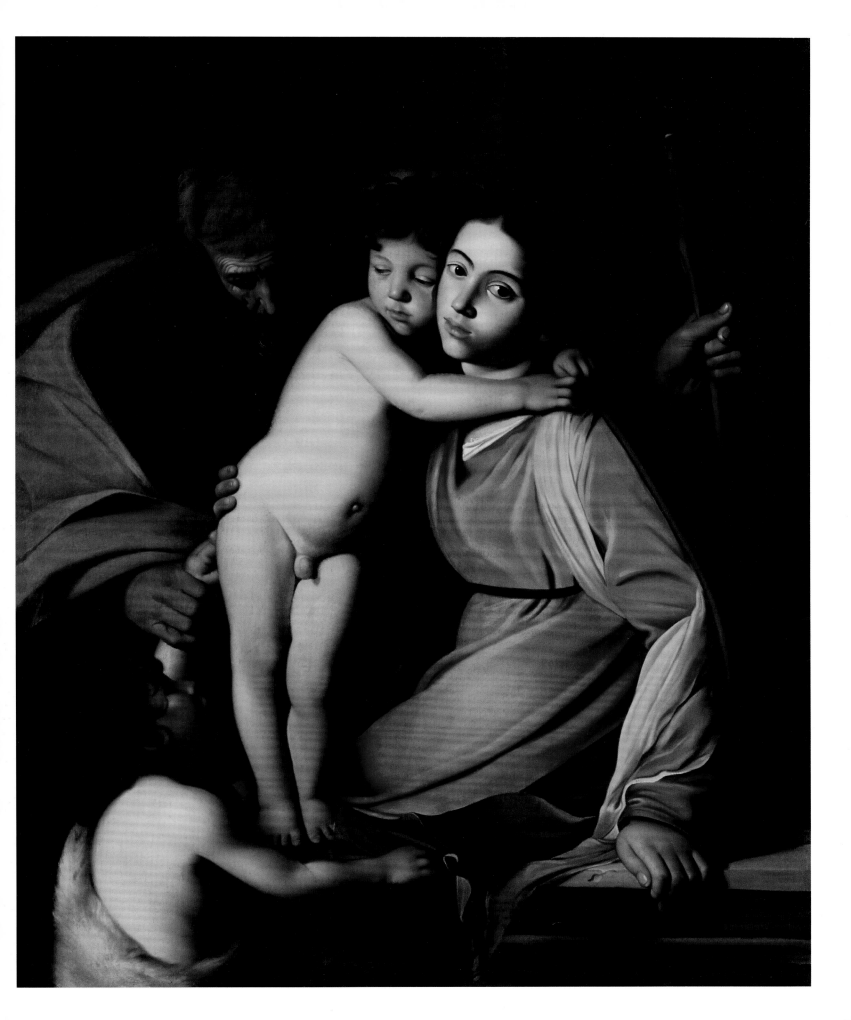

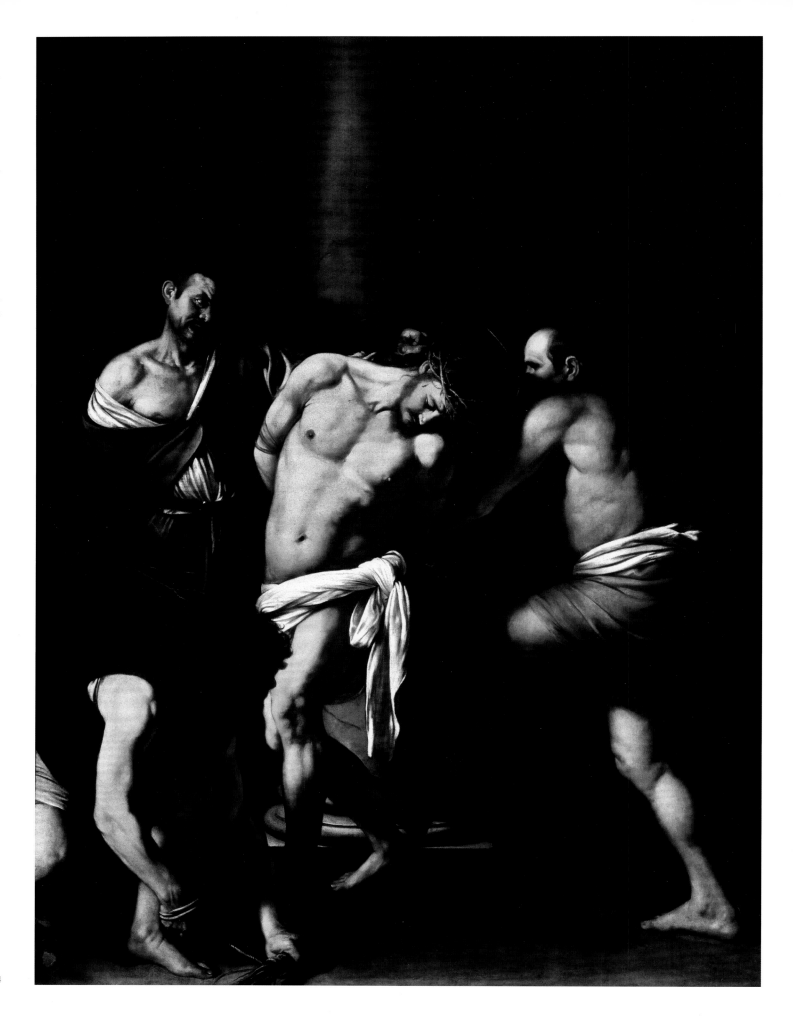

himself before being represented. The hypothesis can be made that his brisk and incisive personality, along with brutal gestures, gave him a specific acuity to physically feel then reproduce on the canvas the diverse motor activities of his figures. This interpretation led the art historian Patrizzi to qualify the painter as "an impulsive example of artistic imagination, in line with what we know of his behaviour in daily life". He then added that "his spontaneous working methods that consisted of painting from real life characters met in the street, without using conventional sketches and preparatory drawings, are the image of his unpredictable and ready reactions (during a quarrel in an inn, he threw his dish of artichokes in the waiter's face)". The historian described Caravaggio's unusual personality as prone to excessive reactions both physically and in his relationship with others. In the light of behaviour marked by a need for escape, his tendency to lie and to deny all evidence (see the incident with his brother), his violent and compulsive reactions, and his claims of being a lonely and envied artist, one can only agree with the idea that his antisocial personality influenced his artistic approach and style.

After Caravaggio's adventures in Malta, and right up until his death, violent events occurred frequently in his life. He escaped from Malta during the night and ran away to Syracuse where he undertook several commissions for the clergy, notably the *Burial of Saint Lucy*. He then left for Messina, where he painted *The Raising of Lazarus* (p. 158) and injured a school teacher. He finally arrived in Naples where he was involved in a fight with a group of bandits at the Cirillo tavern, after which he was in such a bad state that he was barely recognisable. During his stay, he painted several works, notably *Saint John the Baptist*, *David with the Head of Goliath*, and *The Martyrdom of Saint Ursula* (p. 166). He then sailed along the Tyrrhenian coast, perhaps pursued by enemies or motivated by a desire for revenge. Still hoping to benefit from a pardon by the Pope, he desperately tried to reach Rome. In 1609, Baglione reported that Cardinal Gonzague was negotiating to get him back in Pope Paul V's good graces. Caravaggio then decided to board a felucca. It was on a beach along this coast that he collapsed of exhaustion (perhaps the victim of a new and violent attack of malaria) before dying. The painter was buried near Porto Ercole in a grave, of which no trace remains. The letter written by the bishop of Caserte, gives us a few details about the circumstances of Caravaggio's death, which may have taken place on the beach of Orbetello, according to the stele that has been placed there.

The details of the last few weeks of his life gave rise to several legends, and the circumstances of his death on 18 July 1610 still remain obscure.

The Flagellation of Christ, c. 1607.
Oil on canvas, 390 x 260 cm.
Museo Nazionale di Capodimonte,
Naples.

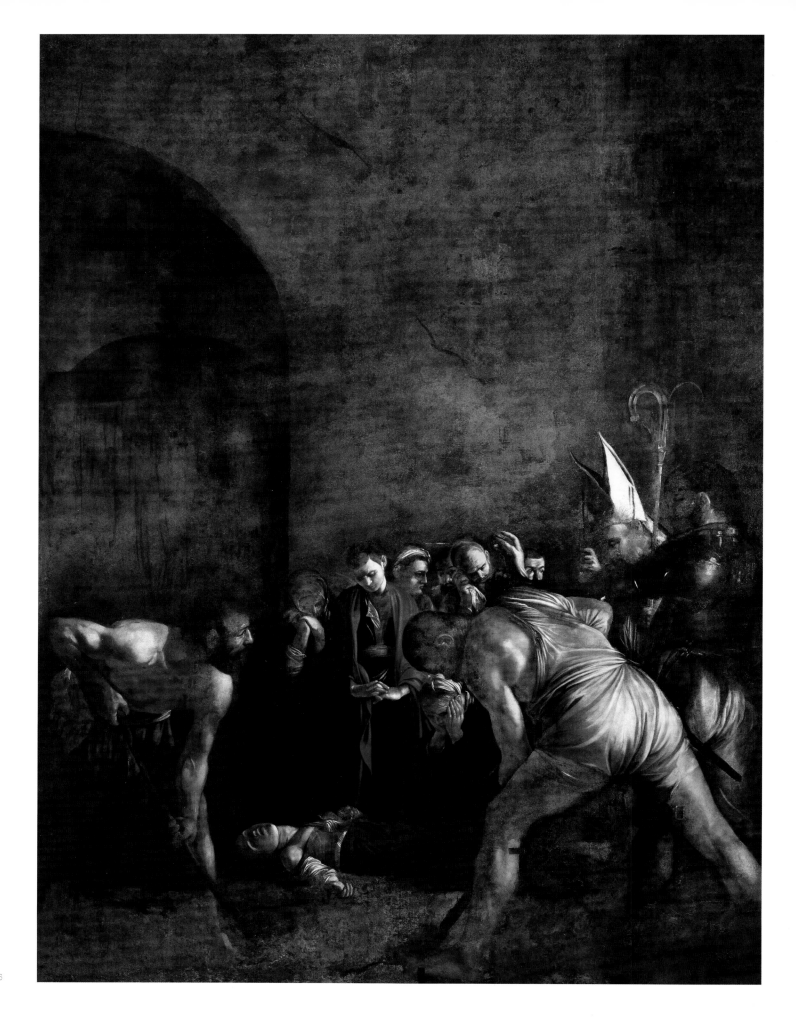

CARAVAGGIO IN A DIFFERENT LIGHT

The Life of Caravaggio by Giovanni Pietro Bellori

The Greek sculptor Demetrios was so captivated with resemblance that it gave him more pleasure to imitate things than to represent their beauty. It was the same for Michelangelo Merisi, who admitted no other master than the model itself and did not favour the most beautiful forms. It is surprising to note that without cultivating artistic style, he managed to make art emerge. The village of Caravaggio in Lombardy, where the artist was born, witnessed his growing reputation. Caravaggio was also the home of the famous painter Polidoro, and both painters devoted themselves in their youth to the art of the fresco and had to confront the technical difficulties posed by the use of lime or plaster.

As Caravaggio worked with his father, who was a mason, he often had to prepare the plaster for painters who painted frescos and, seized by the desire to use colour too, he followed them and dedicated himself to this style of painting.

He developed his craft over four or five years, a period during which he dedicated himself to painting portraits. Thereafter, because of his quarrelsome temperament, he was accused of being involved in brawls and had to flee from Milan, where he was studying. He went to Venice where he was able to study the palette of Giorgione which would inspire him thereafter. It is for this reason that in his first works, he offered us soft and pure colours not yet darkened by the effects of shadow he would use in his later work. And among all the Venetian painters who excelled in the art of colour, Giorgione was the best, using a limited number of colours to represent natural forms, and it was this manner of painting that Caravaggio borrowed when he began representing nature at the beginning of his career. Once in Rome, with no patrons, protection, or recommendations and with no means, he was unable to employ a

Burial of Saint Lucy, 1608.
Oil on canvas, 408 x 300 cm.
Chiesa di Santa Maria alla Badia,
Syracuse.

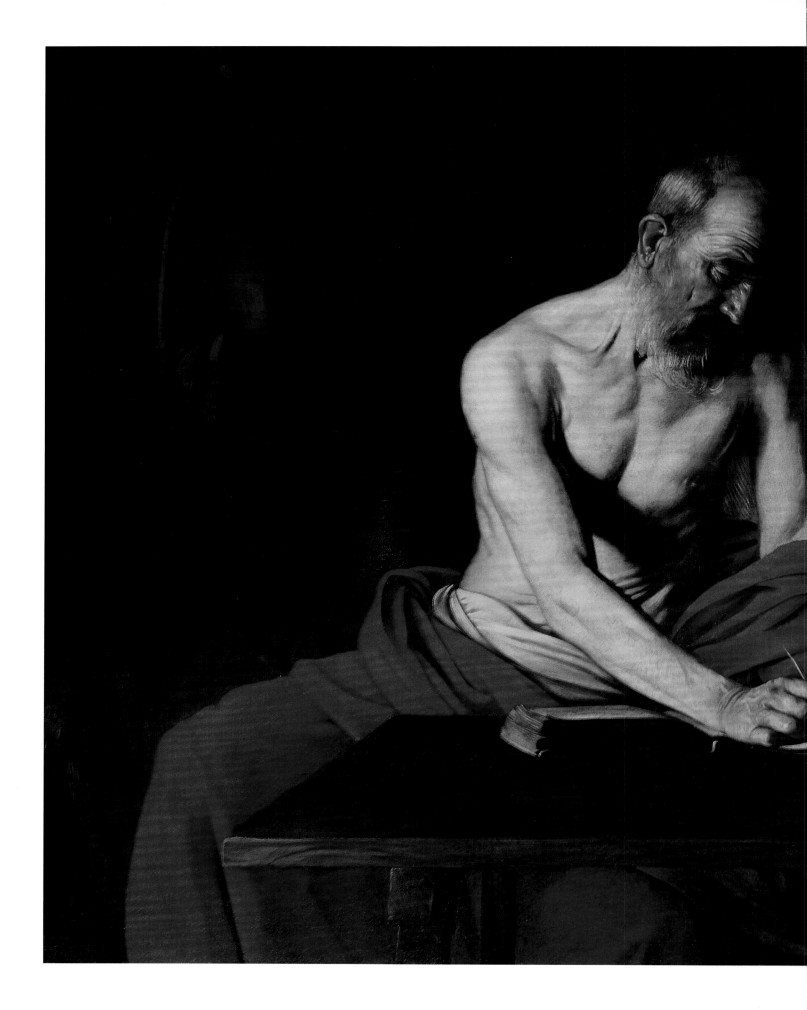

Saint Jerome Writing, 1607.
Oil on canvas, 117 x 157 cm.
St John's Co-Cathedral, Valletta, Malta.

model, and a model was indispensable for his painting. His destitution was such that he could not ensure his own livelihood. Constrained by his needs, Caravaggio had to enter the service of Cavalier Giuseppe d'Arpino, dedicating himself to painting flowers and fruit, which he knew how to imitate so well that he attracted a number of admirers to the studio who came to rave about such beautiful paintings, paintings which we still admire today. He painted a carafe having the transparency of water and glass on which were reflected the windows of the room and containing flowers sprinkled with dewdrops. He also undertook other imitations of exceptional workmanship. But frustrated by only being able to paint in this genre and disappointed by not being entrusted with figures, he seized the opportunity offered to him by Prospero, a painter of grotesque scenes, to leave the workshop of Giuseppe d'Arpino to conquer fame with his own brush. Willing to paint according to his own inspiration, and neglecting the excellent Antique marbles and the reputed paintings of Raphael, he decided to represent Nature as the unique object of his art. Thus, when one day he was shown the most famous sculptures by Phidias and Glicone so that he could study them, he expressed his feelings by pointing at a group of men surrounding him, insinuating that Nature supplied him with enough models. And to endorse his words, he hailed a Bohemian woman who was passing by chance in the street and took her to his local inn where he painted her portrait. representing her telling a fortune as these gypsy women do. He added to the scene a young man whose gloved hand is resting on the handle of his sword and who gives his other hand to the woman who takes it to tell his fortune. These two half-figures illustrate Caravaggio's words on Realism.

The same views were reported about the Antique painter Eupompos, even though his teachings were no longer currently recognised for their value. It is why Caravaggio dedicated himself exclusively to the exaltation of colour which gives to the complexion, to the skin and blood the natural appearance to which he dedicated his eye and hand, thereby neglecting other objectives of art. In his way of choosing and putting together characters that he met in the streets of the city and who moved him, without challenging his genius, he satisfied himself with these creations offered to him by Nature. He painted a young girl sitting on a chair who, with her hands at chest level, is drying her hair. In this refreshing indoor portrait, he placed on the ground, by the feet of the young girl, a vessel of ointment, pearl necklaces and precious stones, declaring that the painting represented Mary Magdalene. The young woman, slightly in profile, whose neck and chest are in clear and realistic colours, presses her cheek against her hand and the clothes she is wearing enshroud her with natural simplicity; a shirt covers her arms and her yellow dress, lifted to the knee, reveals a petticoat of flowered damask. We have described this figure in detail to illustrate the very natural manner of

Portrait of Alof de Wignacourt, 1608.
Oil on canvas, 118.5 x 95.5 cm.
Palazzo Pitti, Florence.

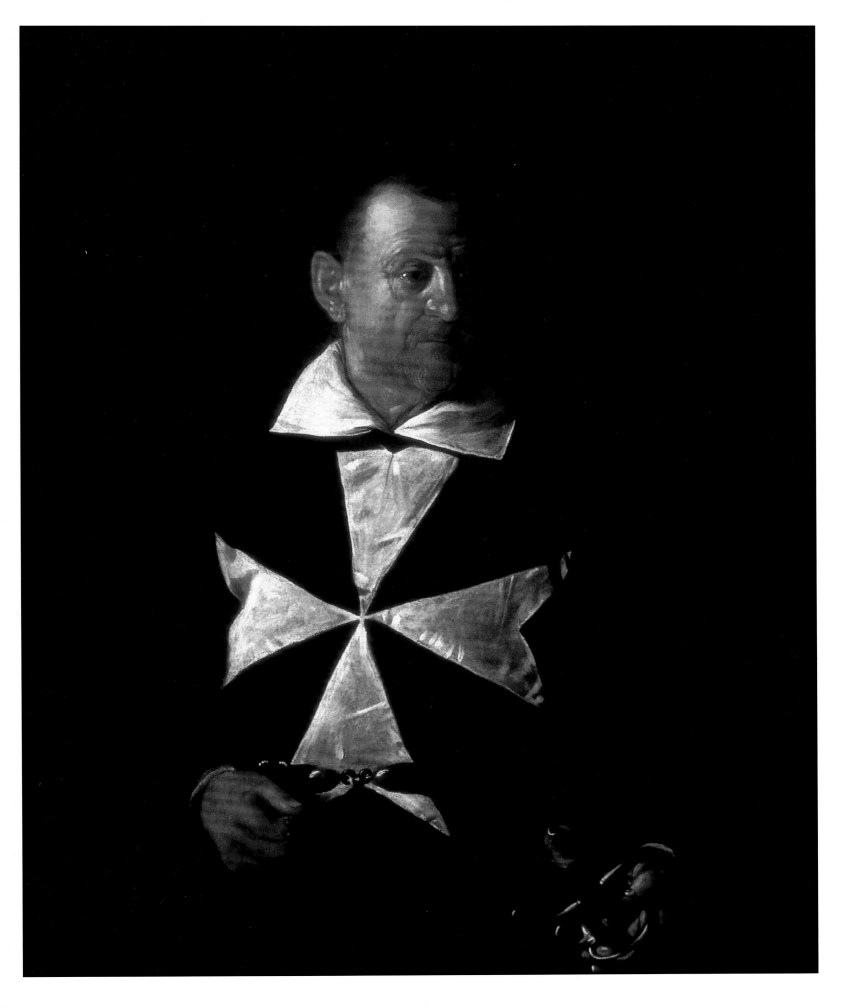

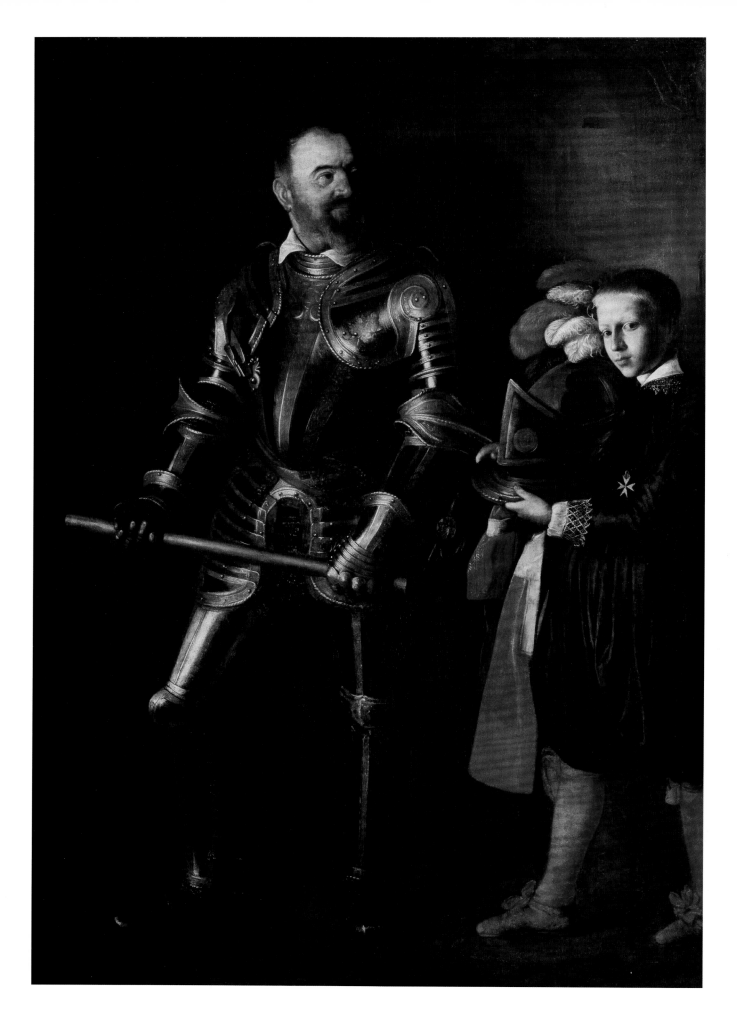

Caravaggio, who, with the use of few colours, achieved an astounding realism of colour and effect of imitation. He produced a famous painting of the Virgin resting on the flight into Egypt; in this painting he chose to include the figure of an angel standing and playing a violin, for whom a sitting Saint Joseph holds the musical score. The angel slightly inclines his head to one side showing his winged shoulders and his barely-covered naked body. On the other side, the Madonna, sitting and bending her head seems to be sleeping while she is holding the child against her breast. This painting can be admired in the palace of Prince Pamphili, while another, just as admirable, representing three characters playing cards, can be seen in the apartments of Cardinal Antonio Barberini. It shows a young and simple man with an agreeable and lively face, wearing dark clothing. In front of him, a cheat is sitting in profile, one hand leaning on the gaming table, the other hiding cards behind his back. A third character is looking at the cards of the young man and indicates with his three fingers what these cards are to his accomplice, who is bending over the table and therefore offers to the light his yellow doublet decorated with black bands, whose colour shines with naturalness. These first works are characteristic of Caravaggio's manner, inspired by Giorgione, but the first shadows are already perceptible, and Prospero, praising Caravaggio's new style, contributed to advertise his work so much that his reputation reached the high dignitaries of the Court. Cardinal Del Monte, who was a keen admirer of painting, acquired the card player canvas, spoilt Caravaggio with favours, and welcomed him into his house in the company of his gentlemen. The painter undertook for the Cardinal a painting representing in half-figure four young men playing music, a woman with a shirt playing the lute with her score in front of her, and Saint Catherine on her knees, leaning against a wheel. With their more contrasting colours, these two paintings, still exhibited in the same apartments, show the evolution of the painter towards *chiaroscuro*.

He painted Saint John in the desert in the guise of a young naked man sitting and bending his head forward, holding a lamb in his arms, a painting that can be seen in the palace of His Lordship the Cardinal Pio. But Caravaggio, who took his name from his native town, became more renowned for the palette that he was progressively developing and that contrasted with the soft and light colours of the beginning of his career. They were audacious, strong and emphasised by dark tones, in which black, often used, gave relief to the bodies. He cultivated this technique to the point of never exposing his figures to sunlight. In order to make the most of the contrast between light and dark areas, he placed his characters in the dark atmosphere of an enclosed room, lit only by a beam falling vertically on the main part of the bodies, the rest of the scene being left in shadow. This innovation had such an impact that the painters who were then working in Rome, in particular the younger

Portrait of Alof de Wignacourt, c. 1608.
Oil on canvas, 194 x 134 cm.
Musée du Louvre, Paris.

ones, visited and celebrated him as the only true imitator of Nature, whose admirable and miraculous paintings they imitated by undressing their models and placing the source of light higher. Neglecting studies and teaching, the young painters were searching for inspiration on the squares and streets in which they found models and characters that favoured the imitation of Nature. This rather easy method was largely imitated and only the older painters, faithful to the old manner, were offended by this new technique used to study Nature. They kept on criticising Caravaggio's work and reproached him for never leaving the cellars, not being creative enough, using drawings without any ornament, and lacking inspiration, as he was lighting all his figures with a single beam of light, with no gradation of tone. All these criticisms did not prevent the rapid development of his reputation. Caravaggio made a portrait of the Knight Marino that made him famous in the circle of men of letters, because in the academies the poet and the painter were the subject of the same admiration. That his how the Knight Marino himself praised the painting of Medusa that Cardinal Del Monte offered to the Grand Duke of Tuscany. The Knight Marino, in a gesture of benevolence towards Caravaggio, introduced him into the house of His Lordship Melchiorre Crescenti Chierico di Camera, a very learned prelate. Caravaggio painted his portrait and that of His Lordship Virgilio Crescenti. The latter, inheriting the charge of Cardinal Contarelli, commissioned him, with Giuseppino, to paint the chapel of San Luigi dei Francesi. The Knight Marino, a friend of the two painters, recommended the attribution to Giuseppe, who excelled in the art of the fresco, of the figures in the upper part of the building and to Caravaggio that of the oil painted canvases. Then an event occurred that caused some trouble in the mind of Caravaggio and made him doubt his reputation. Indeed, having completed the central painting showing Saint Matthew, he placed it on the altar, where the priests removed it, saying that this figure without a trace of nobility, sitting with his legs crossed and rudely showing his feet to the people, was not that of a saint. Discouraged by such an insult to his first work destined for the Church, Caravaggio luckily met Marchese Vincenzo Giustiniani, who comforted him and liberated him from his torments. Interposing himself between the priests and the painter, he decided to acquire the painting and commissioned another one from him that can now be seen on the altar. To honour the first painting, he placed it in his home near to three paintings representing the Evangelists by Guido, Domenichino, and d'Albano, three of the most renowned painters of the time. Caravaggio did his best to make a success of this second painting and to confer naturalness on the character of the saint writing the Gospel. He therefore chose to represent him with a knee leaning on a stool and his hands on the small table, dipping his quill in the inkwell placed on the book. The character turns his head towards the angel on his left, who, deploying his wings, talks to him and makes a sign to him, his two index fingers touching each other. The angel

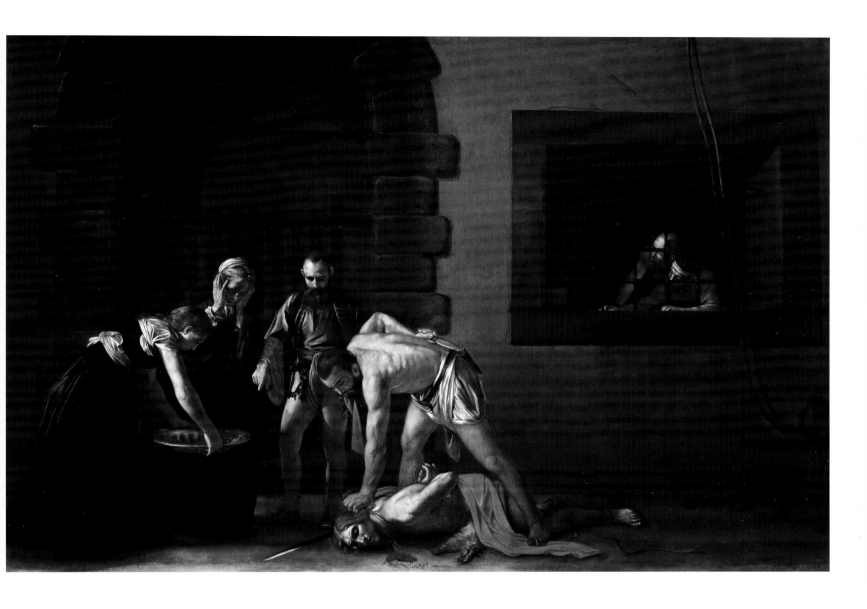

in the background is enshrouded with insubstantial colours and seems suspended in the air, his arms and chest naked, his body covered with a white veil that contrasts sharply with the darkness of the scene. On the right side of the altar one can see Christ calling Saint Matthew for his apostolic mission. Other figures are painted in a very natural manner, notably the saint who has stopped counting his money, one hand on his chest, and is now turning towards the Lord. By his side is an old man putting on his glasses and observing a young man sitting at the angle of the table who is grabbing a few coins. On another panel, the saint martyr, clothed in the priestly outfit, is lying down on a bench while, in front of him, the executioner is brandishing his sword to execute him while the people who attend the scene move back in horror. Although the painting has been reworked twice, the flimsiness of the composition and the gestures of the characters do not convey the tragedy of the event. The obscurity of the chapel and the dark colours of the canvas give a disservice to the

The Beheading of Saint John the Baptist, 1608.
Oil on canvas, 361 x 520 cm.
St John's Co-Cathedral, Valletta, Malta.

contemplation of these two paintings. The artist then produced for the church of Sant'Agostino the other painting of the Cavaletti chapel, a Madonna standing up, holding the divine Child in her arms while he is giving his blessing to two pilgrims kneeling in front of them, their hands joined in prayer. The first one is a poor man, with bare feet and legs, carrying on his shoulder a leather bag and his pilgrim's stick. He is accompanied by an old woman with a headdress.

But among the best works produced by Caravaggio's brushes, *The Entombment* (p. 70) in Nuova dei Padri del Oratorio, where the figures are placed above a stone at the entrance of the sepulchre, is held in particular esteem. The sacred body is visible at the centre and Nicodemus is holding his feet. On the other side Saint John passes an arm under the shoulder of the Redeemer whose face is looking up, his chest showing the pallor of death, his arm falling out of the shroud, and the whole nude figure is treated with the most faithful sense of imitation. Behind Nicodemus one can catch sight of three women crying, one raising her arms, the other concealing her eyes and the third contemplating the Lord. In the church of Santa Maria Del Popolo, in the Assumption chapel painted by Annibale Carracci, the two paintings on each side are by Caravaggio's hand: *The Crucifixion of Saint Peter* (p. 65) and *The Conversion of Saint Paul* (p. 69) whose scenes have been treated without any heroic movement. Still benefiting from the protection of Marchese Vincenzo Giustiniani, Caravaggio produced these paintings for him: *The Crowning with Thorns* (p. 86) and *The Incredulity of Saint Thomas* (pp. 76-77). In the latter, the Lord is grabbing the hand of Saint Thomas and taking the saint's finger to his wound while uncovering his chest by lifting the shroud covering him. In addition to these two figures he also painted an *Amor Victorious* (p. 89), *or Cupid,* brandishing arrows in his right hand, while arms, books, and other instruments representing trophies are lying at his feet. Other Roman noblemen, attracted by the magic of his brushes, commissioned paintings from him, notably Marchese Asdrubale Mattei, who asked him to undertake *The Taking of Christ* (p. 46), also in half-figures. Judas' hand lies on the Lord's shoulder after kissing him. Nearby, a soldier in armour extends his arm and his iron-gloved hand towards the Lord, who, resigned and humble, endures being arrested with his hands crossed in front of him, while, at the back, Saint John is fleeing, arms raised and hands open. The painter has imitated with great precision the black bronze armour of the soldier whose head and face are covered with a helmet that only reveals his profile. Behind him a lantern is raised, feebly lighting two other heads with helmets. For the noblemen Massimi, Caravaggio undertook the famous painting *Ecce Homo*, which was transferred to Spain, and for the Marchese Patrizi, *The Supper at Emmaus* (pp. 84-85), in which Christ is represented at the centre, blessing the bread while one of the sitting disciples, having recognised him, is opening his arms; the other, his hands on the table, is looking at him, amazed; behind

The Annunciation, 1608-1609.
Oil on canvas, 285 x 205 cm.
Musée des Beaux-Arts, Nancy.

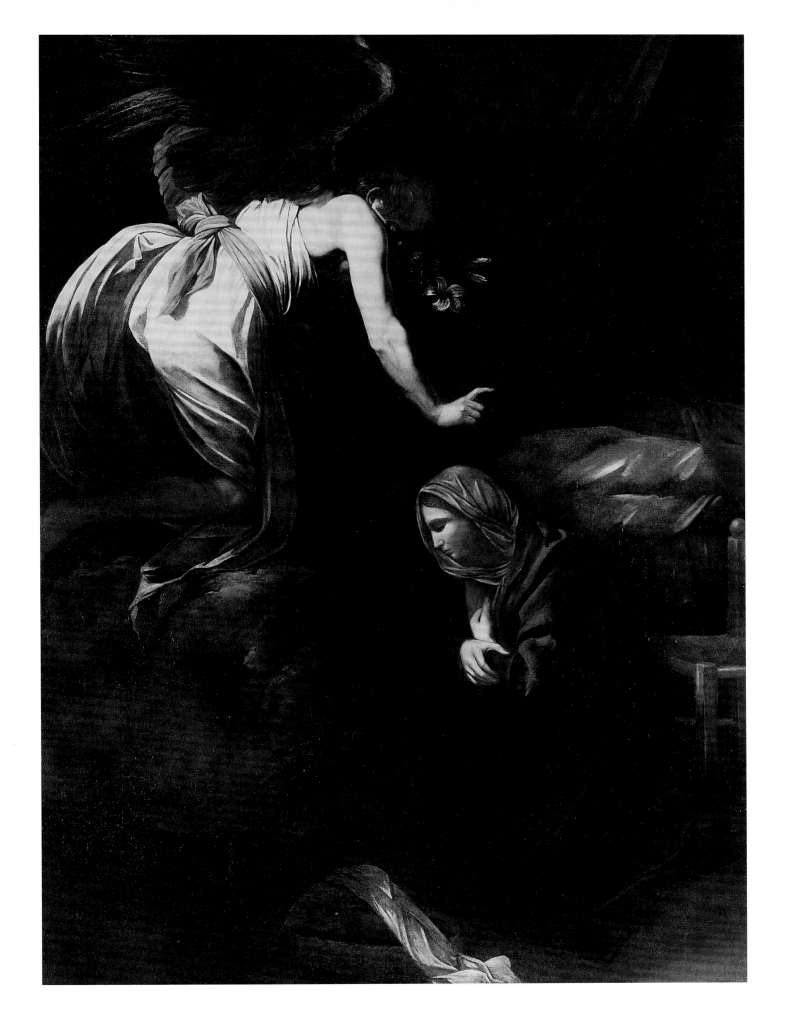

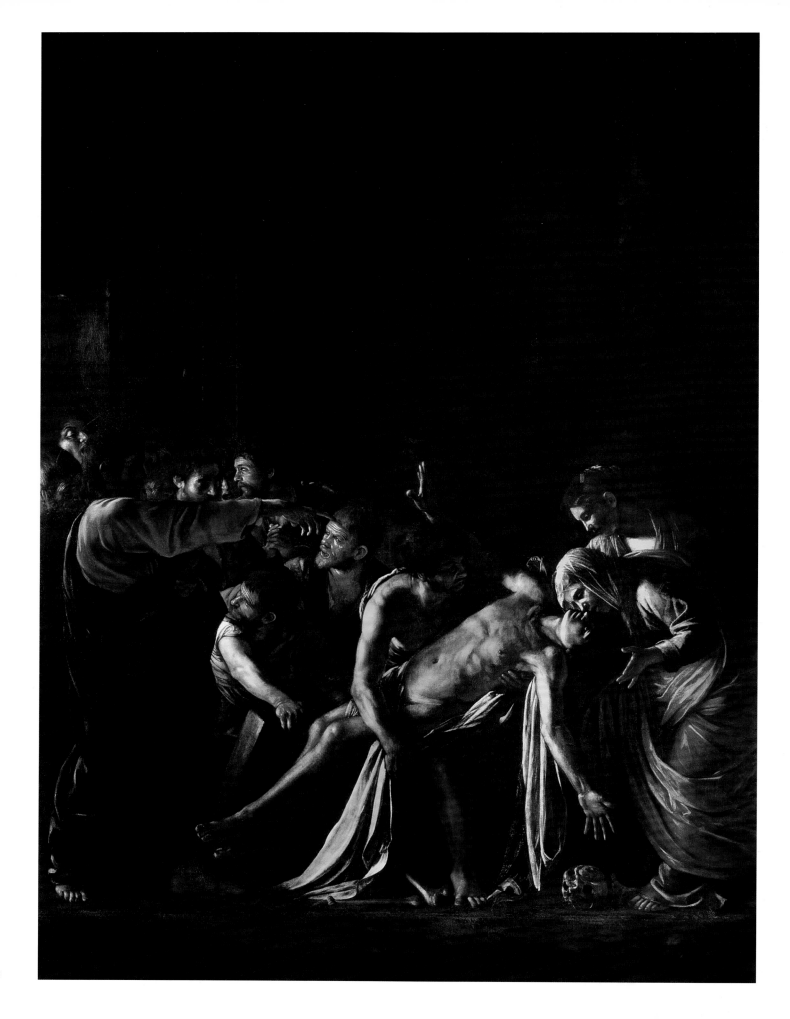

them stands the innkeeper wearing a hat and an old woman bringing the dish of food. For Cardinal Scipione Borghese, Caravaggio painted another version of this creation, rather different: the first painting is more colourful but both extol the virtues of natural colour, even these compositions, that Caravaggio treats like common domestic scenes, lack a sacred tone. For the same Cardinal, he painted a *Saint Jerome Writing*, stretching his hand and quill towards the inkwell, and a half-figure of David brandishing Goliath's head by the hair with one hand (the painter has represented himself in the guise of Goliath), holding his sword with the other. David is painted with the features of a young man, half naked, his shirt showing his bare shoulder; the shadows and the blackness of the background give more strength and relief to the figures and to the elements of the composition. As he particularly appreciated the paintings that Caravaggio created for him, the Cardinal decided to introduce the painter to Pope Paul V. The painter made a portrait of the Pope sitting, for which he was paid generously. For Cardinal Matteo Barberini, who was to become Pope Urban VIII, Caravaggio painted, in addition to his portrait, the *Sacrifice of Isaac*, in which Abraham is brandishing his knife against the face of his son who, firmly held, utters a scream.

Despite his activity as a painter, Caravaggio did not abandon his inclination to arms, and after a few hours dedicated to painting, he was off to town armed with his sword to practise his technique, therefore proving that painting was not his only occupation. One day he quarrelled while playing court tennis with a young friend, the two men ended fighting with the racquets. Then, grabbing his sword, Caravaggio killed the young man and was injured himself. As he was pursued, he ran away from Rome penniless and went to Zaragolo, where he found protection from the Duke Don Marzio Colonna, for whom he painted *Christ at Emmaus* sitting between the two disciples, and another painting of Mary Magdalene. He then took the road to Naples where he rapidly found employment as his name and manner were already well known. For the di Franco family chapel in the church of San Domenico Maggiore he was commissioned to paint *The Flagellation of Christ at the Column* (pp. 184-185), and for the church of Santa Anna de Lombardi, *The Resurrection*. In Naples one can see one of his best works: the *Denial of Saint Peter*, exhibited in the sacristy of San Martino, representing the handmaid pointing at Saint Peter, whose hands turning towards himself indicate that he is repudiating Christ. Saint Peter is painted with dark colours while the other characters of the scene are warming themselves by the fireplace. In the same town, he undertook for the church of Pio Monte della Misericordia a ten-palm high painting entitled *The Seven Works of Mercy* (p. 136). This painting is notable in the way it portrays the face of an old man who passes his head through the bars of the prison and drinks the milk of a woman, who talks to him whilst breastfeeding him. Among the other figures is a dead body, whose feet can be seen, being taken to his grave. The torch

The Raising of Lazarus, 1608-1609.
Oil on canvas, 380 x 275 cm.
Museo Nazionale, Messina.

held by one of the men carrying the corpse reveals a priest with a white surplice that enlightens the composition and gives it its sacred character. Caravaggio wanted to receive the Cross of Malta which was usually attributed to deserving or virtuous men as a proof of gratitude. That is why he decided to embark for the island of Malta where, on his arrival, he was introduced to the Grand Master of Wignacourt, a French nobleman. Caravaggio painted a portrait of the Grand Master, standing up, in formal armour, and another one, sitting and unarmed, wearing his Grand Master's robes. The first of these paintings is in the Armoury of Malta. To thank him, the Grand Master gave him the Cross and commissioned *The Beheading of Saint John the Baptist* from him for the church of San Giovanni. The saint lies on the ground and the executioner, after having injured him with his sword, is grabbing his dagger and holds him by the hair to sever his head. Herodias observes the scene as well as an old woman, afflicted by the spectacle, while the jailer, in a Turkish outfit, is present at the terrible scene. In this work, Caravaggio uses all the techniques of his palette to reproduce the scene with intensity, to the point of neglecting to paint the background, that therefore still shows the colour of the canvas primer. In addition to having offered the Cross to him, the Grand Master, very satisfied, put round his neck a precious golden necklace and gave him two slaves as a proof of his esteem and to congratulate him for his work.

In the same church of San Giovanni, the painter undertook for the chapel of Italy two half-figures placed above the two doors: *Mary Magdalene* and *Saint Jerome Writing*. He painted another Saint Jerome meditating on death with a skull in front of him (*Saint Jerome in Meditation*), a painting that has remained in the same building ever since. Awarded with the Cross of Malta and covered with eulogies, Caravaggio could have lived happily in Malta, benefiting from a certain wealth and from the admiration of all. But suddenly his tormented mind made him give up this state of relative prosperity and lose the benevolent protection of the Grand Master. Indeed, having an untimely quarrel with a noble knight, he was thrown into prison and reduced to terror and exhaustion. He had to face many dangers to escape the prison during the night and fled to Sicily quickly and in secrecy.

Having reached Syracuse, he undertook for the church of Saint Lucy situated outside the Marina, the *Burial of Saint Lucy*, in which one can see the archbishop giving his blessing to the Saint as well as two characters digging her grave. After arriving in Messina, he painted a *Nativity* for the Capuchins on which he placed the Madonna and Child in front of a ruined crib and piled up beams and planks with Saint Joseph by their side, leaning on his stick, and a few shepherds looking on in adoration. For the Capuchins again, he painted a *Saint Jerome* writing in the Book for the Lazzari chapel of the church Degl'infirmi and *The Raising of Lazarus*, who is taken out of the sepulchre and opens his

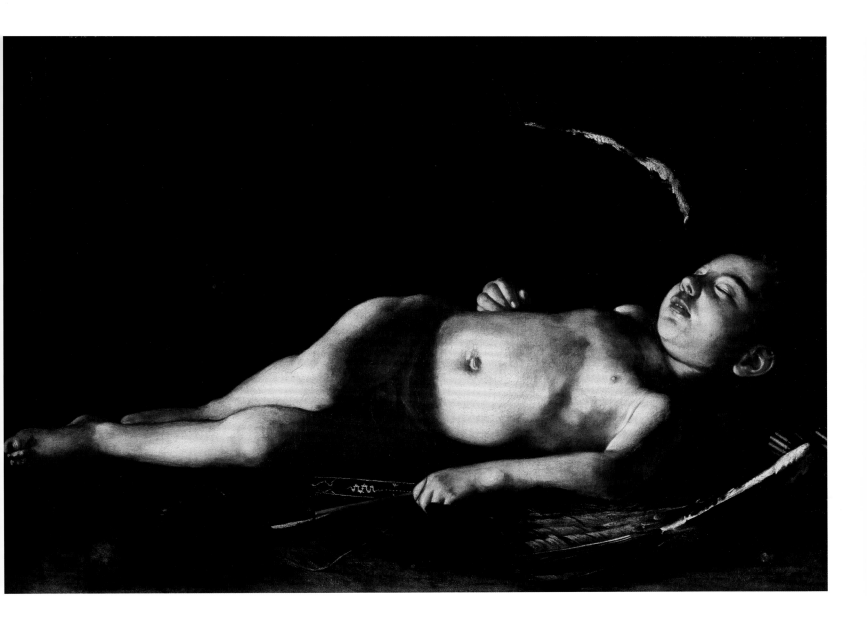

arms when hearing the voice of Christ, who calls him and stretches his hand towards him. Martha is crying and Mary is struck with astonishment while another character is holding his nose to protect himself from the putrid smell of the corpse. The painting is of a large format and the figures contrast with the dark background where a grotto can be seen and a bright glow falls on Lazarus' naked body and on the two characters who support him; this work is held in great esteem for its power of evocation.

But Caravaggio's misfortune did not abandon him, and fear hunted him from place to place. He crossed Sicily, leaving Messina for Palermo where he painted another *Nativity* for the Oratory of the Company of San Lorenzo; in this painting the Virgin contemplates her newborn baby in the company of Saint Francis and Saint Lawrence. Saint Joseph is also sitting nearby and an angel, flying through the air and iridescent

Sleeping Cupid, 1608.
Oil on canvas, 72 x 105 cm.
Palazzo Pitti, Florence.

with light, contrasts with the shade. After completing this work, afraid of staying in Sicily any longer, Caravaggio left the island and sailed again for Naples where he thought he could stay until he received the news of his pardon from the Pope and the permission to return to Rome. In an attempt to please the Grand Master he sent him a painting of Herod with the head of Saint John on a platter. His diligence was to no avail; indeed, one day, as he was standing in the doorway of the Ciriglio inn, some armed men suddenly surrounded him, beat him and slashed his face. As soon as it was possible, he embarked on a felucca and, full of bitterness, set out for Rome after having obtained, through the intercession of Cardinal Gonzaga, his pardon from the Pope. When he reached the shore, the Spanish guard, who was waiting for another knight, arrested him by mistake and held him prisoner. Although he was soon granted his liberty, he could not find the felucca on which he had embarked and that carried all his belongings. Anguished and desperate, he ran along the shore under the hot summer sun to Porto Ercole where he arrived exhausted and collapsed, victim of a malignant fever. He died within a few days, almost reaching the fortieth year of his life, in 1609, a tragic year for painting, as both Annibale Carracci and Federico Zuccaro also died the same year.

Thus Caravaggio lost his strength and his life on a deserted beach. While in Rome his friends were waiting for his return, the unexpected news of his death reached them and aggrieved many of his admirers. His very good friend, the Knight Marino, paid a tribute to him by writing the following verses:

> Against you, Michelangelo,
> Death and Nature have fomented a cruel conspiracy.
> The second feared to be defeated by
> your hand with each image
> you created and not copied.
> The first, decimating people with her scythe,
> was consumed by indignation
> when, with your brush, you gave them life again....

Caravaggio started painting at a time when Naturalism was not really in fashion and when human figures were painted in a conventional manner in which grace took precedence over realism. Purifying his colour from any artificial element and vanity, he deepened the hues and gave them back life and blood, giving painters the sense of imitation. However, he would never use cinnabar red or azure blue in his figures, and if by chance he employed them, he would then reduce their strength, saying that they were the poison of colours. There is no need to say that he never used deep or clear blue skies in his compositions. Indeed, his backgrounds were always dark and

Adoration of the Shepherds, 1609.
Oil on canvas, 314 x 211 cm.
Museo Nazionale, Messina.

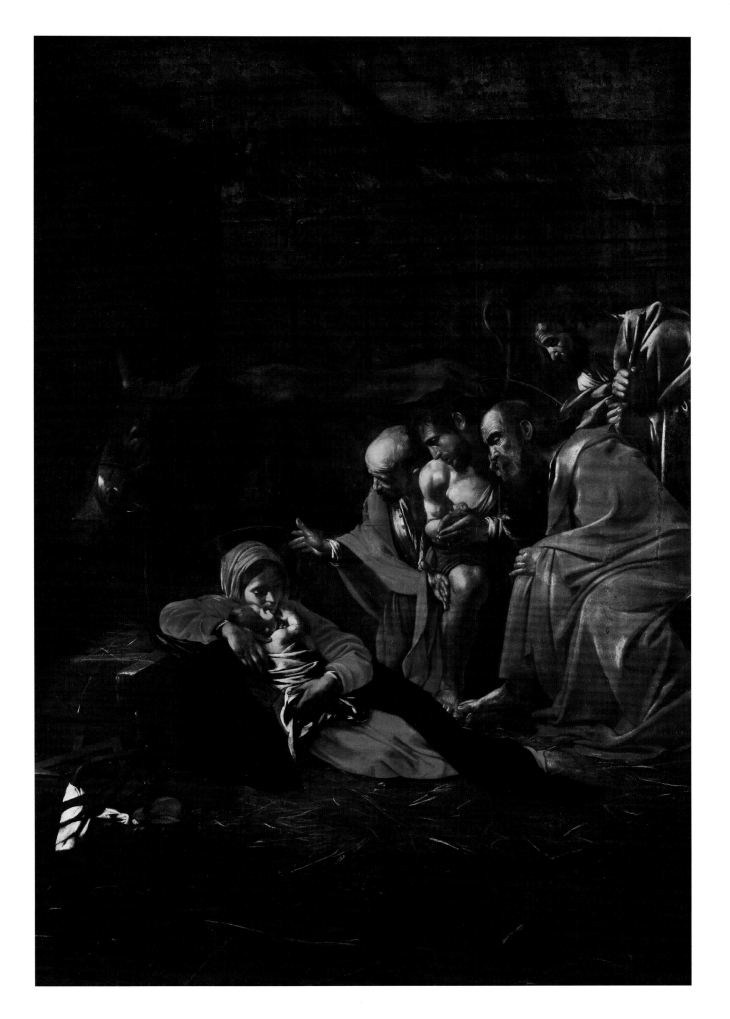

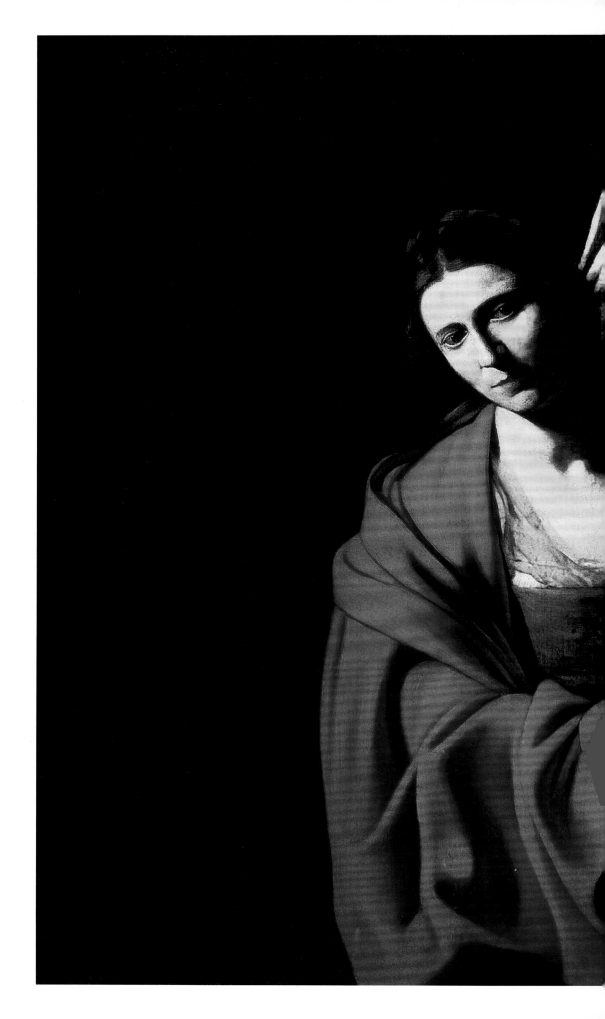

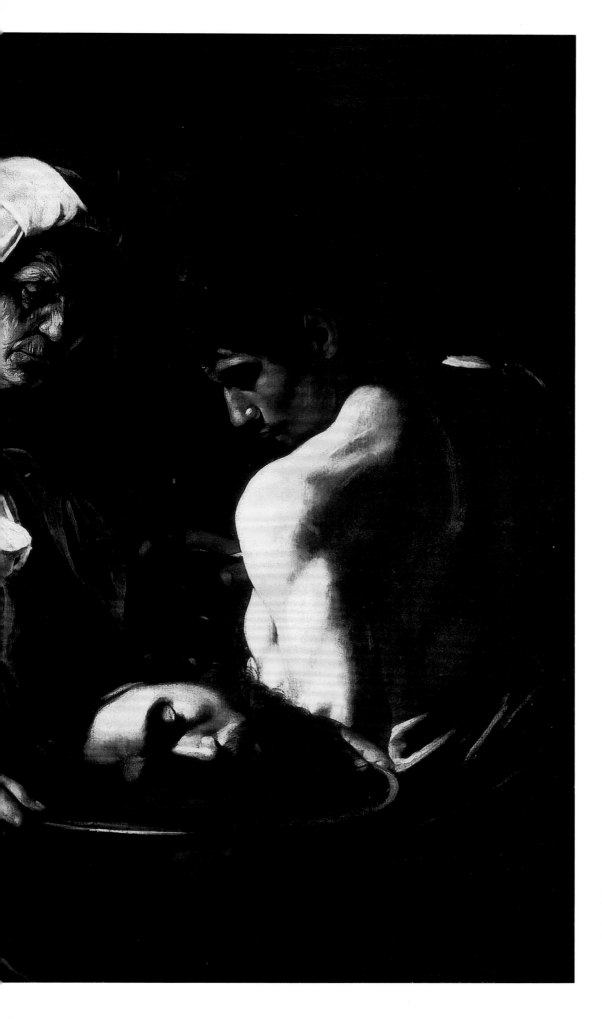

Salome with the Head of Saint John the Baptist, c. 1609.
Oil on canvas, 116 x 140 cm.
Palazzo Real, Madrid.

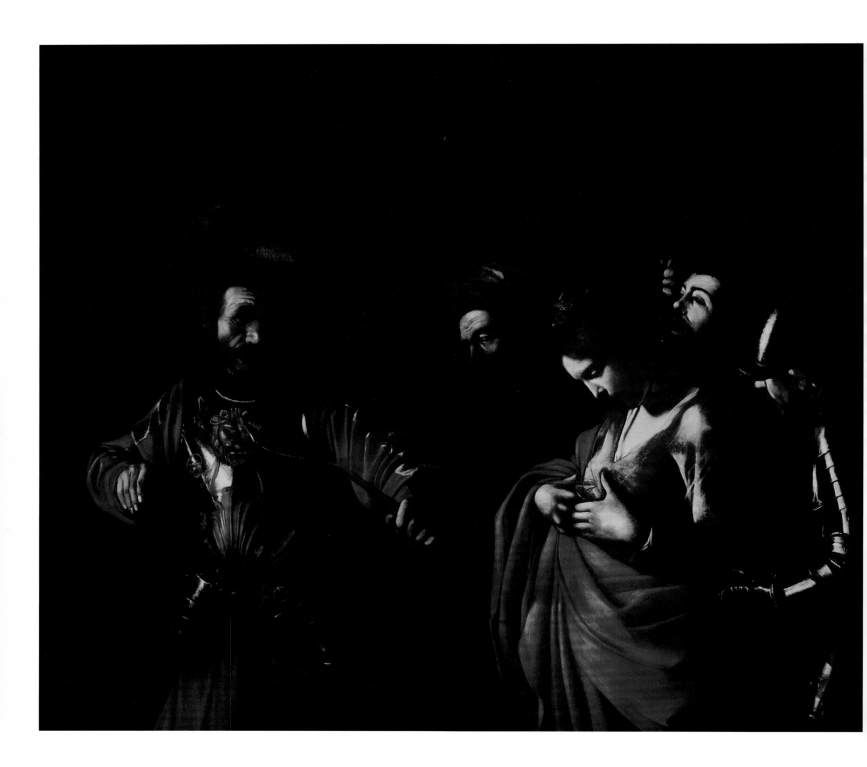

crepuscular. He used black as well for the painting of flesh, reserving the strength of light to some areas of the composition. He was so faithful to the model that he refused to make any brushstroke that would be inspired by his imagination and that would not serve to imitate nature. He also believed that for an artist, not to be obligated to academic rules was the height of art.

This new manner was so successful that he managed to convert some of the best painters of the time, trained in the most renowned schools. This was the case with Guido Reni, who imitated his manner for a while, as shown by the Naturalism of his *Crucifixion of Saint Peter* in Tre Fontane, and of the painter Giovanni Francesco da Cento, who did the same. Full of the praises he was receiving, Caravaggio did not appreciate the works of any other painter, declaring that he was the only true imitator of Nature while he was still lacking many of the best techniques of an artist. His painting lacked creativity, decorum, nobility, drawing, and technique. Take away the model from his eyes and his hand and imagination became helpless.

Many of the best painters, attracted by his technique, imitated him gladly because without any study or exertion they yielded to the easy way by copying what they could see around them and painting vulgar bodies without beauty. So, as Caravaggio had underestimated the majesty of art, each painter he inspired rejected it, giving less value to beautiful things and rejecting Antique painters and the work of Raphael. Since it was easier to paint from life and reproduce a face from nature than creating a painting from a story, painters dedicated themselves to making half-figures, which had not been commonly used before. Then came the time for imitating trivial subjects, searching for obscenity and deformity, as some had dreamt to do. If they had to paint armour, they would choose the rustiest, if they had to represent a vase, they would not paint it in its entirety but chipped or cracked. The clothes they chose to paint were their own shoes, breeches, or common caps, and so in imitating bodies all their study fixed upon wrinkles, and if they had to represent bodies they would go as far as painting the defects of the skin and even knotted fingers and limbs distorted by disease. For these reasons Caravaggio encountered some disappointment when his canvases were rejected, as we saw happen in San Luigi. The same fate awaited *The Death of the Virgin* in the church of La Scala, refused because the painter had too closely imitated the swollen body of a dead woman. The other picture of Saint Anne was also removed from one of the minor altars of the Vatican Basilica because he portrayed the Virgin with common features and the Infant Jesus naked, as can be seen in the Villa Borghese.

In Sant'Agostino the dirt on the pilgrims' feet shocked his commissioners and in Naples, in *The Seven Works of Mercy*, at the risk of shocking his contemporaries, he

The Martyrdom of Saint Ursula, 1610.
Oil on canvas, 154 x 178 cm.
Banca Commerciale Italiana, Naples.

painted a man who was raising his flask and drinking with his mouth open, letting the wine pour into his mouth in a shameful manner. In his *Supper at Emmaus*, in addition to the peasant look of the two disciples and the depiction of Christ as a young man without a beard, one can see the innkeeper wearing a cap and on the table is a dish of grapes, figs and pomegranates which were out of season. Just as some plants produce both healing medicine and deadly poison, Caravaggio's painting had both a beneficial and harmful influence, shunning the art of ornaments and good practices in painting. The painters who had turned away from the imitation of Nature needed someone to put them on the right path, but while fleeing one extreme they fell into another; getting away from Mannerism to search for Naturalism at any cost, they cut themselves off from art and plunged into darkness until Annibale Carracci arrived to enlighten their minds and restore beauty to the imitation of Nature.

Caravaggio's manner was the image of his physiognomy and appearance: "His skin was dark and he had dark eyes, dark eyebrows and his hair was black. But he was nevertheless naturally gifted in his art." His early style, soft and pure in colour, was his best because he achieved great results and was recognised as the best Lombard colourist. But then he chose a darker palette, drawn from his own tormented and quarrelsome temperament; he had to leave Milan and his native land, then he was forced to run away from Rome and Malta to hide in Sicily and Naples, to face numerous perils and then die miserably on a beach.

His colours were so appreciated that his figure of Saint Sebastian with two henchmen tying his hands behind his back was sent to Paris. The Count of Benevento, who was Viceroy of Naples, took the Crucifixion of Saint Andrew to Spain, and the Count of Villamediana kept the half-figure of David and the portrait of a youth with an orange blossom in his hand for his own collection. In Antwerp, in the church of the Dominicans, is conserved the painting of the *Madonna of the Rosary*, a work that contributed largely to the reputation of his talent. In the Ludovisi Gardens near the Porta Pinciana in Rome, the painting *Jupiter, Neptune, and Pluto* (p. 50) is said to be by his hand. It is painted on the ceiling of the casino of Cardinal Del Monte, who was keen on chemistry. Caravaggio decorated his laboratory with the famous gods who represented the elements, a globe in the middle of them. Offended that some may have said he knew nothing about perspective, Caravaggio used all his expertise to paint the figures seen from underneath, using the most difficult technique of foreshortening. It is true that the figures of his gods are far from realistic and were painted in oil on the vault as Caravaggio had never practised the art of the fresco. All his followers who painted from life always used oil. Many painters imitated his manner of painting from life and were therefore called 'Naturalists'.

Nativity with Saint Francis and Saint Lawrence, 1609.
Oil on canvas, 268 x 197 cm.
San Lorenzo, Palermo, until 1969 (whereabouts unknown).

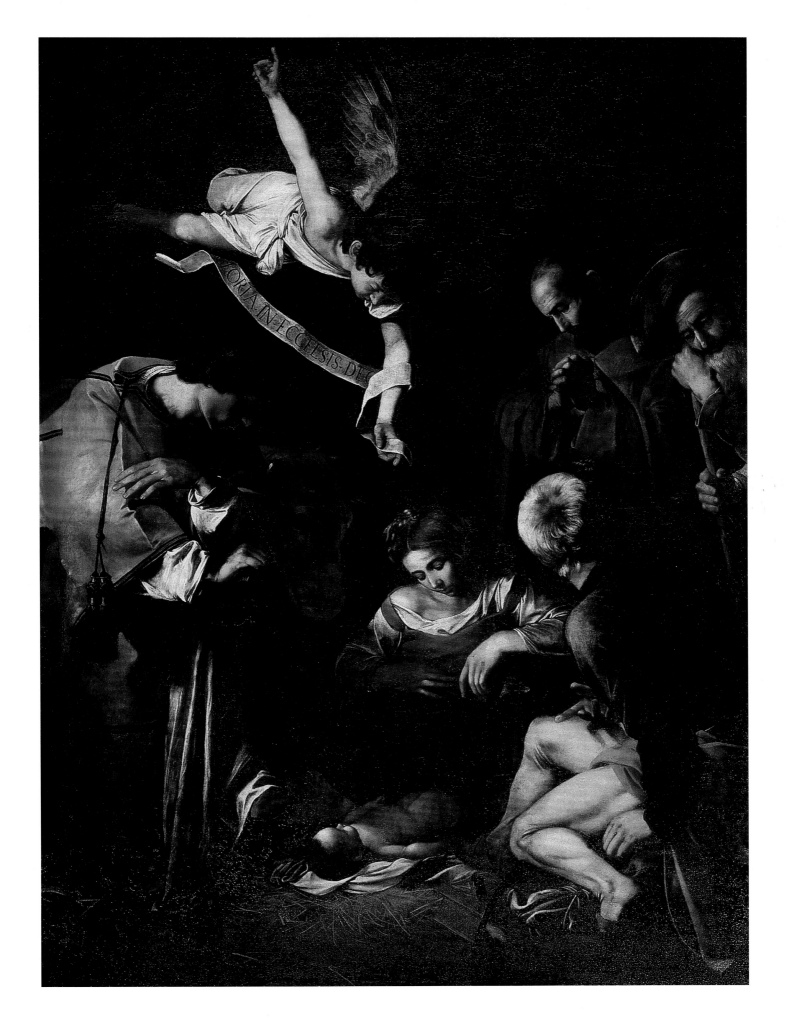

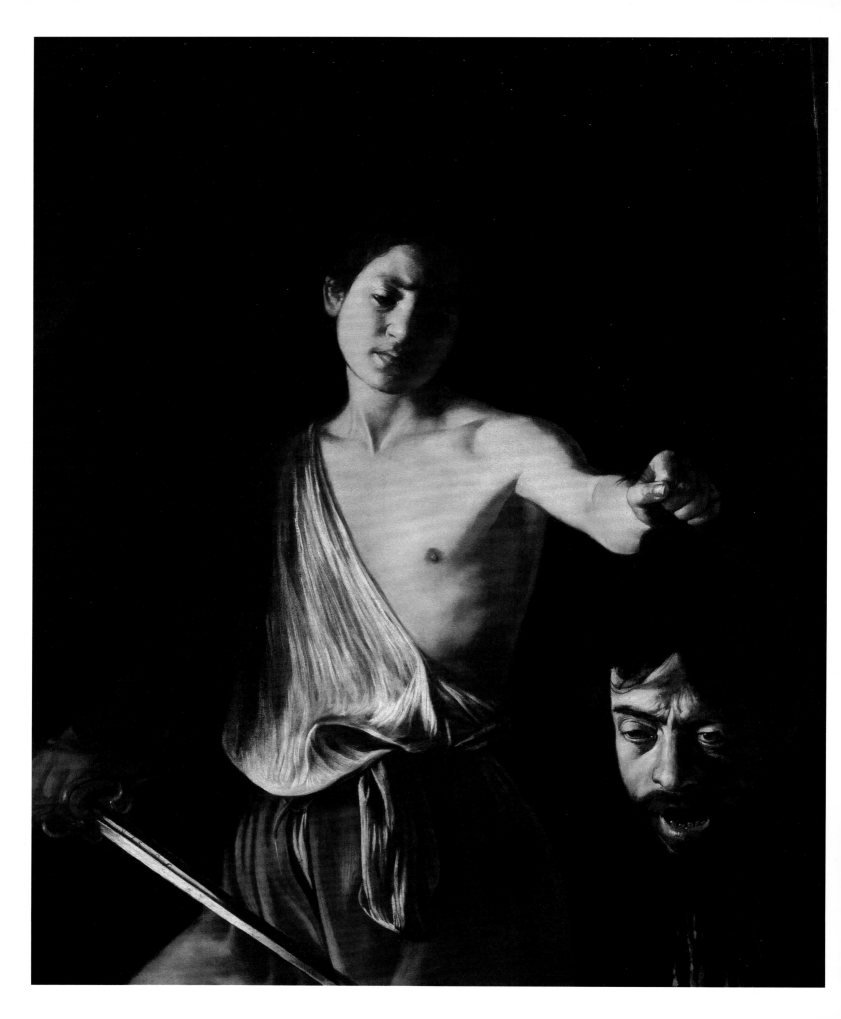

Notizia by Mancini

Our generation is fully indebted to Michelangelo Merisi da Caravaggio for the style he created and that is now largely imitated. Caravaggio, his hometown from which he took his name, produces honourable citizens, such as his father, who was foreman and architect for the Marchese of Caravaggio. In his teenage years, he served a four or five year apprenticeship in Milan where he sometimes found himself in trouble because of his extravagance: the reflection of a brisk and passionate mind and of a strong personality.

When he was twenty, he went to Rome, where, from lack of means, he was obliged to live at Pandolfo Pucci da Recanati's, beneficiary of Saint Peter, where he had to work to pay his board and lodging by doing tasks that displeased him. This arrangement was not entirely satisfying to him in view of the poor quality of the food provided. Indeed, he was sometimes served for his supper a salad as starter, main course and dessert. Therefore, after a few months, he left this house, rather unsatisfied by the services provided by his host whom he nicknamed 'Monsignor Insalata'. During this period, he undertook several copies of religious paintings that are now exhibited in Recanati; he also painted several works that he sold, notably one representing a young boy crying because he has been bitten by the lizard he is holding in his hand, another with a young boy peeling a fruit with a knife, and the portrait of an innkeeper with whom he was staying.

Not long after, struck down by illness and with no money, he was obliged to go to the Hospital of Consolation, where he undertook during his convalescence many paintings for the prior of the hospital, who then took them to Sicily, his motherland. Thereafter, I was told that Caravaggio was accommodated in the residence of Cavalier Giuseppe and Monsignor Fantin Petrignani, who offered him a bedroom. This arrangement allowed him to undertake many paintings, in particular one representing a Bohemian woman telling the fortune of a young man, the famous painting of the *Rest on the Flight into Egypt*, *The Conversion of Mary Magdalene*, a *Saint John the Evangelist* and, later, *The Entombment of Christ* in the new church, paintings for San Luigi (San Luigi dei Francesi), and *The Death of the Virgin* in Santa Maria della Scala. But the fathers, who had learned that Caravaggio had asked a simple courtesan to model for the Virgin Mary, removed the painting that is now owned by Monsignor of Mantua. He also painted the *Madonna di Loreto* (San Loreto), that of the altar dedicated to Palafrenieri in Saint Peter's, as well as many paintings now belonging to the Borghese family, those of the Cerasi chapel in the

David with the Head of Goliath, 1609-1610.
Oil on canvas, 125 x 101 cm.
Museo e Galleria Borghese, Rome.

church of Santa Maria Del Popolo, and many paintings now owned by the Mattei, Giustiniani, and Sannesio families.

After certain events endangering his life, he had to ask Onorio Longo for protection, and after having killed a man with whom he had quarrelled, he had to run away from Rome. He then went to Zagarola where he was secretly sheltered by the Prince and painted a Mary Magdalene and a Christ on the road to Emmaus, works acquired by Monsignor Costa in Rome. Their sale allowed him to reach Naples, where he painted a few works and from whence he reached the island of Malta, where he carried out a few paintings appreciated by the Grand Master, who, as a sign of recognition, granted him the Knighthood of the Order of Saint John of Jerusalem. Hoping to obtain his rehabilitation, he went to Porto Ercole where, struck by a malignant fever and without receiving any care, he died of exhaustion at the age of 39 at the height of his glory, and was buried nearby.

It is undeniable that he reached a high level of perfection in painting characters and faces, as well as in mastering colour, and that the painters of this century owe him much. Nevertheless, to his expertise in art, he added strange habits. He had only one brother, of high morality, a priest and a man of letters, who, informed of his brother's eccentricities and knowing that he was living at Cardinal Del Monte's, thought it good to meet the latter and to tell him everything. He was asked to come back three days later. In the meantime, the Cardinal called Caravaggio and asked him if he had some family, to which he said no. As the Cardinal could not believe that the priest had lied to him on such an easily verifiable point, he had an enquiry undertaken and discovered that it was the painter who had lied.

After three days the priest came back and was received by the Cardinal who asked Caravaggio to come, too. The prelate showed him his brother and Michelangelo then affirmed he did not know him and that he was not his brother. The poor priest, encouraged by the presence of the Cardinal, spoke to him in these familiar terms: "Brother, I came from far only to see you and, having seen you, I obtained what I wanted, having come myself, by the grace of God, as you know, not for myself or for my children but rather for yours, if God gives you the grace of starting a family and having heirs. May God help you to succeed like I will ask Our Lord in my prayers and I know that your sister, in her chaste and virginal prayers will do the same." With these warm and affectionate words that did not seem to move Michelangelo, the priest left without his brother uttering any word to wish him *bon voyage* or say farewell. This event shows the extravagance of his character and the misbehaviour which may have deprived him of a few dozen years of life and may have tarnished his glory and reputation. If he had lived longer, he would have pushed his art even further for the great advantage of those who still follow his path.

David with the Head of Goliath (detail), 1609-1610.
Oil on canvas, 125 x 101 cm.
Museo e Galleria Borghese, Rome.

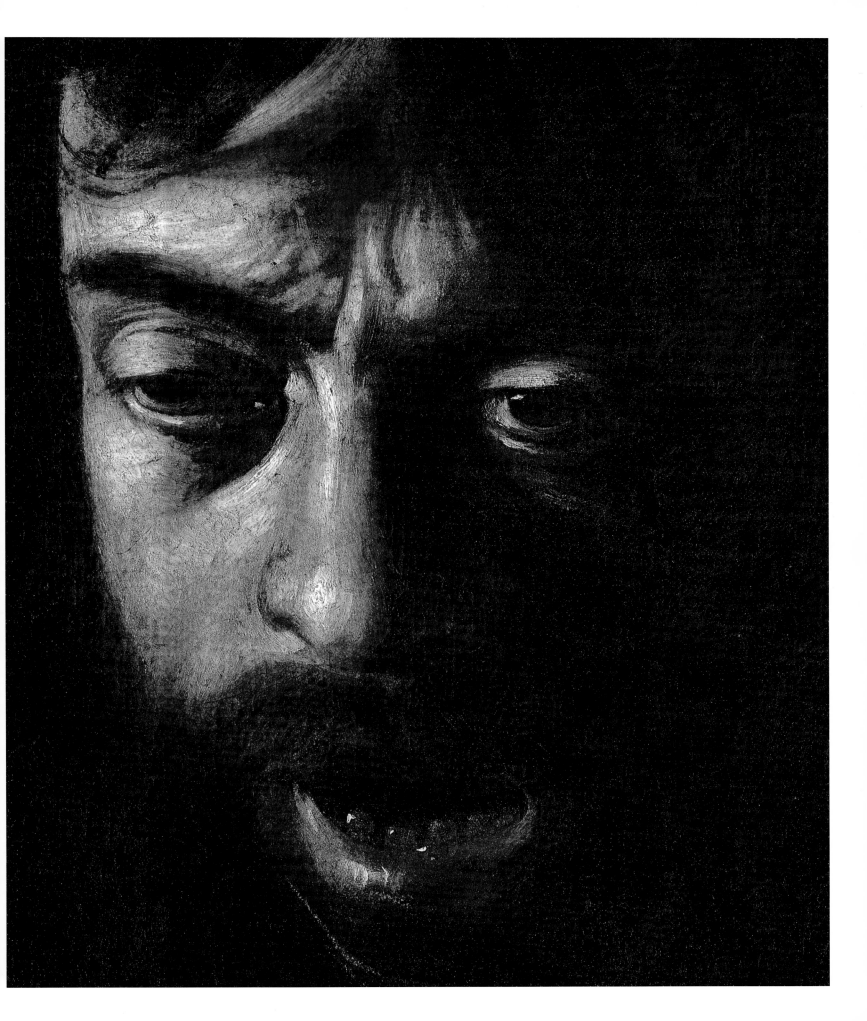

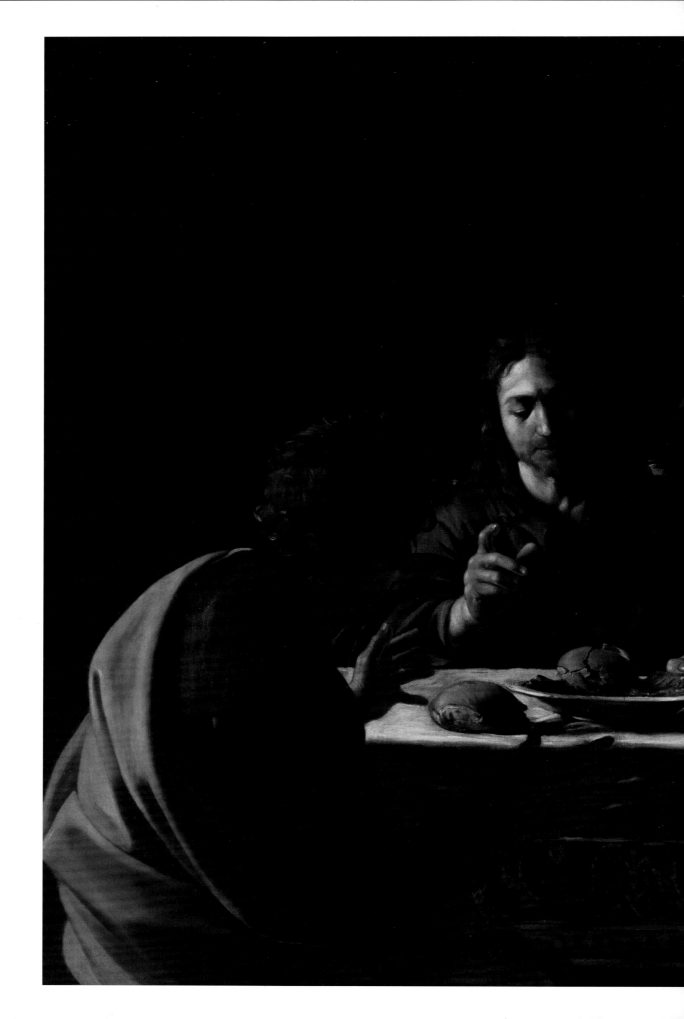

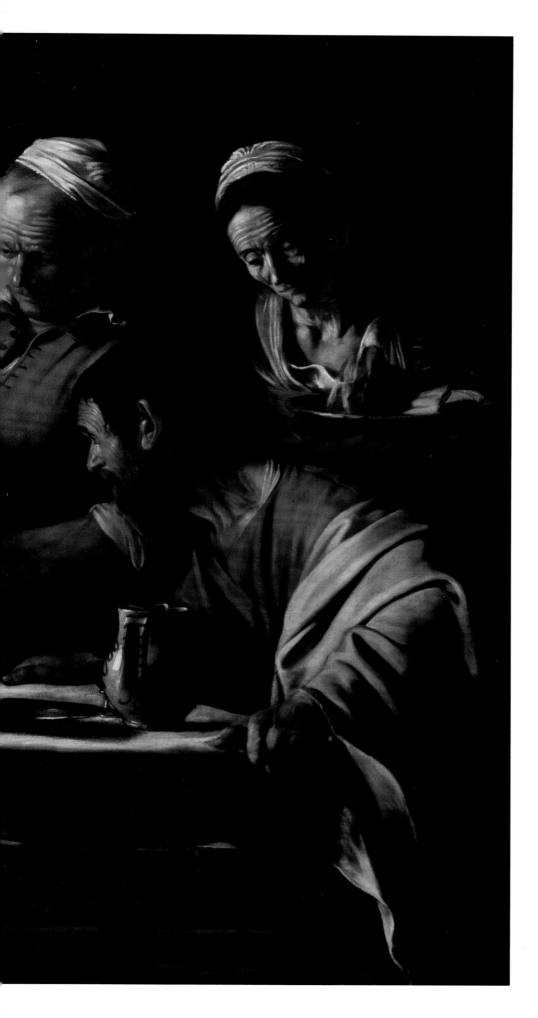

Supper at Emmaus, 1606.
Oil on canvas, 141 x 175 cm.
Pinacoteca di Brera, Milan.

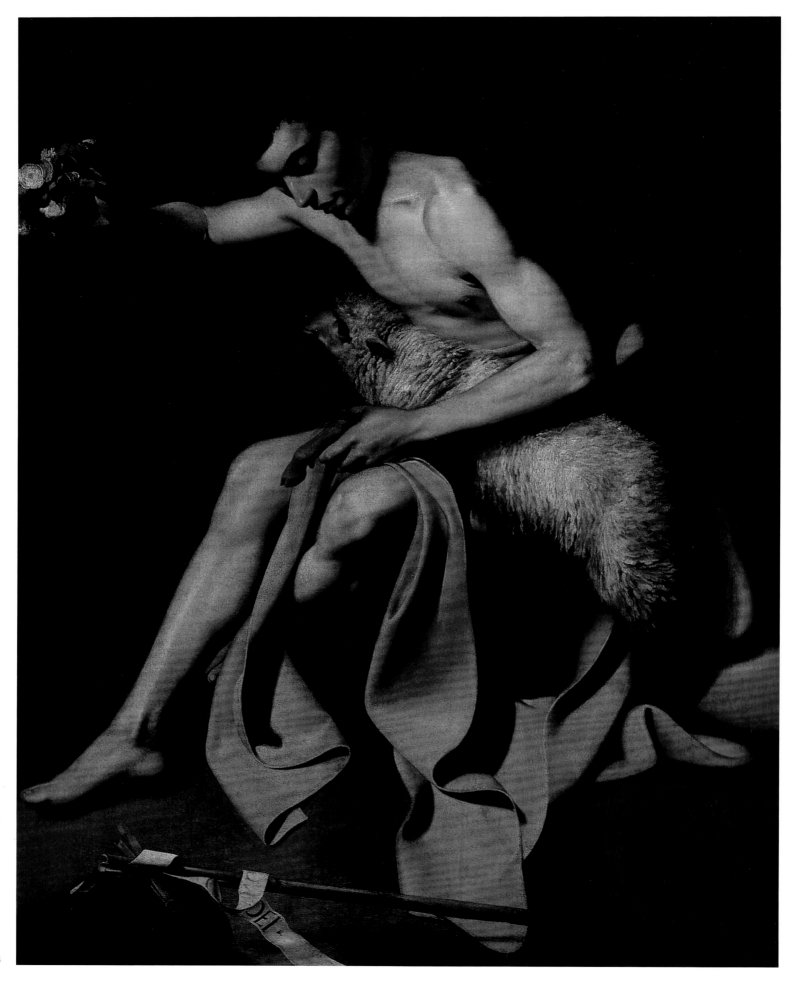

The Curriculum Vitae of a Criminal Painter

Around 1585, Caravaggio's contemporary Giulio Mancini reported "some extravagances from time to time that can be explained by a hot tempered and passionate temperament". In his youth, writings indicate that he prepared plaster for painters who painted frescos and also practised painting himself. After four or five years during which he painted portraits, being of a tormented mind he had problems with the law because of certain quarrels and had to flee Milan (Bellori).

Between 1590 and 1595 – Disagreement between Caravaggio and the Cavalier d'Arpino but the duel never took place as Caravaggio was not a knight.

In 1599 – Fight between Onorio Longhi and the painter Marco Tullo; Caravaggio separated the rivals and as he was still convalescing, he had to have his sword carried by a young boy, "but he was incapable of using it. Caravaggio could hardly stand up, he could therefore not remove his sword from its scabbard".

19 November 1600, Rome – Caravaggio allegedly started an argument with Girolamo Spampa di Monte Poliziano. At three in the morning, while knocking on the door of a hardware shop to buy some candles, Girolamo Spampa was hit with a series of blows from a stick. He defended himself shouting; some butchers arrived with candles and Michelangelo drew his sword and engaged in a duel with Girolamo, who fought back with his own sword from which Caravaggio suffered lacerations "as one has been able to observe", Caravaggio took flight and was therefore recognised. Orazio Bianchi confirmed his testimony, but a verdict was never reached.

7 February 1601 – Michelangelo da Caravaggio obtained a pardon from the sergeant of the Castel Sant'Angelo prison, Flavio Canonico, whom he had hit with his sword, and the trial that had already started was cancelled. Canonico was the companion of Caravaggio in the affair against the architect Onorio Longo.

28 August 1603 – Fight between the painter Baglione and Onorio Longhi, Michelangelo da Caravaggio, Orzio Gentilesco and the Roman painter Filippo

Saint John the Baptist, 1609 (?).
Oil on canvas, 102.5 x 83 cm.
Öffentliche Kunstsammlung,
Kunstmuseum, Basel.

Trisegni, about "the famous nickname". Gian Baglione was nicknamed Gioan Bagaglia or Gian Coglione.

The witness of Salini accused Caravaggio and Onorio Longhi of having written a pamphlet against Baglione. On 13 September 1603 in his deposition, Caravaggio mentioned the fact "of having been arrested the day before on Navona Square without knowing the motive". In addition he said: "Sir I am not guilty of composing vulgar or Latin verses." On 25 September 1603, after the intercession of the Ambassador of France, the Governor freed Caravaggio and summoned him to appear in court a month later, ordering him in the meantime not to offend the plaintiff, to consider his house as a prison and not to leave it without written authorisation from the Governor.

26 April 1604 – Quarrel between Michelangelo da Caravaggio and Pietro de Fosaccia, waiter in the Moro inn. Caravaggio threw a plate of artichokes at the waiter's face, injuring his cheek. Caravaggio was close to drawing the sword of one of his companions, but the waiter moved away and was advised not to quarrel with Caravaggio. According to the testimony of Pietro Antonio de Madii, copyist, Caravaggio had asked if the artichokes were in oil or butter. The waiter had responded that he did not know, and took one to smell it, a gesture that displeased Caravaggio greatly, who then got up in anger and said: "It seems to me that you, poor idiot, think that you are serving a rabble!" and he took the plate of artichokes and threw it in the face of the waiter.

20 October 1604 – One night, Caravaggio was surprised by some men at four in the morning in the street of the Trinity leading to the Popolo who asked "Why did you throw a stone?" and Michelangelo responded: "Go and search for the person who threw the stone, rather than insulting me with your abusive words."

18 November 1604 – It has been reported that, at five in the morning at the Bufalo canal lock, Michelangelo da Caravaggio was arrested by my men while carrying and brandishing a sword. When I asked him if he was authorised to carry a weapon, he responded in the affirmative and held the authorisation out to me. When I gave it back to him, I said to him that he could go and wished him 'Goodnight, Sir'. He responded in a loud tone saying "Back off ..." and it was then that I told him he was being arrested if he would not take back what he had said. I had him put to the ground while he was handcuffed and he repeated "Go to hell". This is why I imprisoned him in the Torre di Nona. (Archive of the State of Rome, police report, Vol. VIII, 1604-1606, sheet 38).

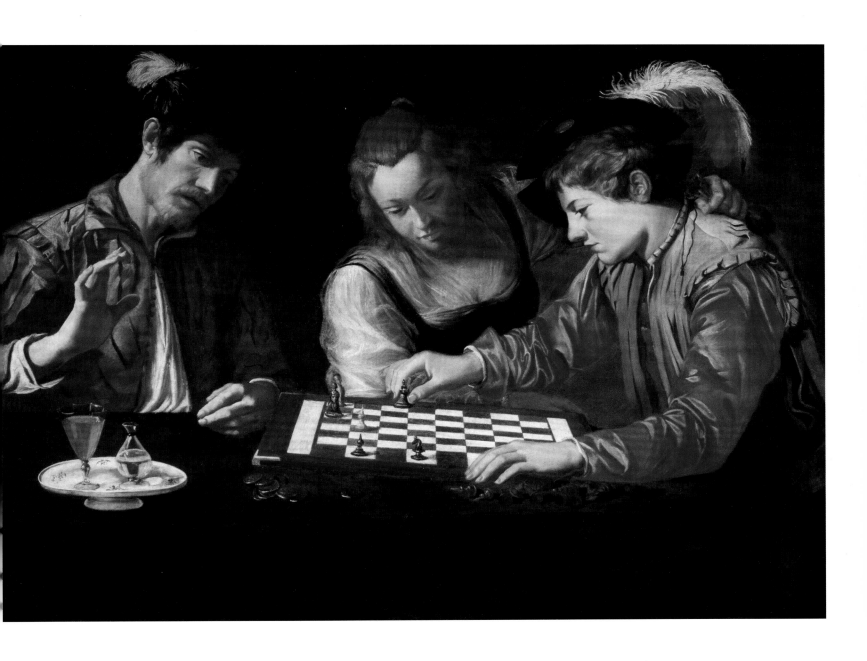

Follower of Caravaggio,
The Chess Players.
Oil on canvas.
Galleria dell'Accademia, Venice.

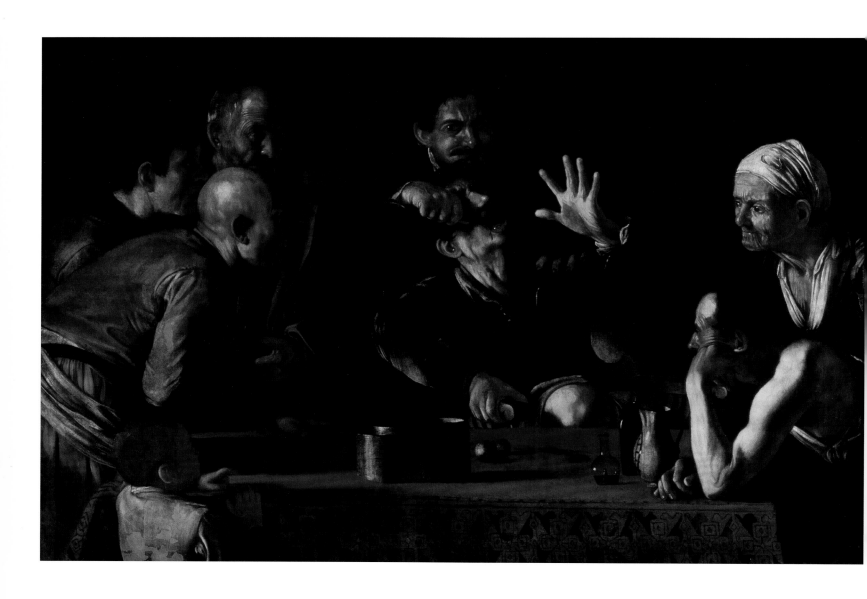

The Tooth Puller, 1608-1610.
Oil on canvas, 140 x 195 cm.
Palazzo Pitti, Florence.

28 May 1605 – Michelangelo da Caravaggio was imprisoned because, at seven in the morning, he was carrying and brandishing a sword without written authority.

20 July 1605 – Cherubino, painter of the Saint Sepulchre, Crocicchia Calzolaio, Prospero Orsi, painter, and Ottaviano Gabriello, bookseller, promised that Michelangelo da Caravaggio 'imprisoned in the Torre di Nona' will present himself before the Governor to obtain his freedom for the payment of 100 *écus* and that he will not offend Laura and her daughter Isabelle again, who had put him into court.

29 July 1605 – The notary of the Malefizii made a visit to Mariano Pasqualone da Accumulo, notary of Paolo Spada's office, who declared in his sworn deposition "having been attacked at around one in the morning 'by a group coming from behind' and having been struck with a stick that made him fall to the ground and then cut by a sword – injured on the head by the group. The testimony of Galeazzo Roccasecca recounted that he had seen a man armed with what seemed to be a sword or a pistol who immediately got up in three jumps … He had a blackbird on his shoulder and he told me that the injured person indicated that it could be none other than Michelangelo da Caravaggio". In the evening, on Navona Square, Pasqualone and Caravaggio had exchanged strong words regarding a woman called Lena, 'Michelangelo's wife'. Caravaggio affirmed that he had hit him in the face and not from behind. On the 28 August, having obtained a pardon, Caravaggio returned to Rome.

1 September 1605 – Michelangelo da Caravaggio threw stones against the shutters of Prudenzia Bruna, a Roman woman residing in Campo Marzio – at around five in the morning – because she had seized some of his belongings as recompense for the debts the painter owed her.

Between September 1605 and May 1606 – The work of Guido Reni who went to Rome in 1605 displeased Caravaggio a great deal as he was afraid that a new manner totally opposed to his own could put his work in the shade. He did not hesitate to criticise the work in the way his figures were too well observed and unrealistic. He searched for any occasion to challenge his painting, declaring one day that he would threaten him with his hands and not only with his paintbrush; he would surely have done it if Guido Reni with great ability had not avoided any meeting with Caravaggio and had not sought the protection of honourable people. One day, during an encounter, Caravaggio said to him that he did not think anything of him and that if he had come to Rome with the idea of living in the same city, he was willing to give him satisfaction in any way, that he will get rid of his arrogance

and advised him to stay at home and not visit others to plan any fights. Guido responded saying that he was his servant and that he came to Court to paint and not to fight a duel, not by free choice but to serve his Masters who had appointed him. Guido did not claim that "his value was equal to that of other painters", and knew and judged himself to be inferior to all. He also used this subtlety when he learned that Caravaggio also competed with other painters to obtain the commission for the dome of Santa Casa di Loreto. Being supported by Cardinals Sansio, Santi Quatro and more, Guido Reni told Caravaggio via Gio Battista Croce that he was also competing for the job and if he won the commission he would gladly give Caravaggio some work. Caravaggio responded by saying that he did not want this work or if he accepted it, he wanted to do it alone without his intercession or his help, and that he was perfectly capable of taking on this work on his own without these so-called masters. Caravaggio was asking himself why Guido Reni, who claimed to be such a generous soul, was spending his days searching for pictures signed by him while he, Caravaggio, would have given them to him directly. What mystery was behind this and what was the purpose of this behaviour? Why in the painting of the *Crucifixion of Saint Peter* with three fountains did he steal his manner and his palette? Even in this painting he had copied his style, he had nevertheless not stolen his reputation, he who was a man capable of killing this miscreant d'Arpino who could have easily fomented this conspiracy and provided him with this painting of Cardinal Borghese which was supposed to be by his hand. Guido Reni was particularly afraid of him and knew him to be very violent and determined, and as the project of the dome was finally given to Pomarancio the in-house painter and Master of his brothers, slashed or had his face slashed (Malvasia).

12 October and 16 November 1605 – Caravaggio received 32 *écus* from the public speaker Estense and promised but did not keep his word to paint a picture within a week.

Before 20 May 1606 – According to Baldinucci, Caravaggio, who could not stand Pomarancio any more, would have fled because the suspect "had spoken in very negative terms about his work".

Also, before 20 May 1606 – "Cigoli preferred to accompany him to the tavern so as not to suffer the outrage and persecutions of this man who had strange reactions ..." while Passignani was producing a painting of Saint Peter, or more precisely, while his student Niccodeme Ferrucci was doing preparatory work in the covered enclosure (Passignani was absent), Caravaggio broadly slashed the canvas with his sword, poking his head through the cut and looking carefully at the painting,

The Tooth Puller (detail). 1608-1610.
Oil on canvas, 140 x 195 cm.
Palazzo Pitti, Florence.

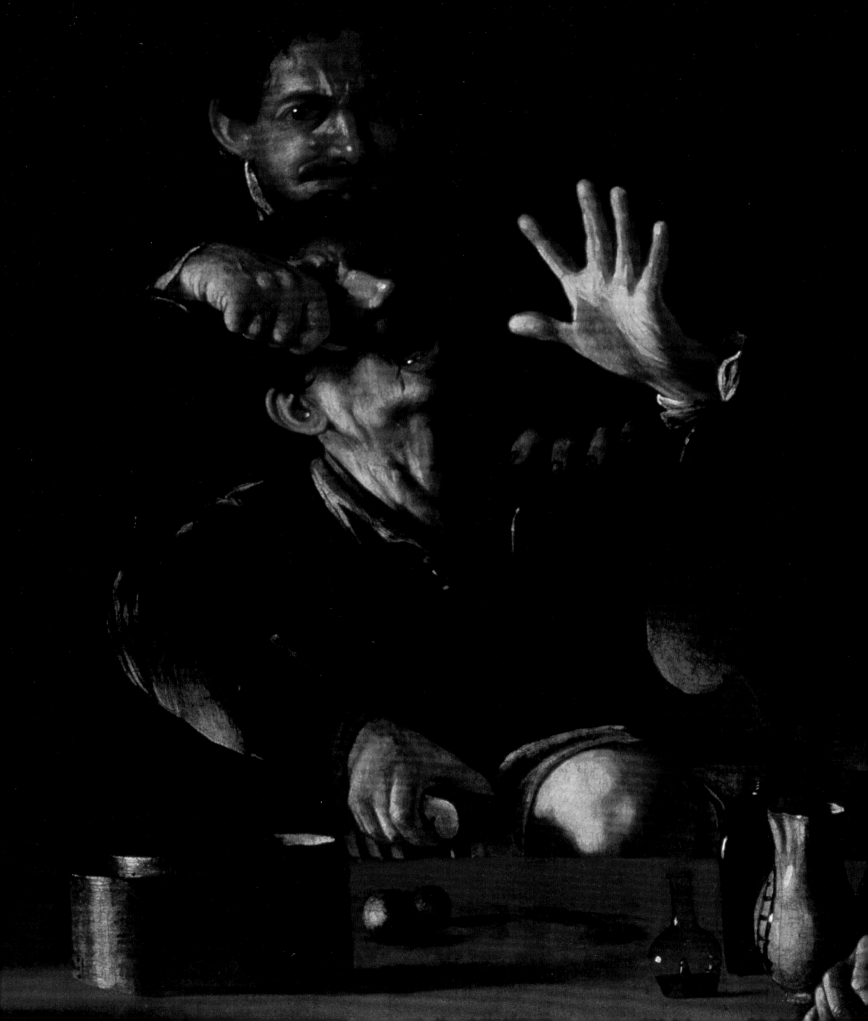

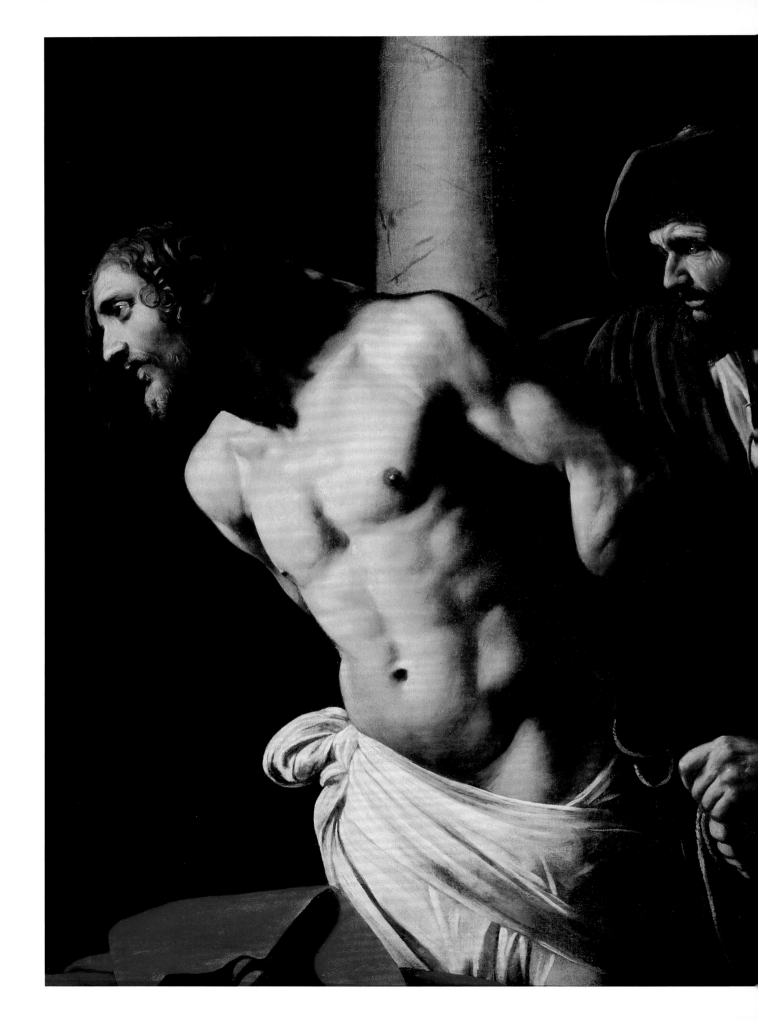

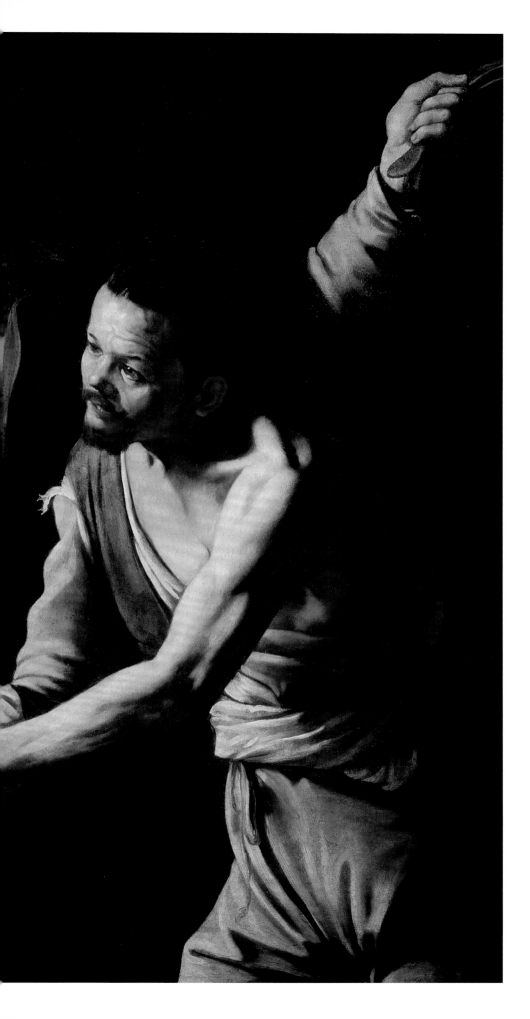

The Flagellation of Christ at the Column, c. 1607.
Oil on canvas, 134.5 x 175.5 cm.
Musée des Beaux-Arts, Rouen.

then left uttering all sorts of negative criticisms. Ferrucci was beside himself with rage but Passignani told him "that is all that is damaged, nothing more". And there was no movement of anger towards Cigoli, nor towards Caravaggio. (Baldinnucci, in *The Life of Cigoli and Passignani*)

20 May 1606 – Michelangelo da Caravaggio killed Ranuccio Tommasoni, a young nobleman "because of an argument while playing court tennis, the players having challenged each other ended up fighting with swords, Ranuccio fell to the ground and Michelangelo then impaled his thigh with his sword, fatally wounding him." (Baglione)

30 May 1606 – The notary of the Malefizii visited the injured Caravaggio bedridden in the house of Rufetti close to Colonna Square. "I injured myself with my own sword which slipped out of my hand in the street and I don't even know where it happened." While the examiner insisted, the painter responded "I can't say anything more". The notary told Caravaggio he would have to pay 500 *écus* if he did not leave the house. Bortolotti assumed that it was during the course of the murder of Tommasoni that the painter had received his injuries.

1606 (15 July, 23 September): 1607 (25 May, 20 August) – Michelangelo da Caravaggio, according to information from the Public Speaker Estense, was in hiding close to Rome in Paliano.

1607-1608 – Michelangelo da Caravaggio fled to Malta where he was imprisoned for causing a quarrel with an Officer of the Law. He climbed the walls of the prison at night and escaped to Sicily. (Baglione)

1608 – He fled from Messina directly to Naples, after injuring a school teacher. (Sacca)

1609 – In Naples, "caught up by his enemy", he was injured so badly in the face that he was unrecognisable (Baglione).

May 1609 – He was about to return to Rome, thanks to the intercession of Cardinal Gonzague, "who interceded with Pope Paul V to obtain his pardon". (Baglione) He was imprisoned by mistake and was freed two days later. Not long after he undertook his long run along the coast "under the terrible heat of the sun" to meet the felucca which was carrying away his belongings. He was then struck down by a malignant fever and died near Porto Ercole. "Without the support of his friends, he died in a few days as tragically as he had lived." (Baglione)

Portrait of a Gentleman, c. 1600-1605.
Oil on canvas.
Private collection, New York.

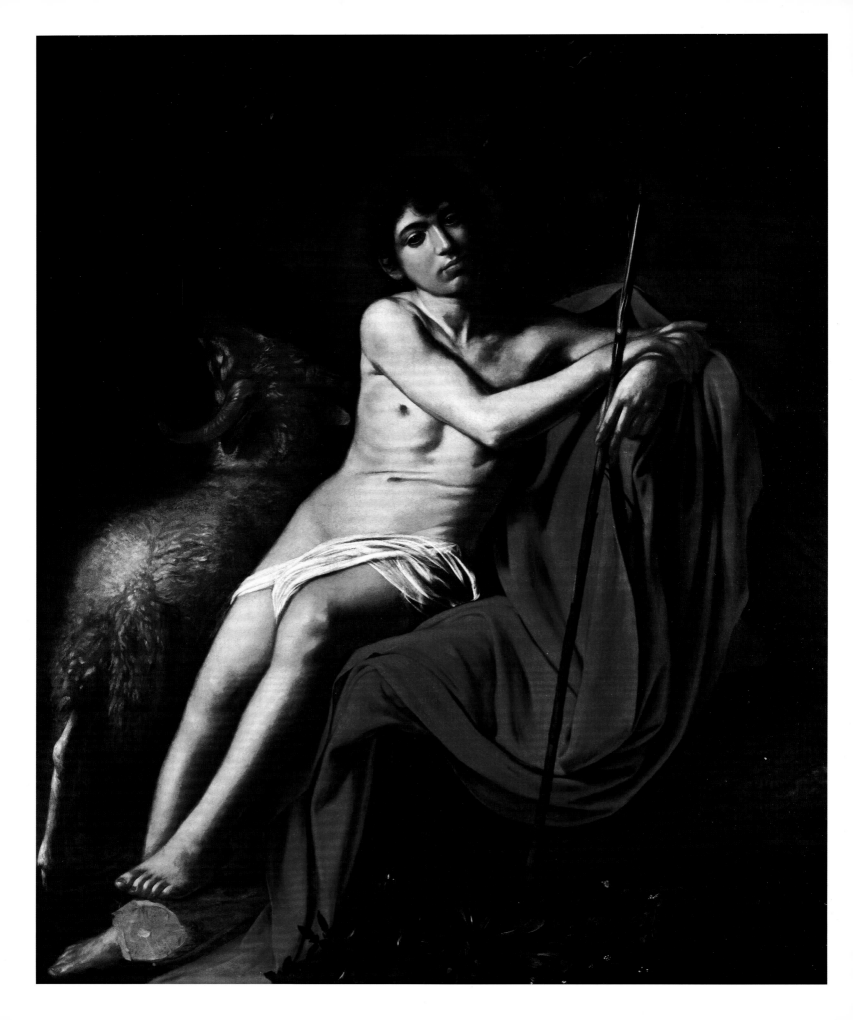

Letter of 29 July 1610 from the Bishop of Caserte to Cardinal Scipione Borghese

Dear Reverend and Respectable Master,

I refute what has been reported in the letter of The Very Illustrious Lanfranco of 24 July 1610 to Your Very Illustrious Lord regarding the painter Caravaggio. As I was not informed, I immediately tried to obtain information on this subject and have discovered that the unfortunate Caravaggio had died at Porto Ercole and not at Procida as it had been said. Indeed, having arrived at Palo aboard a felucca on which he was travelling, Caravaggio had been imprisoned by the captain and he was informed when he was set free that the felucca had already left on its voyage to Naples. Caravaggio remained in prison and obtained his freedom for a large sum of money and would probably have reached Porto Ercole by land, perhaps following the coast on foot. There he fell ill and died. On their return to port, the crew of the felucca returned the rest of his belongings to the Marquise of Caravaggio who lived at Chiaia from where Caravaggio was born. I also tried to find out if the paintings were there and I discovered they were missing, except for the following three: two paintings of Saint John the Baptist and one Mary Magdalene. At my express demand they have been placed under guard so as not to be damaged or seen and even less moved because they are destined for you and must be kept for Your Very Illustrious Lord until the aforesaid heirs and creditors of Caravaggio are dealt with and given due satisfaction, which is already partly done. I will make sure that these paintings are preserved in any way and will arrange for their delivery to Your Very Illustrious Lord in front of whom I bow humbly.

Naples, 29 July 1610.

Your very humble, very devout and very obliged servant and creature,
Fra Deodato Gentile, Bishop of Caserte

Saint John the Baptist, 1610.
Oil on canvas, 159 x 124 cm.
Museo e Galleria Borghese, Rome.

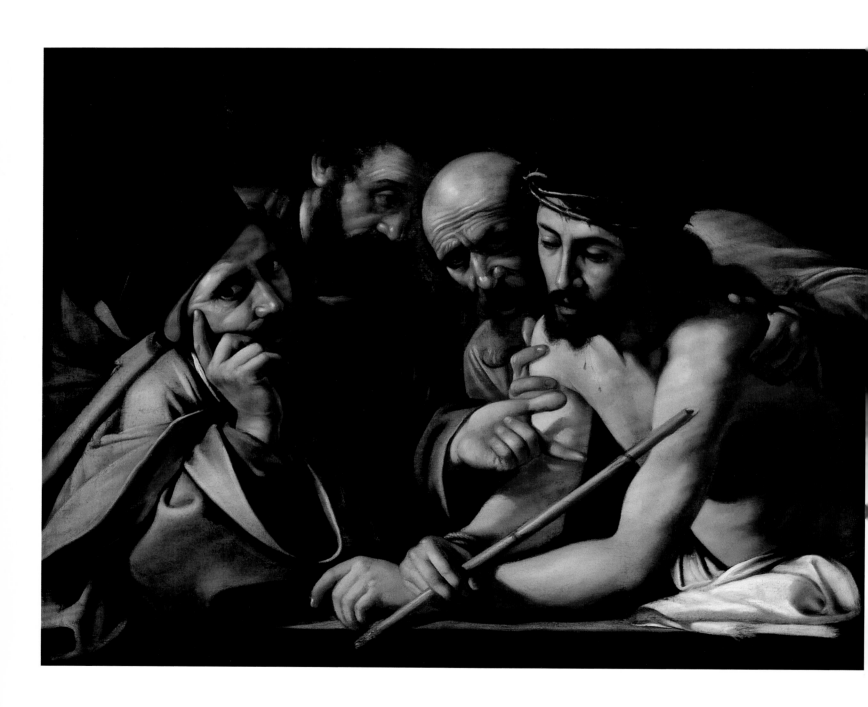

Ecce Homo, c. 1609.
Oil on canvas, 83.3 x 104 cm.
Private collection.

Conclusion

Although Baglione suggests that Caravaggio only began to focus upon his profession in earnest in Milan, we can nevertheless assume that he had previously been stimulated by art in Bergamo, close to his place of birth. Cariani's style, inspired by Sebastiano del Piombo and Giorgione, his mastery of portraiture, as well as his occasional tendency to paint genre-like portrayals may have had a significant influence on the young artist[78], and he would have found personal guidance in Bernardino Licinio's similar work, which remained decisive in his future development[79]. Many people like to establish a relationship between the spirit of Caravaggio's work and his life[80]. One is tempted to assume that his tragic destiny was the result of an accumulation of experiences he had sought himself, which he thought necessary for his artistic nature and which he exploited. From this point on he could indulge his tendency to prove to the observer that, as already mentioned, "in spite of all the holy events of former times, everything was as ordinary as in the streets of Italy towards the end of the 17th century"[81], and to represent those gypsies, beggars, and gamblers that people said were the debauched descendants of giants, sculpted in a majestic fashion after Michelangelo[82]. In contrast to this, it has been suggested from a more understanding point of view that the important artistic influence that was Caravaggio's pathos arose from the honesty of his characters, and the fact that he could only imagine the divine in human form, whether in a sombre, festive, or turbulent atmosphere[83]. This contrasted with the Mannerists, who only conceived of forms behind which there seemed to be no personality to offer an individual representation. Bellori wrote that "as long as the model was out of his sight, his hands and mind remained idle"[84]. In the same way as the representatives of the Bolognese School, chiefly the Carracci, concentrated on the construction of complex forms and the arrangement of beautiful drapery, Caravaggio depended on the "natural example", which was vital in meaning for his art, as his patron the Marchese Vincenzo Giustiniani noted[85].

In Rome the style of the masters from northern Italy developed first towards representation in the manner of *bas-reliefs*, which of Caravaggio's works, *The Cardsharps* (pp. 18-19) is the most marked example. In the monumental creations for San Luigi dei Francesi and Santa Maria del Popolo, the first signs of research into a greater depth can be seen, which is apparent in *The Death of the Virgin* (p. 80), and which developed into the perspective effect found in the *Madonna of the Rosary* (p. 115).

In the same sense, he also lent his paintings an appealing poetic reality through his use of lighting, with which he had already aroused the interest of his contemporaries. Baglione describes in detail the reflections of light in a glass vase which creates a delightful ambience around the flute player[86]. Caravaggio went beyond artistic miracles of imitation through his grandiose style, the detailed playing of stark and gentle light, with areas of *chiaroscuro* and illuminated shadows, which he accentuated within the image in order to balance the areas of realistic representation, and to achieve an impact that would go hand in hand with his carefully calculated colouring. It is this *contrapposto* treatment of light that, with its movement across the image, gives his works the great charm that many like to describe as the principal dimension of Caravaggio's art[87]. Caravaggio has been criticised for this lighting effect, similar to the lighting of an underground room, which excludes the rich variety of tones and colours that come with daylight[88]. Despite the lack of sympathetic and intimate accord found in Rembrandt's works, the golden tones of the reflections illuminate the space and render it habitable, and it must be recognised that Caravaggio had his own artistic laws[89].

Caravaggio achieved the effects in his paintings by means of a technique that astonished his contemporaries. Bellori remarked that the artist concentrated solely on the complexion, skin, blood, and the natural surface, and left all other artistic considerations aside[90]. Carracci added to this exaggerated comment by claiming that Caravaggio probably mixed real flesh into his colours in order to achieve the skin tones. Without question, Caravaggio needed an abundance of technical means to depict the *esempio naturale* in such an impressive way, means which he developed to perfection in the various studios of his apprenticeship, in the tradition initiated by Leonardo da Vinci in Milan, and through his own inventive talent. Uninterested in fresco painting, Caravaggio concentrated entirely on oil-on-canvas techniques. "He didn't work in any other way", reports Baglione, which allowed him to focus his strength on perfectly mastering this medium. Unlike the representatives of the Bolognese School, Caravaggio never tried to disguise the brush-stroke as such. The fluidity of the painting that fills his works goes hand in hand with great visibility of his working techniques.

The scope of Caravaggio's work is immense both because of the amount of paintings he undertook during his brief life and the creativity he showed. But his art, as innovative as it may have been, remained unrecognised for almost three centuries and it was only at the beginning of the 20th century that the impact of his influence throughout various later eras was finally acknowledged. His subversive work, whose genius and destiny have inspired numerous painters beyond frontiers and over

Phyllis (copy), c. 1597.
Oil on canvas, 66 x 53 cm.
Disappeared, formerly in the Kaiser Friedrich Museum, Berlin.

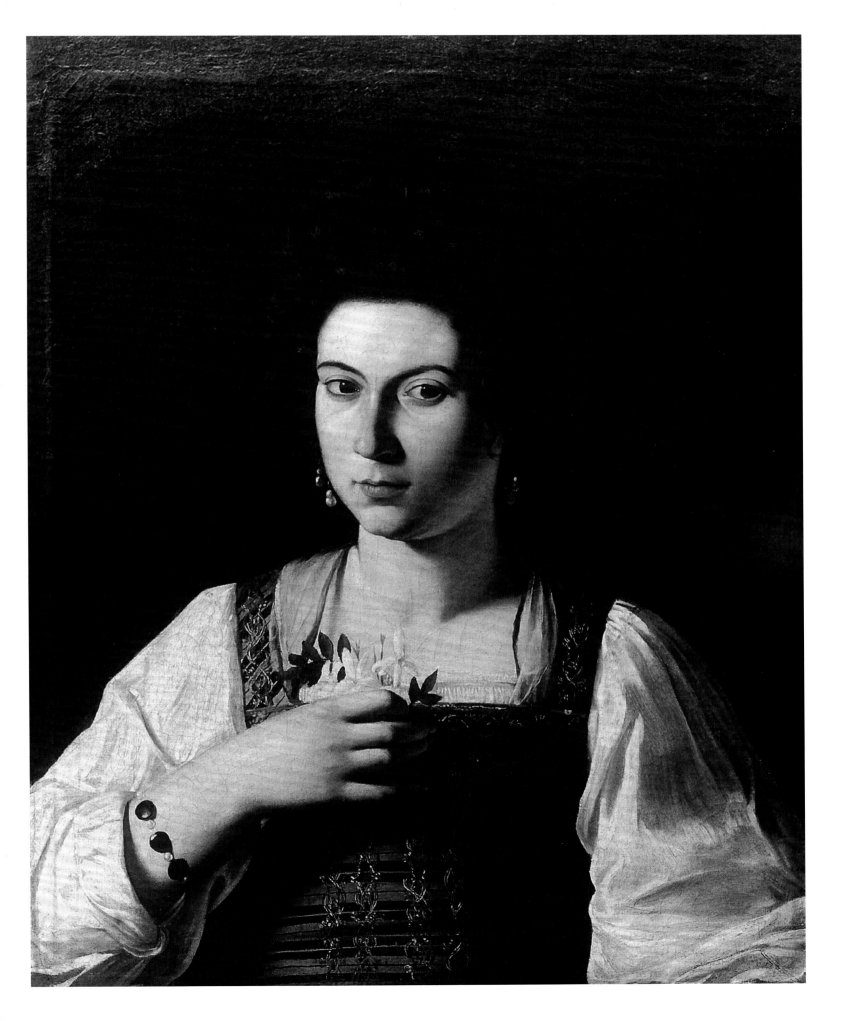

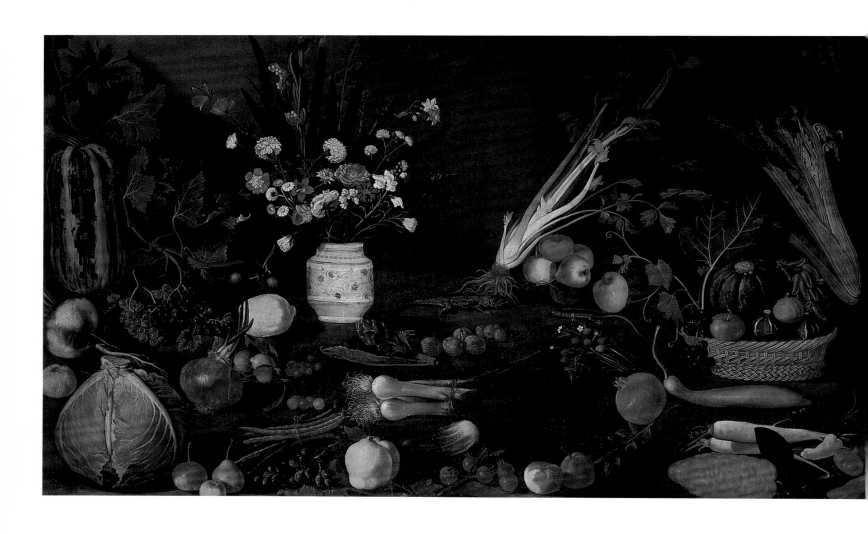

Still-Life with Flowers and Fruit, 1601.
Oil on canvas, 105 x 184 cm.
Museo e Galleria Borghese, Rome.

centuries, such as Georges de La Tour, Rembrandt van Rijn, Francesco Solimena, Diego Velázquez and Peter Paul Rubens, still fascinates us today.

With a provocative independence from religious institutions, he affirmed the place of Man at the centre of the universe whilst aspiring to the purity of the Divine. He anchored his vision of the sacred in the brutal and sensitive reality of mankind. An ardent defender of art taken from nature, he rose against Mannerism and established his own values, rejecting historical painting in which only the imagination guides the artist.

In some geniuses, two personalities confront each other without merging: that of the artist and that of the man. But Caravaggio managed to stay faithful to himself in his daily life as well as in his artistic approach, displaying the same soul and the same clothes both in his daily routine and in his social life. Showing great freedom of thought and loyalty to his principles, he triggered an inversion of the hierarchy that prevailed in art at the time, *inventio* (invention) over *imitatio* (imitation) which was its subordinate, never accepting any compromise in his life as well as in his work through which he constantly tried to innovate and question dogmas and established rules, which resulted in so many refused commissions. Caravaggio's prodigious idea that the artist should "seize the light from the shadow" ranks him among the greatest figures who sought to create, by means of colour, a more "ideal" world.

In his lifetime he was favourably received by enlightened admirers such as Cardinal Del Monte, Costanza Colonna, and by young Roman painters. As Bellori said, they were "captivated by newness and the young, in particular, rushed up to him and celebrated him as the only admirer of Nature, considering his works veritable miracles, they followed him, all trying to outdo each other in imitation". It is therefore difficult to dissociate his life from his work and the fascination he creates is still linked to what we know of his extravagant and criminal life. His paintings, which had an incredible impact all over Europe in his time, forever marked a decisive turning point in the history of painting.

Franz Kugler, who in 1836 compared Rembrandt to Caravaggio, stated: "There are artists who are clearly inclined to represent banality and ugliness, but who know how to draw from them all the components of passion, its strength and the strange greatness resulting from certain unusual states of mind; they, therefore, give the viewer an impression that is of course hardly edifying but that often seizes him with the power that emanates from it."

Bibliographical Notes

1 Baglione, G. & Battista Passari, G. (1733). *Vite de' pittori, scultori, architetti.* (p. 129). Naples, Italy.

2 Di Bassano, V.G. (1768). *Raccolta di lettere sulla pittura* etc., (Vol. VI, p. 249). Rome, Italy.

3 Baglione, G., *op.cit.*, (ch. 1).

4 Giulio Cesare Gigli cited by Meyer, J., Ed. (1872). *Allgemeines künstler-lexikon.* Vol. I. Leipzig, Germany: W. Engelmann.

5 Di Bassano, V.G. *op.cit.*, (Vol. VI, p. 315).

6 Schopenhauer, A. *Die Welt als Wille und Vorstellung,* additional information to Book III. (ch. 36).

7 Waagen, G.F. (1838). *Kunstwerke und Künstler in England* (Vol. I, pp. 249, 462, 499; Vol. II, pp. 82, 485). Berlin, Germany.

8 Unger, M. (1865) *Kritische Forschungen auf dem Gebiete der Malerei,* (pp. 159-178). Leipzig, Germany.

9 Meyer, J. *Künstlerlexikon I,* (pp. 613-623).

10 Dohme, R. (1878-1879). *Kunst und Künstler II,* (part 3). Leipzig, Germany: E.A. Seemann.

11 Woltmann, A. & Woermann, K. (1858) *Geschichte der Malerei III.* To be compared with *Repertorium für Kunstwissenschaft.* (Janitschek III, p. 144; VIII, p. 86; IX, p. 72; XIII, p. 144).

12 Burckhardt, J. (1855). *Das Cicerone,* (1st ed.).

13 Harden, M. (1902, January) *Zukunft.*

14 To be compared with Burckhardt, J. *op.cit.*

15 Burckhardt, J. *op.cit.*, (p. 7).

16 *Ibid.*

17 Unger, M. (1865). *A Kritische Forschungen auf dem Gebiete der Malerei,* (p. 56).

18 To be compared with Thode, H. (1901). *Tintoretto.* Bielefeld and Leipsig.

19 Burckhardt, J. *op.cit.*, (p. 3).

20 Baglione, G. *op.cit.*, (ch. 1).

21 To be compared with Burckhardt, J. *op.cit.*, (p. 914) ; Bode, W. "Giorgione nahestehende Gemälde im Herzoglichen Museum zu Braunschweig" in *Quellen und Forschungen zur Braunschweiger Geschichte* (VI, p. 253).

22 Bode, W. *op.cit.*, (p. 952).

23 Baglione, G. *op.cit.*, (ch. 1).

24 Baglione, G. *op.cit.*, (ch. 1).

25 To be compared with Meyer, J. *op.cit.*

26 Baglione, G. *op.cit.*, (ch. 1).

27 Goethe, J.W. (1996). *Traité des couleurs.* Paris, France: Triades.

28 Baglione, G. *op.cit.*, (ch. 1).

29 Meyer, J. *op.cit.*, (p. 623).

30 Baglione, G. (1642). *Vita di Michelangelo da Caravaggio.* Rome, Italy.

31 Baglione, G. *op.cit.*, (ch. 1).

32 Exhibited at Burlington Fine Arts Club, 1894, illustrated catalogue (VII, p. 1).

33 In Berlin (Museum III, 76) and Wilton House. – Lomazzo mentions, in his *Trattato* (1584; p. 439), that mural paintings can be found in several Italian *osteria* (both indoors and outdoors) with representations of ruffians, drinkers, gamblers in Milan. Compare with: Bertolotti, N. (1880). *Artisti belgi et ollandesi a Roma.* Firenze, Italy. The genre paintings by Dosso Dossi are also mentioned (oval paintings with eaters, drinkers and musicians at the gallery in Modena, *bambocciata* in the Palazzo Pitti (n 148) in Florence. In Ridolfi. (1648). *Delle Maraviglie dell'arte in Venetia* I (p. 79), Ridolfi talks of Giorgione's genre paintings on façades (frescos).

34 Waagen, G.F. *op.cit.*, (Vol. II, p. 82).

35 *Ibid.*, (Vol. I, p. 249).

36 Compare with Meyer, J. *Künstlerlexikon.*

37 Catalogue n 227 of the main collection. – Louvre catalogue n 1122.

38 Capitolinian Collection, catalogue n 244; Pommersfelden, Painting Department, n 39.

39 Berlin, Gemäldegalerie, catalogue n 369, (1815) from the Giustiniani Collection. Dijon, museum, catalogue n 646.

40 Only example in Berlin, Gemäldegalerie, n 381, this is the catalogue : „Wie durch gleichzeitige Berichte bestätigt wird, hat Caravaggio in Nr. 369 und 381 die irdische und die himmlische Liebe darstellen wollen." ("As contemporary reports confirm, Caravaggio wanted to represent earthly and heavenly love in n 369 and 381.")

41 Musée des Offices, n 1031.

42 Buckhardt, J. *op.cit.*, (Vol. II, p. 1001).

43 Catalogue n 408, canvas.

44 Baglione, G. *op.cit.*, (ch. 1) – According to Baldunucci (Opere X, p. 204 s.), the order was given by a certain Vergilio Crescenzi.

45 Baglione, G. *op.cit.*, (p. 251).
Baglione, G. *Vita del Caval. Gius. Cesari d'Arpino, pittore*, p. 129
Baglione, G. *Vita di Caravaggio.*

46 Buckardt, J. *op.cit.*, (p. 977).

47 Witting, F. (1903). *Von Kunst und Christentum.* Strasbourg, Germany: Heitz.

48 Burckhardt, J. *op.cit.*, (p. 984).

49 *Ibid.*, (pp. 3, 8).

50 Catalogue n 365 ; canvas, height: 2.32 m x width: 1.83 m. Compare with Hirth-Murther, Cicerone der Königliche Gemäldegalerie Berlin (p. 111); Gesellschaft (Photographic Association), Berlin.

51 Catalogue n 32; according to Eisenmann, (1879) and Burckhardt, *op.cit.*, (p. 984), the painting belonged to Caravaggio himself; the colours are imprecise, undefined, which is why it seems clear that this copy is not by Caravaggio's hand.

52 Baglione, G. *op.cit.*, (ch. 1); Louvre, catalogue n 1121.

53 Compare with Eisenmann, *op.cit.*, (p. 12).

54 Baglione, G, (ch. 1.c). Catalogue of the pictures in the National Gallery (1894), n 172.

55 Innsbruck, Ferdinandeum catalogue n 565. – The image in Notre Dame de Bruges can be found on a pillar in the central nave, to the right of the crossing. – Bellori also mentions three variations of the Emmaus painting; Bellori, G.P. (1672). *Vite de' pittori etc. moderni*, (ch. 1. c). Rome, Italy. According to him, one featuring five figures was painted for the Marchese Patrizj, the second was made for Cardinal Scipione Borghese in Rome, and the third was painted in Zagarolo, near Palestrina, for Count Mazio Colonna.

56 Burckhardt, J. *op.cit.*, (p. 972).

57 Vasi, M. (1818) *A new picture of Rome, and its environs, in the form of an itinerary.* (ch. 1. c; p. 4). The two small decorative pieces in the Kestnermuseum in Hanover (n 61, 62) were probably made in collaboration with Prosperino.

58 See Baglione, G. (ch.1. c); also Vasi, M. *op.cit.*, (ch. 1. c; p. 5).

59 Buckhardt, J. *op.cit.*, (p. 995).

60 The Mattei family were known for their interest in works of art from Antiquity. Compare with Michaelis, A. (1908). *Ein Jahrhundert kunstarchäologischer Entdeckungen*, 2nd edition.

61 Meyer, J. *op.cit.*

62 *Ibid.*

63 Baglione, G. *op.cit.*

64 Compare with Woltmann, A. & Wörmann, K. *op.cit.*; also Vasi, M. *op.cit.* (ch. 1. c, p. 28) regarding the picture in the Palazzo Doria.

65 Bellori, G.P. *op.cit.*

66 *Ibid.*

67 See Vasi, M. *op.cit.* (ch. 1). – Munich, Alte Pinakothek n 1234. – Bordeaux, museum, catalogue n 5.

68 Baglione, G. *op.cit.*

69 Compare with Burckhardt, J. (1909). *Cicerone*, (p. 985).

70 Burckhardt, J. *op.cit.*, (p. 816, 969).

71 Baglione, G. *op.cit.*.

72 To be compared with Meyer, J. *op.cit.*

73 *Ibid.*

74 Unger, M. *op.cit.*, (p. 176).

75 Baglione, *op.cit.*

76 Regarding this artist, see Burckhardt, J. *op.cit.*, (p. 596).

77 Rosa, J. (1796). *Gemälde der K. K. Galerie in Wien*, (Vol. I, p. 108) ; compare with Burckhardt, J. *Erinnerung aus Rubens*, (p. 15) and Meyer, J. *op.cit.*, (Vol. I, p. 622).

78 *Ibid.*, (p. 7). Compare with *L'Arte a Bergamo e l'Academia Carrara*, 1897, published by the artistic circle. Bergamo.

79 Compare with Muther, R. (1912) *Geschichte der Malerei.* Berlin: Neufeld and Henius, (Vol. 3).

80 Burckhardt, J. *op.cit.*

81 Justi, C. (1900). *Michelangelo*, Leipzig, Breitkopf & Härtel. (p. 190).

82 Unger, M. *op.cit.*, (p. 167).

83 Baglione, G. *op.cit.*

84 In a letter to Teodoro Amideni. (1768). *Raccolta di lettera sulla pittura etc.*, (Vol. VI). Rome, Italy..

85 Baglione, G. *op.cit.*, see Appendix I.

86 Wöfflin, H. *op.cit.*

87 Burckhardt, J. *op.cit.*

88 Meyer, J. *op.cit.*

89 Baglione, G. *op.cit.*, (ch. 1).

90 Meyer, J. *op.cit.*

Biography

1571: Birth of Michelangelo, eldest son of Fermo Merisi, foreman, mason, and architect of the Marchese of Caravaggio, and of Lucia Aratori, daughter of a well-to-do family, probably from Milan where the Marchese had his court.

1576: The plague arrives in Milan, causing the Caravaggio family flee.

1577: Death of his father.

1584-1588: Four year apprenticeship in Simone Peterzano's studio in Milan.

1592-1593: In Rome, where he works for the famous painter Giuseppe Cesari d'Arpino. The well-known works of this period are *Young Boy Peeling Fruit* (his first known work), *Boy with a Basket of Fruit*, and *Sick Bacchus*.

1594: Leaves Giuseppe Cesari d'Arpino in January. He makes an important friendship with the painter Prospero Orsi who introduces him to some leading collectors. His work *The Fortune Teller* gives him some recognition and allows him to gain the protection of Cardinal Francesco Maria Del Monte.

1599: Receives the commission to paint the Contarelli chapel in the church of San Luigi dei Francesi. His works are met with immediate success.

1606: The Carmelites refuse *The Death of the Virgin*. Giulio Mancini, a contemporary of Caravaggio, supposes that Caravaggio chose a courtesan as the model.

During a brawl, Caravaggio accidentally kills the painter Tomassoni. Although under the protection of high dignitaries, he must flee. He goes to Naples where he is out of reach of Roman justice and is protected by the Colonna family. Thanks to the influence of this family, the church awards him the commission to paint the *Madonna of the Rosary* and the *Seven Works of Mercy*.

1607: Departs for Malta, to the headquarters of the Knights of the Order of Malta, where he hopes to obtain the protection of Alof de Wignacourt, Grand Master of the Order, and to finally be pardoned.

1608: Wignacourt, impressed by having Caravaggio as official painter of the Order of Malta, bestows on him the Knighthood of the Order. The known works of this period are *The Beheading of Saint John the Baptist*, the *Portrait of Alof de Wignacourt*, and some portraits of knights.

He is imprisoned in August after a brawl, during which one of the knights is seriously wounded. In December, he is expelled from the Order of Malta.

1609: He spends nine months in Sicily but after getting attacked he returns to Naples to enjoy the protection of the Colonna family, and waits for the papal pardon in order to finally return to Rome. But in Naples, he is once again attacked by strangers. He paints *Salome with the Head of John the Baptist*, showing his head on a serving plate, and sends it to Wignacourt to implore his forgiveness.

1610: Departs for Rome to obtain his papal pardon. A messenger from Rome informs the court of Urbino about the death of the painter. A poet friend of Caravaggio establishes the date of his death as 18 July.

Index